This compendium contains 100 of the most mind-blowing colors our human eyes can see (plus a few we can't!). Discover:

- **ROYGBIV AS YOU'VE NEVER SEEN IT BEFORE:** In addition to unique examples of the classic spectrum (like Helenite Green and Quasar Blue), you'll also find neutrals and extra-spectral colors like Vantablack, Landlord White, and Magenta.

- **STRUCTURAL COLORS:** Opal and Blue Morpho Butterfly Wings have colors that arise from the physical structure of the object's surface, which scatters light to produce dazzling displays of color.

- **IMPOSSIBLE COLORS:** Forbidden colors exist outside the range of human visibility, chimerical colors are ones we can trick ourselves into seeing, and imaginary colors exist in mathematical theory but we'll never see them! This section includes fun visual experiments that simulate the experience of seeing some of these "impossible" colors.

Perfect for anyone who loves science, art, or nature, *The Universe in 100 Colors* is a wonder for the senses.

**THE UNIVERSE IN
100 COLORS**

SASQUATCH BOOKS | SEATTLE

WEIRD AND WONDROUS COLORS
FROM SCIENCE AND NATURE

THE UNIVERSE
in 100 COLORS

Tyler Thrasher and Terry Mudge

To the curious minds

whose boundlessness mirrors the infinite spectrum of colors and the vast cosmos they illuminate.

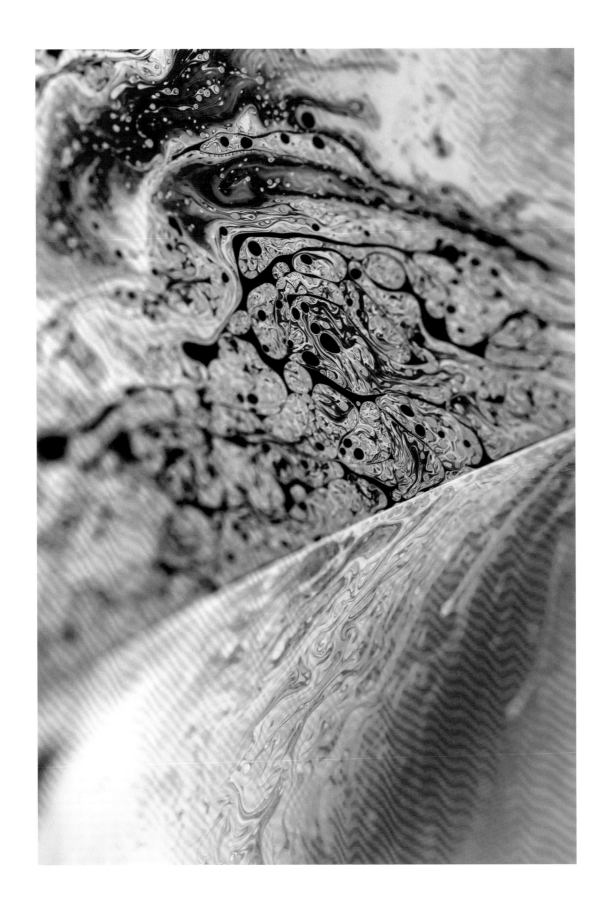

Contents

Foreword	x	
Dear Reader	xiv	
Introduction	xvi	

Acknowledgments	232	
Glossary	234	
References	238	
Index	252	

1 Cosmic Void	9	
2 Vantablack	11	
3 Black Substance	13	
4 Eigengrau	15	
5 Black Pearl	17	
6 Cuttlefish Ink	19	
7 Anthocyanin in Black Plants	21	
8 Gray Matter	23	
9 Glaucous	25	
10 Lunar Dust	27	
11 Polar Bear Fur	29	
12 White Rot	31	
13 Lead White	33	
14 Ultrawhite	35	
15 Mistake Out	37	
16 Ivory	39	
17 Cosmic Latte	41	
18 Landlord White	43	
19 Mummy Brown	45	
20 Brown Dwarf	47	
21 Feuille Morte	49	
22 Carmine	51	
23 Ancient Chlorophyll	53	
24 Falu Red	55	
25 Hydrogen-Alpha	57	
26 Dragon's Blood	59	
27 Pompeian Red	61	
28 Kermes Red	63	
29 The Great Red Spot	65	
30 Realgar	67	
31 Redshift	69	
32 Blood Moon	71	
33 Martian Red	73	
34 Poppy Red	75	
35 International Orange	77	
36 The First Color	79	
37 Fulvous	81	
38 Tiger's-Eye	83	
39 Orpiment	85	
40 Bastard Amber	87	
41 Sodium-Vapor Light	89	
42 Baltic Amber	91	
43 Venusian Yellow	93	
44 Libyan Desert Glass	95	
45 Imperial Yellow	97	
46 Gold	99	
47 Indian Yellow	101	
48 Letharia Vulpina	103	
49 Luciferin	105	
50 Fluorescein	107	
51 Uranium Glass	109	
52 Radium Decay	111	
53 Earth Aurora Green	113	
54 Helenite Green	115	
55 Scheele's Green	117	
56 Fuchsite	119	
57 Chalkboard Green	121	
58 Smaragdine	123	
59 Malachite	125	
60 Mercury E-Line	127	
61 Green Pea Galaxies	129	
62 Mirror	131	
63 Comet C/2002 E3 (ZTF)	133	
64 Zelyonka	135	
65 Water	137	
66 Maya Blue	139	
67 Unappetizing Blue	141	
68 Prussian Blue	143	
69 Tsetse Fly Blue	145	
70 Horseshoe Crab Blood	147	
71 Quasar Blue	149	
72 Ciel	151	
73 Egyptian Blue	153	
74 Sonoluminescence	155	
75 Cherenkov Radiation	157	
76 Chalcanthite	159	
77 YInMn Blue	161	
78 Ice Giants	163	
79 Navy Blue	165	
80 Blacklight	167	
81 Han Purple	169	
82 Tyrian Purple	171	
83 Amethyst	173	
84 Gentian Violet	175	
85 Lepidolite	177	
86 Mauveine	179	
87 Purpleheart	181	
88 Avocado Dye	183	
89 Magenta	185	
90 Astaxanthin	187	
91 Baker-Miller Pink	189	
92 Ruby Chocolate	191	
93 Hydrangea Pink	193	
94 Opal	201	
95 Cystoseira Tamariscifolia	203	
96 Giant Blue Morpho Butterfly	205	
97 Marble Berry	207	
98 Oil or Soap & Water	209	
99 Monarch Chrysalis Gold	211	
100 Colloidal Gold	213	
Impossible Colors	216	

Foreword

We often tend to assume that our experiences are typical, but the more we look out at the rest of the matter in our galaxy, the more it seems like that just isn't the case. The sun is strangely stable and calm compared to other stars, for example, which makes things a lot simpler for living things on our planet.

But what, to me, is most surprisingly atypical about our lovely planet is that it has a star at all. Planets form as matter globs together and, at the center of that disk of planets and stuff is a star (sometimes more than one star). And so, you'd think that all planets revolve around stars! And you would be wrong.

Most planets that exist in our galaxy today, at some point in the formation of their system, were ejected. They got flung out by some gravitational interaction and now roam the cold, dark space between the stars orbiting nothing except (very distantly) the same supermassive black hole at the center of the galaxy that our solar system orbits.

We call these rogue planets.

Alone in the dark. Only stars in the sky. No light, ever.

Or is there?

I think about these planets quite a lot, which I know sounds weird, but I will reiterate, they are most planets. And I sometimes think about what life would be like on a planet like that. And maybe you're thinking, "Well, there couldn't be life without sunlight," but that's definitely not true.

Here on Earth, many argue that life began at hydrothermal vents at the bottom of the sea. The organisms back then (like the life that lives there now) fed on the chemical energy emitted from the planet. Those ecosystems do not require light at all. If Earth were ejected from the solar system and flung into the deep darkness between the stars, certainly you and I and our entire species

would die. The oceans would ice over in that empty darkness and Earth would appear to be barren and dead.

But the hydrothermal vents would, for billions of years, keep spitting out those yummy chemicals and those ecosystems would continue to thrive.

And even though they are at the bottom of the ocean in a place so dark there could never be light, animals at hydrothermal vents do have eyes, and they also have colors. It turns out that warm spots in the deep sea make their own light, it's just infrared light that is invisible to us. Even more bizarre, some animals at hydrothermal vents make their own light through bioluminescence.

So, you could imagine a rogue ice planet with a warm core melting some of that water, with nutritious chemicals spewing from vents in the seafloor. And you could imagine that there, in the darkest of places imaginable, there would still be light and eyes and color.

It is very odd that you have two extremely sensitive electromagnetic wave detectors in your face, but you do. You have them because electromagnetic waves are a very useful thing to be able to detect. That's why eyes are so common, and why they have evolved over 1,000 independent times on our little planet alone. We get to live on a world of light and the result is so many eyes seeing so many colors for so many reasons. And, no doubt, some of the wildest reasons to have eyes are for joy and wonder and curiosity and amazement. Perhaps those are not the most important of evolutionary reasons, but I think they are definitely among the best.

I hope your electromagnetic wave detectors enjoy what's coming at them in the pages ahead.

—HANK GREEN

Dear Reader

Through my endeavor to find the most fascinating matter our planet has to offer for my scientific subscription box, Matter, I have seen many unique scientific phenomena. Color, the range of energy that fills the visible universe, has been a constant highlight throughout this journey.

From the intricate patterns and brilliant hues of minerals formed deep beneath Earth's surface, to distant galaxies creating grand displays of exploding, dying, and newly forming stars, this vibrant range has not only illuminated my path but revealed hidden connections between everything across the universe, both known and unknown.

In this book, you will find not just a collection of colors, but a spectral celebration of the profound, the enigmatic, and the outright mind-blowing. Each color included here represents a mystery unraveled. From the mesmerizing blue of a quasar to the haunting glow of fox fire, the colors in these pages are the keys to understanding some of the most captivating phenomena in the natural world.

This book is a labor of love, born from countless hours of research, discussions with experts in the most esoteric fields, and my firsthand observations. It's my hope that these colors will inspire you, challenge you, and reveal the interconnections to be found between everything in the entire universe. Now it's your turn to explore. Enjoy the revelations that await within these pages.

—TERRY MUDGE

As an artist and citizen scientist, it's only natural that this intersection would bring my career to the big questions about color. What is a color? How are colors even able to exist in the first place? I began a pursuit to not only understand colors, but to synthesize them in my studio/lab through the wonders of nanoparticle science.

After dedicating several years of my creative career to synthesizing crystals and minerals, I decided to tackle one of the most alluring mineraloids of them all: the opal, that master conductor of the orchestra of light play. The journey to synthesizing opals is a tricky one. It's an endeavor that requires immense patience, structural stability, and fine-tuning to the degree of just a few hundred nanometers. My countless experiments involved late nights waving my phone flashlight across dozens of oil-filled jars hoping white blobs would reveal flashes of color.

It would take a solid year of tinkering and hundreds of failed experiments before I would create some of the world's first lab-grown opalized insects and flowers. Along the way, I deepened my love of color and furthered my understanding of it. My obsession with projects that depend on color and light led to this book, where I can share what I've learned in hopes that you, too, can see what all the fuss is about.

—TYLER THRASHER

Intro
duc

o-
tion

What Is Color?

At its heart, color is a form of communication, an interaction between an observer and particles of light. It is an aspect of the universe that many humans (and other life-forms) get to experience. To see color, you need three things: light, an object, and eyesight. Light is made of energy that travels in waves. Different waves result in different colors. When light hits an object, some of the light gets absorbed and some gets reflected. The color you see is the light that bounces back. Inside your eyes, special cells pick up on this light and send a message to your brain, which tells you what color you're seeing.

Think of color as a silent symphony of wavelengths that plays on the grand stage of reality. Like music, colors can hum in soft pastels or belt out bold neons. They sing song-stories of scientific phenomena—and of perception. To fully unravel what it means to experience color, one must delve into the domains of physics, chemistry, biology, and human curiosity.

Imagine light as an orchestra, with each instrument representing a different wavelength. In the Visible Spectrum Philharmonic, the violins play the shortest wavelengths (which we perceive as violet), while the double basses play the longest ones (which we perceive as red), and yet we know there exists even more instruments and wavelengths contributing to this musical experience—ones completely invisible to us. There are certain waves, such as radio and gamma waves, that are ordinarily imperceptible to us and require special devices to enjoy and observe.

The color of an object that we perceive is a result of the light it reflects. A pigment color, such as the red of an apple, signifies that all orchestra members, except those playing red, have been muted. The apple absorbs these other visible wavelengths, reflecting only the red for our eyes to intercept.

Meanwhile, some objects conduct their own unique symphony in the form of structural colors. Rather than muting certain instruments, they manipulate the performance using nanostructures. It is akin to an acoustic enhancement, and the shimmering blues of a peacock's feather or the iridescent wings of a butterfly are the glorious encores we perceive.

However, like interpreting a complex musical score, our perception of color is subjective, susceptible to influences like lighting conditions, context, and cultural background. Extraspectral colors, like magenta, do not exist as solo instruments but as a harmonious duet created by our brain. Magenta is the brain's improvisation when it hears both the violins and double basses—the ends of our visual spectrum—playing simultaneously. It might sound like its own instrument, but it's really a trick (see page 183).

Physiological factors, too, create variations in the color concert we experience. Color blindness, for instance, occurs when certain audience members—color receptors in our eyes—are missing or nonfunctional. Though we might all attend the same color concert, our experiences can greatly differ.

From cave artists 40,000 years ago with their earthen pigments, to Renaissance painters scouring the earth for the brightest and most durable paints, to today's technologists programming LED lights, humans are not content to be the audience but have always attempted to conduct our own color concerts.

Straddling the realms of science and art, objectivity and subjectivity, color is a multifaceted field of exploration. In this book, we aim to take you on a journey through the universe by way of color, exposing the magic behind color creation, perception, and significance.

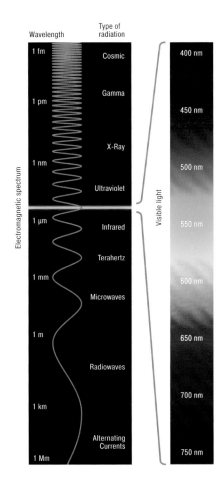

> For your convenience, we've included a glossary of essential terminology at the end of this book (see page 234).

The Science of Color

Every color we perceive, from the orange fluttering wings of a monarch butterfly to the fiery explosions that follow Tom Cruise across our screens, is the result of electromagnetic radiation. This broad spectrum of energy fills the universe with waves from radio to gamma rays.

THE ELECTROMAGNETIC SPECTRUM

At the heart of the electromagnetic spectrum are photons—the elementary particles of light. Each photon carries a specific amount of energy that is directly proportional to its frequency and inversely proportional to its wavelength. This means that photons of high-frequency light (such as gamma rays and X-rays) possess higher energy than those of low-frequency light (like radio waves).

Visible light, the small part of the spectrum that our human eyes can perceive, sits between infrared and ultraviolet light. This part of the spectrum spans wavelengths of energy from about 380 to 750 nanometers (nm), and each color corresponds to a particular wavelength within this range. For instance, red light has longer wavelengths (620 to 750 nm), while blue light is associated with shorter wavelengths (450 to 495 nm).

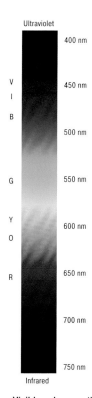

Visible colors are the wavelengths of light between ultraviolet and infrared. Arranging these colors by descending wavelength results in the acronym ROYGBIV.

COLOR AND THE ATOM

At the atomic level, the color we perceive from any object is largely the result of an interaction between the atoms or molecules of the material and the incident light—more specifically, the energy of the light's photons. The electrons in atoms and molecules exist in specific energy states. When a photon with just the right amount of energy interacts with an atom, it can propel an electron from a lower energy state to a higher one, absorbing the photon in the process. This is what is happening when we say a material absorbs light of a particular wavelength. This absorption of certain wavelengths results in the colors we perceive, as the unabsorbed colors are reflected back to our eyes.

When an electron transitions from a higher energy state to a lower one, the energy difference is released in the form of a photon. If this photon's energy corresponds to the visible range of the electromagnetic spectrum, it will result in the emission of light. In addition to absorption and emission, some colors we see are the result of interplay of light with intricate structures. Structural colors, like those in opal, arise when light interacts with the nanostructures that are spaced just widely enough to allow certain wavelengths to pass. The nanostructure of blue- and violet-exhibiting opals, for instance, only allow wavelengths of roughly 400 nm to pass through (see page 201).

Visible light can even play a pivotal role in our understanding of the cosmos. The color of stars can provide a great deal of information for astronomers, such as the star's temperature, composition, age, and even its velocity. Similarly, the redshift (see page 69) of distant galaxies helps astronomers estimate the rate of expansion of the universe and has shed light on the fact that our universe isn't slowing down anytime soon.

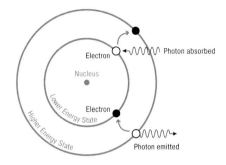

Electrons transition between different energy states by absorbing or emitting photons, corresponding to the required energy change.

THE PERCEPTION OF COLOR

The physics of how light and color are produced is only part of the full story. After all, the existence of color wouldn't mean much to us if we didn't have the ability to observe and comprehend it. The marvel of our ability to perceive color can be attributed to an evolutionary journey that began with the simplest photoreceptive cells, which led organisms toward brightness and away from darkness and culminated in the sophisticated visual system we possess as humans. The eye, through hundreds of millions of years of evolution, has refined its capabilities to capture light and decode it into the vibrant palette of colors we

experience. This evolution is so advantageous that it has occurred independently many times in various creatures over the course of natural history.

Human eyes possess three types of cone photoreceptor cells, each sensitive to certain ranges of wavelengths. One type of cone is most sensitive to shorter wavelengths, allowing us to see blues; another type is attuned to medium wavelengths, corresponding to greens; and the third type is optimized for longer wavelengths, facilitating our ability to see reds. The relative signals sent from these three types of cones to our brain allows us to perceive a diverse array of colors, a process known as trichromacy.

Some animals, like certain species of birds and reptiles, are tetrachromats—meaning they possess four independent channels that convey color. For them, the additional photoreceptors respond to wavelengths outside the human visible spectrum, potentially allowing them to perceive colors we can't see. If humans were tetrachromatic, the number of possible color combinations our brain could interpret would theoretically increase exponentially. We might be able to distinguish subtler color variations and see a wider range of colors. (For more on this, see Impossible Colors, page 216.)

In essence, the science of color is a remarkable fusion of physics, biology, and chemistry. It involves the study of light, the nature of matter, and the mechanics of perception. By understanding color and its origins, we uncover fundamental insights about the universe and our place within it.

INCANDESCENCE: THE COLOR OF HEAT

Color can be produced through fifteen different physical processes, such as refraction, charge transfer, or diffraction, just to name a few. Perhaps the most familiar of these processes is incandescence—the light produced by an object solely by virtue of its temperature. This is the process that provides sunlight, candlelight, and the glowing red coils inside of an electric toaster.

As with all colors, at the heart of this process lies atomic physics. As an object heats up, its atoms and molecules gain energy, causing their electrons to occupy higher energy levels. However, these high-energy states are unstable, and electrons soon fall back to their lower energy states, releasing energy in the process. This energy takes the form of photons, and the energy of these photons determines their color.

Consider, for instance, a metal rod heating in a fire. At first, as its temperature rises, it begins to glow a dull red. This is because

the energy being released corresponds to photons in the red part of the spectrum. As the rod gets hotter, the energy increases, and the color changes from red to orange to yellow. Eventually, if the rod becomes white-hot, it's because the photons being emitted are from across the visible spectrum, resulting in a white light.

Similar principles apply to a roaring fire. The red and orange colors you see in a flame are the result of superheated particles emitting light as they cool. The blue part of a flame, often at the base, is hotter and indicates where combustion is most complete.

From a campfire to molten lava and red-hot metal to the stars in the sky, the connection of heat and light is fundamental to our understanding of many common colors on Earth and throughout the universe.

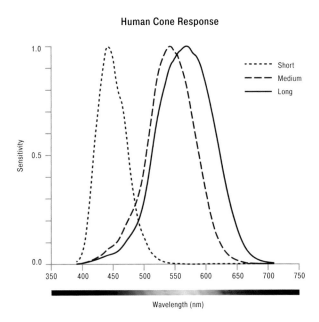

Normalized short, medium, and long cone sensitivity curves in human non-deficient trichromatic vision. Based on Stockman and Sharpe (2000).

Common Color Misconceptions

Despite color being a ubiquitous aspect of our world, misconceptions about its nature and behavior are equally widespread. A few of these myths are detailed here.

MYTH: THE PRIMARY COLORS ARE RED, YELLOW, AND BLUE

This is often taught in schools, art courses, and paint-mixing diagrams, but it's not quite accurate in all contexts. In terms of light, the true wielder of color, the primaries are instead red, green, and blue. When it comes to color printing and photography, dyes and inks work through subtractive color mixing, which requires stacking or overlaying color fields of yet another set of primary colors—magenta, cyan, and yellow—to partially absorb light, allowing only some of the visible spectrum to be observed.

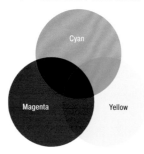
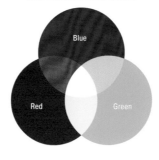

MYTH: RAINBOWS CONTAIN EVERY COLOR

A rainbow, or the visible light spectrum, includes a beautiful array of colors, but it does not include all colors categorized and recognized by humans. Pink, brown, and white, for example, are not found in the spectrum because they result from a mix of wavelengths or from complex interactions within our eyes and brain. Pinks and magentas are perceived when red and blue wavelengths overlap. There are no overlapping colors in a rainbow, and even if there were, red and blue are on opposite sides of the visible spectrum. A lot of overlap would need to occur before blue and red could meet, and at that point it would be a very muddled rainbow. This is the same reason you won't find true purple in a rainbow. The purplish color and bands we see is due to something called supernumerary rings, which are additional faint bands surrounding a primary or even secondary rainbow. Their light interaction gives the illusion of purple but doesn't change the fact that purple doesn't have its own distinct wavelength in the visible spectrum. The closest we get to purple in light is spectral violet, which does have its own wavelength, whereas purple is a range of mixtures between varying ratios of red and blue.

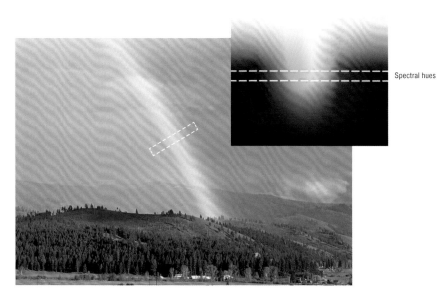

Spectral hues

The rainbow only contains pure spectral colors, called hues, without the addition of white or black.

MYTH: DARK OBJECTS ABSORB MORE HEAT BECAUSE OF THEIR COLOR

Dark objects do absorb more heat, but it's not because of their color per se. It's actually the other way around. An object's color starts with building blocks: molecules. Some molecules and the structures they form are better at absorbing and trapping light—this is the most important detail of color. Those imprisoned wavelengths are converted into a different energy source: heat. The better an object is at trapping and absorbing light the hotter that surface will be. This also means these structures, networks, and molecules reflect less light, resulting in a dark or black appearance. Colors are an indicator of a material's behavior and hint at some incredible physics taking place behind what's reflected.

MYTH: BLACK AND WHITE ARE NOT COLORS

This often sparks debate. In terms of light, white is a mixture of all wavelengths of light being perceived simultaneously, and true pitch black is the absence of any light—no color, no visual information. When it comes to pigments, the whiter and paler a color, the more light is being reflected back at the viewer. The darker and blacker a color, the more light is being absorbed by the surface or medium. If any coated object is to possess color, that color is made up of the wavelengths that managed to escape the structure of the coating.

This doesn't account for the headache-inducing breadth of whites and blacks acknowledged by artists, interior designers, and clothing companies (or anyone with a flannel and an Americano, honestly). If you don't believe us, stand near a hardware store paint section and watch the next couple argue over whether they want their white cabinets "warm" or "cool."

Some of these differences are so small that the average observer may not pay any mind, but if you look closely and make time for subtlety, you might find quite a big difference between an inky bluish black, an endless midnight purple, or a dark slate so flat and nonreflective that one could argue it's just "black in an unlit room."

MYTH: EVERYONE SEES COLOR IN THE SAME WAY

Perception of color can vary significantly between individuals due to factors like color blindness, age, and even cultural context. It's incorrect to assume that everyone has the same visual experience, and it often takes quite a bit of comparison to discern that two humans aren't experiencing the same color/visual phenomenon. It's a classic shower thought: How can we prove we're all seeing the same color? By comparing and contrasting the anatomy of the human eye and finding an average between various samples and how those eyes respond to different lights and colors, we can safely say that there exists an average perception of color outside of color vision deficiencies (CVDs).

CVDs are described as any color vision that doesn't align with standard trichromatic color vision and are the result of an individual's cone cells functioning abnormally. CVDs can be genetic or acquired through illness, damage, aging, or chemical exposure. The differences between CVDs can range from improper functioning of just one of the three cone cells to a total visual absence of color, called achromatopsia. When a single cone is affected, the result could be a visual confusion between blues and greens, yellow and gray, or blues and purples, to name a few.

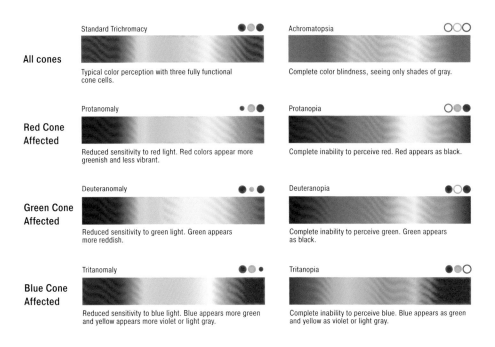

MYTH: ANIMALS SEE IN BLACK AND WHITE

While it's true that some animals do not see the range of colors humans do, it's not accurate to say they see only in black and white. Dogs, for instance, see the world in shades of blue and yellow. Some animals, like mantis shrimp and birds, can perceive a world of color that is completely invisible to humans. Bees and many other insects see wavelengths from 300 nm to 650 nm, meaning they can perceive ultraviolet light. This difference in perception means our bug friends are visually navigating our gardens in ways we can't imagine. Flowers with UV-reactive patterning on their petals can act as lights on a runway for bees and can attract insects through stark contrast. Take a yellow dandelion for example. It's a solid pattern-less yellow flower to humans, but a multicolored and vibrant bull's-eye for the life-forms that not only rely on the plant but help further its existence.

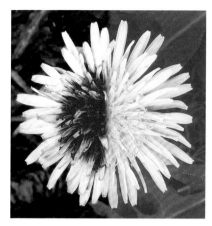

Dandelion under both UV light coloration (left) and visible light coloration (right). A bee can see both simultaneously.

MYTH: THE TERMS *COLOR*, *HUE*, *SHADE*, AND *TINT* ARE INTERCHANGEABLE

There are so many ways we can describe color and color properties. It doesn't help that there are entire professions that rely on accurately describing color and color concepts either. The existence of these practices adds a complexity to color description that can often be lost on the average person. We clarify the true meaning of each term here.

Hue is the root color, the base on which other components, such as value and saturation, are added. A hue is a pure color and pigment. For instance, a calming teal isn't a hue, but the hue for teal would belong to the cyan family—in other words very blue. Starting with cyan, additional values come into play to create teal, such as desaturation, light, and shade. The same can be applied for pink, which isn't a hue but has hues of both magenta and cyan as its root colors. Desaturation and shading come into play to determine what specific form of pink is being used, painted, or printed.

Shade is built upon a hue. It is simply the addition of pure black to a hue or a color that darkens its appearance. The color and its respective category or family remains the same, it's just darker.

Tint is the opposite of a shade. It is a hue or color in which pure white is added with the goal of lightening its appearance and reflectivity. Pastels are typically considered tints, as they're lighter and softer versions of hues that usually have lower levels of saturation or intensity.

In between shades and tints exist **tones**. Tones are hues with the addition of grays. Tones help neutralize and "tone down" the brilliance of a particular hue.

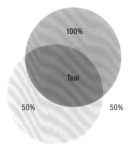

Teal is achieved in the CMY color model by combining cyan with half-saturated magenta and yellow.

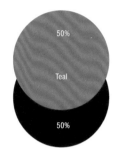

Teal is achieved in the RGB color model by combining half-saturated blue and green.

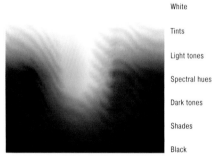

Tints, tones, and shades are pure hues with the addition of white, gray, and black, respectively.

The
Colo

ors

CLASSIFYING COLOR
Our Methodology and Reasoning

Color is both simple and complex, obvious yet obscure, which presents a challenge in any attempt to categorize it comprehensively. Throughout this book, we've adopted a classification system that encapsulates the multifaceted nature of color. Keep in mind that these are not rigid laws. While we found this helpful to understand how colors are related, some gray areas remain—pardon the pun—and you're welcome to disagree with any of these decisions.

Each color included in the book has the corresponding symbols for each relevant element. Note that for colors whose camp we could not definitively determine, we have not included any notation for that element. We've employed this system to navigate the complex landscape of color, and it is our hope that it offers you a new and informed perspective on the colors you encounter daily. With each page turned, you'll not only appreciate the aesthetic appeal of each color but also unravel its origin, its nature, and its place in our vast universe.

Our qualitative classifications are based on five core elements:

1. Contextual/fixed: This criterion considers whether a color's perception is dependent on context or remains constant irrespective of the surroundings. Contextual colors change based on the light and neighboring colors, or sometimes even the velocity, such as the color-constancy phenomenon demonstrated by "the dress"—a viral internet phenomenon in which countless humans engaged in cyber debates over whether or not a specific image detailed a black-and-blue dress or a white-and-yellow one. Fixed colors remain the same under standardized lighting conditions, like the consistent yellow of a lemon.

2. Natural/human-made: This delineates the source of the color. If it's a color inherent to natural phenomena, such as the red of a rose or the green of grass, it is considered natural. If the color results from human invention or manipulation, like the hues in dyes, paints, or synthetic materials, it is classified as human-made.

3. Pigment/structural/luminous: This refers to the mechanism through which color is produced. Pigment colors are created through the absorption of certain wavelengths of light, with the rest being reflected back to our eyes. On the other hand, structural colors arise from the physical arrangement of an object's surface, which can scatter light in specific ways to produce dazzling displays of color. Luminous colors stand apart, as they are produced through the emission of light, often resulting from electronic processes within atoms or molecules. Unlike pigment and structural colors, which are dependent on external light sources for their appearance, luminous colors are self-generated and can be seen even in the absence of ambient light.

4. Cosmic/terrestrial: This demarcates terrestrial colors, or those seen on our planet—like the red of a poppy flower—from those that are extraterrestrial, or cosmic, such as the bands of Jupiter. Some colors, like the vibrant hues of aurora, are classified as both.

5. Single-wavelength/broad-spectrum/extraspectral: This relates to the colors' position on the electromagnetic spectrum. Single-wavelength colors correspond to a specific address in the spectrum of light, broad-spectrum colors cover a range of wavelengths, and extraspectral colors, like brown or pink, aren't tied to specific wavelengths but are instead a product of our complex visual system.

COLOR SPACES

In the realm of color representation, various numerical systems are used to describe colors in different ways for specific industries and applications. We have included specifications for some of the more common color spaces throughout the book to cater to a variety of needs, ranging from digital designers to traditional artists to scientists studying color theory. Understanding these systems allows for precise, consistent color representation across different platforms and mediums.

However, some of the colors in this book represent a range of values, so we've only included this information where it applies.

The most common color spaces include:

RGB (Red, Green, Blue): Widely used in digital displays like computer monitors, television screens, and digital cameras. Each color is produced through the intensity of red, green, and blue light channels.

CMY / CMYK (Cyan, Magenta, Yellow, Key/Black): Commonly used in color printing; this system works on the subtractive principle, where colors are created by subtracting light (as opposed to adding light in RGB). By adding black to the CMY space, dark colors can be printed more efficiently and accurately.

CIE 1931: A foundational system that quantifies color based on human perception, using tristimulus values (X, Y, Z) to create a universal standard for measuring and comparing colors.

Hex Triplet: This base-16 system is used in web design and computing to represent colors. Hex codes are essentially RGB colors expressed in hexadecimal format.

HSL (Hue, Saturation, Lightness) / HSV (Hue, Saturation, Value): This model describes colors similarly to how human eyes perceive them, making them easier to understand and adjust.

LAB: Used in various sciences, this system has the ability to describe all the colors visible to the human eye. Based on CIE 1931, it is designed to be perceptually uniform, meaning that the perceptual difference between colors is consistent across the color space.

PMS (Pantone Matching System): Used in printing and manufacturing, the Pantone system allows for high consistency by providing a color-matching standard.

NCS (Natural Color System): Based on the four unique hues or elementary colors of human vision—yellow, red, blue, and green, and their combinations—leading to a wide array of describable colors.

Teal	
RGB:	rgb (0, 128, 128)
CMY:	c: 100% m: 50% y: 50%
CMYK:	c: 100% m: 0% y: 0% k: 50%
CIE 1931:	X: 11.614 Y: 16.995 Z: 23.086
Hex:	#008080
HSL:	hsl (180, 100%, 25%)
HSV:	hue: 180° saturation: 100% value: 50%
LAB:	L: 48.254 a: -28.846 b: -8.477
PMS:	P 125-8C
NCS:	S 3055-B50G

How a single color can be represented in various color spaces.

The Spectrum of Colors

Ahead of you lie 100 colors we diligently researched and selected to give you a peek into the kaleidoscope that is our universe. Of course, this realm is quite large, and one could argue that 100 colors are nowhere near enough and that in fact this book should never end, falling into a cascading gravity well of infinite variations of colors and the roles they play in our world. But we're here to enlighten, not fracture reality. The colors we chose serve many roles: some hint at the grandeur of space and time, some detail newly discovered physics, some tell stories of dangerous and noble human pursuit or simple curiosity. Others are the product of accident or capitalist greed, and many more pay homage to the lengths nature will go to preserve itself in the epic experiment of evolution and adaptation.

As you page through this book you may notice a pattern, and it's one we spent a great deal of time debating: How do we organize the colors? Alphabetical order would be a speckled mess; not every color has a distinct wavelength, hex code, or single tone; and the rainbow doesn't even contain most of the colors we've selected. It was a challenging undertaking, but we decided to find a middle ground by employing the good ol' ROYGBIV with our own added twist. We've organized neutrals at the beginning of our custom rainbow, with structural colors at the end, and a nice warping and weaving gradient in between. Our rainbow reads something like BGWBROYGBIVishStructural, and we hope you gracefully and patiently accept our efforts.

Without further ado, open your mind and enjoy the universe in 100 colors.

1 COSMIC VOID

What is the color of absolutely nothing? The best place to find out would be a cosmic void. These are the emptiest regions of the universe and likely the darkest. These areas, characterized by an extremely low density of galaxies and dark matter, are thought to shape the large-scale structure of the universe. You can think of the voids like the empty spaces of a spider's web, and the web is where nearly all matter exists, squeezed into thin strands between voids.

Imagine being alone inside one of these cosmic deserts. With no stars in the sky, any light reaching you from distant galaxies would likely be highly redshifted (page 69) out of the visible range of the spectrum due to the expansion of the universe. Your closest neighbor could be over 100 million light-years away and only getting farther. That's right, the voids are growing, perhaps faster than anything else in space, given the acceleration of the universe's expansion. The gravitational force that holds solar systems and galaxies together is stronger than this expansion force, so the solar systems and galaxies aren't expanding themselves. Thus, the most spacious objects are growing the fastest—if you can consider a void an object. It's hypothesized that these voids will continue to expand, herding clumps of matter into smaller and smaller patches.

The driving force behind this expansion is uncertain. Some cosmologists are exploring links between these voids and the mysterious dark energy—the theoretical force, which, despite remaining unseen, is thought to permeate all of space and to cause the universe's expansion to accelerate.

(0, 0, 0)

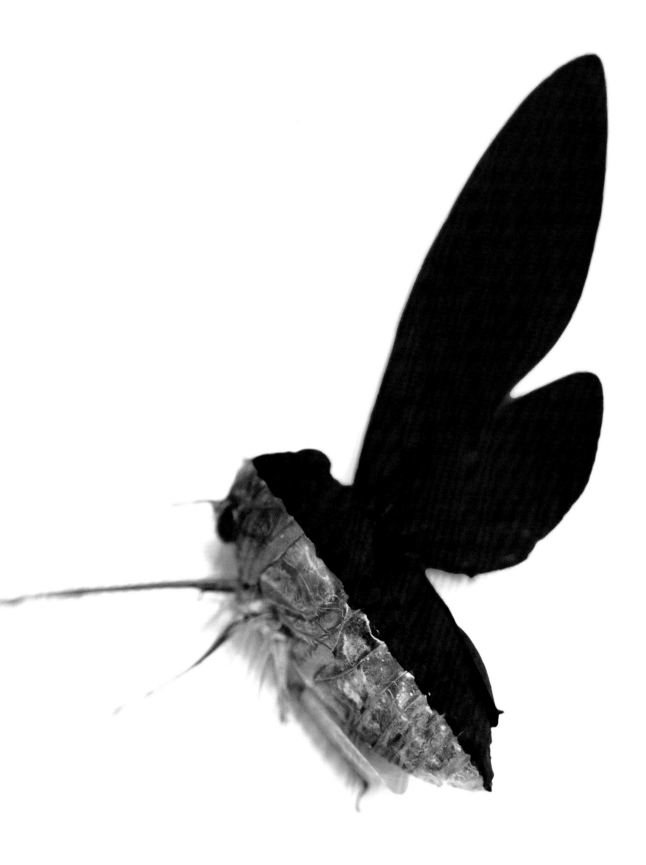

2 VANTABLACK

You can't discuss absurd colors found in the universe without discussing Vantablack, and you can't discuss Vantablack without upsetting nearly every science-minded artist in the room. So let's talk about it.

Vantablack is one of those new colors, and by "new," we simply mean it is only recently that humans learned how to make it. Its intrigue is due to physics: this material is capable of absorbing nearly all visible light that touches it. Boasting the title of the "world's darkest material" at the time of its invention in 2014, Vantablack was first manufactured by materials scientist Ben Jensen and is capable of absorbing 99.6 percent of all visible light that graces its surface. This material is so black that you cease to discern details. A Vantablack LEGO could appear to be a featureless square if viewed from above; a Vantablack backpack would appear as a flat blob when viewed from above. The ability to absorb nearly all visible light means there are no features to distinguish points of illumination and shading.

Typically art and science play the roles of public servants. They exist to enlighten, inspire, and ultimately give. But what happens when a black so black that it makes the viewer realize what black is becomes commercialized and in turn gatekept? You end up with one artist hoarding what ultimately should be a marvel of science that is shared with all. The reason any artist in the room will roll their eyes at the mention of Vantablack is because immediately after its discovery, this pigment was exclusively licensed to the creative studio of artist Anish Kapoor. There remains a lot of debate surrounding the ethics of excluding every human except a few from freely exploring this novel material.

Despite the cultural and ethical implications of Vantablack, the science behind its properties is truly fascinating. Vantablack is comprised of tiny carbon nanotubes that act as a sort of cylindrical prison for roaming photons. Light enters the nanostructure, where it is then trapped, wandering for an exit before its wavelengths are absorbed into the material, leaving a seemingly literal dark void capable of consuming light.

(0, 0, 0)*

Cicada half-coated in matte black to simulate effect of Vantablack.

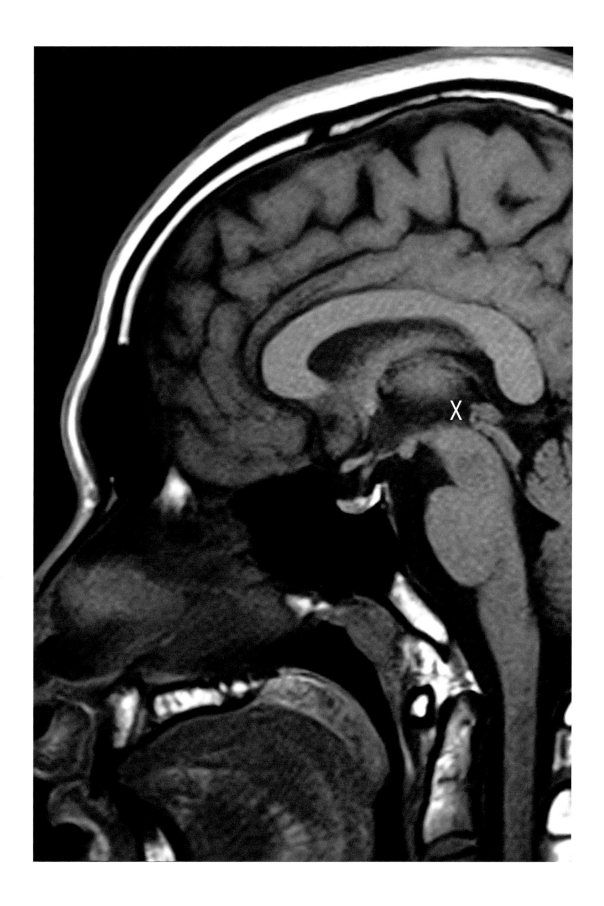

3 BLACK SUBSTANCE

We all love dopamine, the chemical that helps regulate the brain's reward and pleasure centers. Much of the brain's dopamine is produced in a small structure within the brain stem that resembles a black streak. It is this appearance that led to its name, *substantia nigra*, which is Latin for "black substance." The characteristic dark hue of the substantia nigra arises from a dark pigment called neuromelanin, which is made when the brain is preparing the ingredients to make dopamine.

Substantia nigra plays a vital role in a wide range of brain functions but is primarily responsible for physical movement. It turns out there is a profound link between dopamine and a body's ability to move, a relationship made evident in humans diagnosed with Parkinson's disease. When it functions correctly, the delicate balance of dopamine's excitatory and inhibitory effects on different parts of the brain allows for smooth, coordinated movements. In a brain with Parkinson's, the cells of the substantia nigra deteriorate and lose their protective neuromelanin pigment. As the black substance loses its namesake color, the brain loses its control of motor functions, emphasizing how important this tiny dark spot of our brain is.

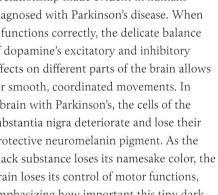

Profile of an MRI scan of the human brain. X marks substantia nigra in the midbrain.

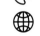

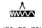

(73, 73, 73)

4 EIGENGRAU

Eigengrau is one of those colors that is near impossible for us humans to get our hands on, and that's largely due to the fact that we only realize its existence when it is literally right in front of our faces. This is the color we perceive in the absence of light, and it's not pitch black (as we often refer to extreme darkness, such as a night without stars). Instead, it's a deep, dark, fuzzy gray that is created by the human brain in that very absence of light.

Also referred to as intrinsic gray or brain gray, this is a color field fabricated by our brains as a survival mechanism because it allows us to still observe contrast if needed. The rods in our eyes possess a protein known as rhodopsin that responds to photons and light, rather than color. Even when there is little visual stimuli, these proteins can continue to react as if there is a light stimulus, giving the experience of a semi-gray visual field instead of complete, utter blackness. This dark gray can seem black, but true black would still contrast against a field of eigengrau.

The ability to perceive contrast is far more important for human survival than perceiving light. Take for instance a predator that doesn't emit light circling your outdoor camp in the dead of night. A large cat would still be observable against the dark visual field of the night sky, and the keen observer would have just enough information to react. Eigengrau is a phenomenon that the brain creates exclusively for the observer experiencing it, yet it is one that many of us have witnessed and can agree exists, all without any way of physically sharing that observation.

(22, 22, 29)

5
BLACK PEARL

Nature's most mesmerizing creations are often dazzling accidents, considered waste as far as nature is concerned. Some of this waste is encased in hard mineral and discarded, leading humans to the bottom of the sea. One of the rarest of these scraps is the dark and iridescent black pearl. There's only one thing that makes this pearl so desirable and sets it apart from a majority of pearls produced naturally: the way this byproduct interacts with the visible spectrum.

Aragonite, a type of calcium carbonate, makes up the composition of all natural pearls. When sand, shell fragments, or other debris finds its way inside of a mollusk, such as an oyster or mussel, it acts as an irritant, much like getting a fragment of tortilla chip jammed under your gums. The finger-lacking mollusk isn't well equipped for removal of this debris, so it tries a different tactic: cover it up so as to not deal with it ever again. An oyster can secrete layers upon layers of aragonite and conchiolin, also called nacre, to cover the irritant. These compounds also make up the structure of the mollusk's shell. Given enough time, the debris becomes sufficiently coated in a familiar material suitable for the mollusk. If humans had similar capabilities, upon encountering the dreaded tortilla chip fragment, your gums would secrete fluids that would solidify into flesh and make a permanent nodule in your mouth. Human life could be worse.

So what makes the black pearl so special? It can only be produced by one species of oyster, *Pinctada margaritifera*, also known as the black-lip pearl oyster because it possesses a rim of black nacre that lines the shell. The presence of this black nacreous layer is due to the production of melanin within the oyster. The closer a pearl forms to that site, the blacker it will appear. There is no special process for this; its color is strictly the result of its formation near the black lip. To complicate matters, *Pinctada margaritifera* is also capable of forming lighter pearls that are often a dark metallic gray. The black lips only cover a small portion of real estate, meaning that a black pearl is rare even from the only oyster that can produce it. All of these circumstances together results in a light-absorbing, smooth, iridescent mouth wound that has grabbed humanity's attention for centuries.

6 CUTTLEFISH INK

In the natural world, pigments tend to serve one of two purposes: finding a mate or avoiding predation. This rule applies to the cuttlefish, which comes mightily equipped with a unique survival sack of pigment designed to obscure and confuse. The high concentrations of melanin present in cuttlefish ink make it not only one of nature's most creative pigments but also one sought after by creative humans.

When threatened, the cuttlefish is capable of releasing dense plumes of a dark-brown, nearly black, substance that spreads throughout the water in its immediate vicinity. This tactic allows the cuttlefish to escape danger by obscuring the predator's view and confusing it. Cuttlefish also deploy pigment in the form of pseudomorphs by releasing clouds of ink with a higher mucus content that helps the ink blobs retain more of a shape. These shapes resemble the form and size of the cuttlefish and are often released at a distance, hopefully tricking and distracting the predator.

The rich melanin contents of this compound have found their way into human culinary arts and writing. When heated during cooking, cuttlefish ink retains its dark properties, essentially dying the dish nearly black. This food coloring practice has prolific use in Sicily in the form of a pasta dish called nero di seppia, or "spaghetti with squid ink." Cuttlefish ink has also found a use in the arts as a means for giving visual media a warm-brown-colored appearance and mood, traditionally referred to as sepia toning. The term is directly derived from the cuttlefish genus name *Sepia*, and the application was particularly prominent in early photography. Sepia toning was originally used to extend the longevity and durability of photographs by converting the silver into silver sulfide, which resulted in a brown-toned appearance similar to its namesake ink.

(0, 0, 0)

Pasta dyed with cephalopod ink.

7 ANTHOCYANIN IN BLACK PLANTS

Of all the naturally occurring pigment molecules present in plants and flowers, there's one that would have even Batman himself gardening. We're talking about anthocyanins, a type of flavonoid and water-soluble pigment found abundantly in the realm of botany. Anthocyanins are responsible for the reds, purples, and blues we see in flowers, leaves, stems, fruits, and vegetables. They're some of the last pigments observed as fall sets in and dormancy comes for our gardens.

The functions of anthocyanins vary between plants, with an understandable advantage being the higher absorption of light and in some cases more visibility and contrast for animal consumption and seed dispersal. Humans have also found a way to make anthocyanins benefit us, specifically in the field of horticulture. Entire lineages of plants have been selectively bred to produce higher concentrations of anthocyanins, often resulting in near-black foliage and stems. The landscaping industry is constantly searching for the botanical gold to be found in the creation of colors that nature struggles to maintain. There are few black and deeply purple plants in the world, but if a keen breeder were able to make a dark and broody variant to adorn a gothic garden, that would be one valuable patent.

In fact, whenever a blackish houseplant variant is bred or cultivated, it is often given a distinguished name and paraded around plant shows where large commercial growers can compete for the first debuts of the cultivar. But given the rarity and allure of black plants, it's worth asking: Are they really black?

Take the popular Raven ZZ houseplant for example. This variety was discovered after a completely normal ZZ plant was propagated. The leaves began to darken as they matured and hardened off and eventually took on a black appearance. This could be a bad sign to the nervous plant parent, but this plant was completely healthy. The black variant was stabilized and became a houseplant staple. But despite its name, it is not truly black. As the leaves mature, the concentration and production of anthocyanins increases. What closely resembles a very dark-purple pigment can appear black when overlaid on a field of dark-green chlorophyll. These two layers absorb enough light and blend together well enough to appear as a uniform black, which is the case for most cultivated plants.

(59, 11, 46)*

A *Zamioculcas zamiifolia,* or **Raven ZZ**, plant.

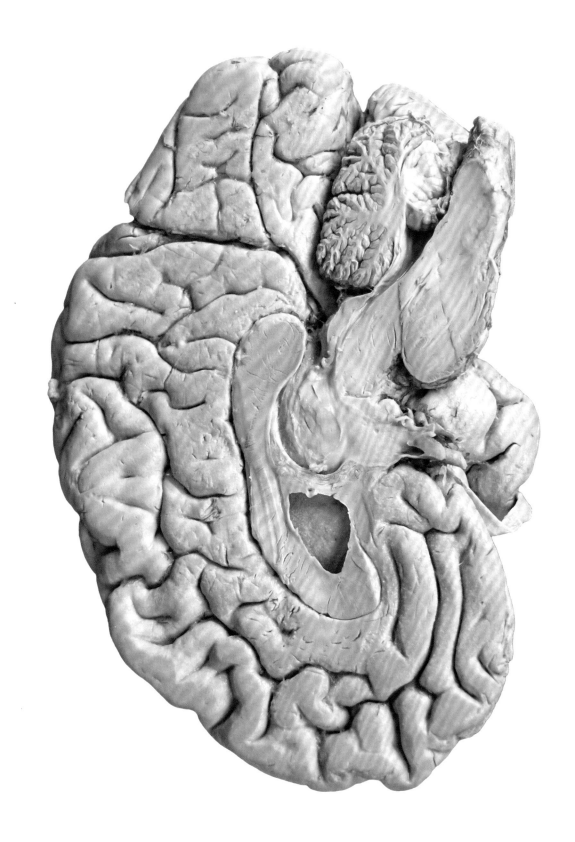

8 GRAY MATTER

As you read and absorb the information on this page (that we ourselves previously absorbed and shared), the gray matter within your head is converting the stream of words into coherent concepts that facilitate storage. Later, you'll have the ability to recall these ideas, transmute them back into communicable language, and share your newfound knowledge with others.

Gray matter is a type of brain tissue where the actual processing occurs. The gray hue of this tissue is due to the densely packed neural cells found within. Notably, though, the grayness is primarily observed once the tissue is no longer alive. In a living brain, the grayish hue of the neural cells combines with the red of capillaries to give the tissue a pinkish appearance.

Despite making up only about 40 percent of your brain, gray matter forms the outermost layer, leading to the common assumption that it represents the color of the entire brain. It also extends down into your spinal cord, playing a pivotal role in processing and transmitting information throughout your nervous system.

So what makes up the other 60 percent? Most of the remaining brain mass is white matter, which gets its color from a substance called myelin that insulates the nerve fibers. While the gray matter handles the computation, white matter acts like a high-speed network, transmitting information between different areas of the brain.

(182, 147, 166)

Dissected human brain in rotated profile: gray matter comprises the outer layer of the brain.

9 GLAUCOUS

Glaucous is a color that is easy on the eyes and so useful that nature slaps it on plants across the globe.

Chances are if you went shopping for common succulents like *Graptopetalum*, sedum, echeveria, and various cacti, you'd come across a dusty film known as farina. It's responsible for the soft pastel appearance that makes these plants so enticing and popular—and it is often wiped off by unknowing and curious customers.

This coating is a soft bluish-gray color called glaucous, and it serves an interesting purpose when it comes to preserving and protecting the plants we love so much Loss of this coating can unfortunately be irreversible in many cases, leaving the plant susceptible to mold and bacteria. This same film can be found on the exterior of some fruiting plants, like grapes and blueberries. (The color is also used to describe the glaucous-winged gull, common along the Pacific coast.)

When it comes to botanicals, glaucous-colored farina serves some pretty crucial roles: protecting the plant from intense UV rays, repelling excess moisture, and helping retain water reserves in times of drought. Succulents and cacti grow in bright, arid regions capable of scorching any plant ill-equipped for the intense sunlight. The farina helps reflect harmful direct light, acting as a natural sunscreen. The glaucous farina is also hydrophobic and ensures that drought-tolerant plants aren't overexposed to water during wet periods, which can lead to rot and bacterial or fungal growth. These same benefits are also extended to some popular produce, such as kale and plums, ensuring that they stave off rot and UV damage long enough to be consumed and eventually propagated.

(96, 130, 182)

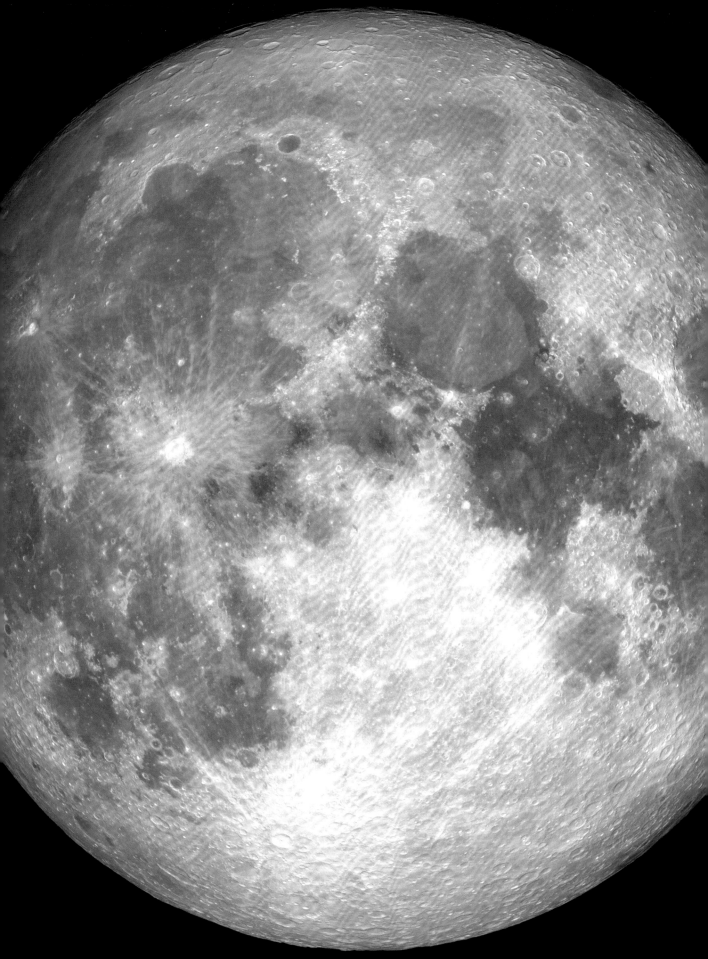

10
LUNAR DUST

Leaving the first footprints in pristine, freshly fallen snow is a satisfying experience. Imagine taking the first steps ever on a celestial body that is entirely covered in a similarly perfect, untouched powder. However, when the Apollo 11 astronauts returned from the Sea of Tranquility, they reported the dust to be more of a nuisance than a novelty. When they reentered the spacecraft, the dust that inadvertently came in with them coated equipment, caused nasal irritation, and smelled of spent gunpowder. It clung to their spacesuits, refusing to be brushed away and even damaging the fabric fibers.

Here on Earth, dust is shaped and smoothed by wind and water erosion, two things that don't exist on the moon. Instead, the dust on the moon is formed by the mechanical pulverization of rocks during meteoroid impacts. The moon's history is filled with meteoric bombardment and volcanic activity. The charred particles end up being very sharp and jagged, sometimes even melted into glass. In fact, terrestrial volcanic ash is commonly considered an analog of lunar dust.

The grayscale lunar surface is broadly divided into light and dark regions that you can plainly see when looking at the moon. The lighter areas, called the highlands, are those that have been churned up by impacts, evident from the increased number of craters. The highland dust is rich in a bright, reflective mineral called plagioclase. The darker areas are the maria (plural of mare). These relatively younger flat plains were created by solidified volcanic flows and darkened by their higher iron content. The regions' distinct grays are the results of their unique violent histories.

The mesmerizing yet irritating dust on the moon's surface presents a stark reminder of the wonders and challenges that await us beyond our own planet.

(128, 128, 128)

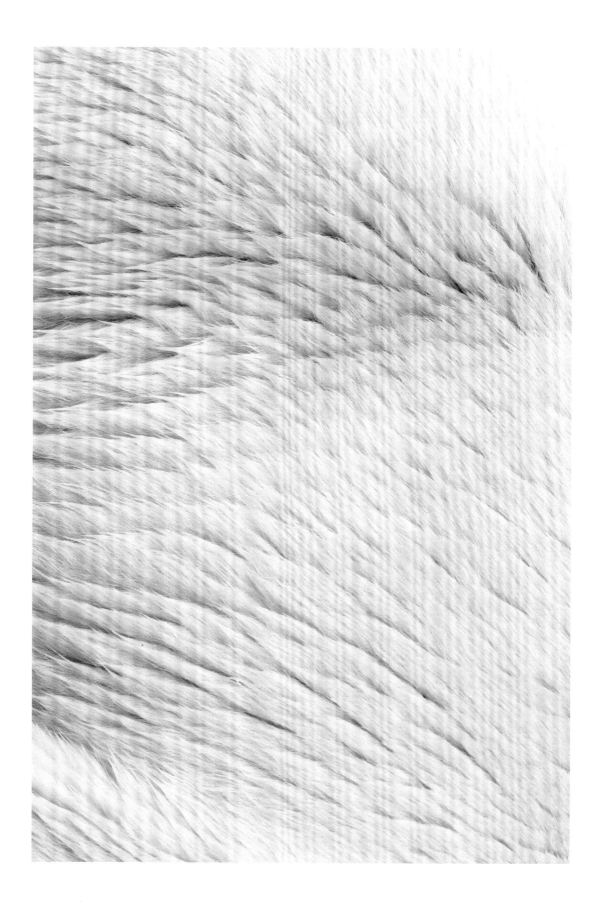

11 POLAR BEAR FUR

Some colors are the result of a well-organized arrangement of fibers working together to fool us entirely. When presented with a collection of information, it's sometimes easier for the eye and brain to collapse those details into a singular idea. This is the case with polar bears. You might think: "Polar bears are white. Their fur is white; their skin is white; everything is white." But the truth is much trickier. Neither a polar's fur nor its skin is white, at least in the pigmented sense.

The hairs that make up the bear's coat are actually hollow and transparent. Viewed as a single strand, the hair acts almost like a fiber-optic cable. When sunlight hits a polar bear's fur, the particles of light travel throughout the hollow strands, colliding, bouncing, and scattering over and over. None of the visible light is absorbed into the hairs. This interaction causes the viewer to perceive the entire visible spectrum as white. This ability to bounce and reflect light means that the luminescence of a polar bear's coat can shift with differing levels of light. The presence of keratin and salt particles gathered from the water also aid in reflecting the gathered light to enhance the illusion of white. The hollow and colorless nature of the hairs, however, means they can be subjected to alteration, which is the case with zoo-enclosed polar bears whose fur begins to appear green due to pond algae trapped within it.

The polar bear's skin is another mystery. If you were to completely shave a polar bear—which you have no business doing—you'd find it appears black or dark gray. The light-reflecting properties of their hollow hairs are so efficient that the viewer would have no indication of this fact unless they approached the polar bear in close enough proximity to separate its fur.

(255, 255, 255)

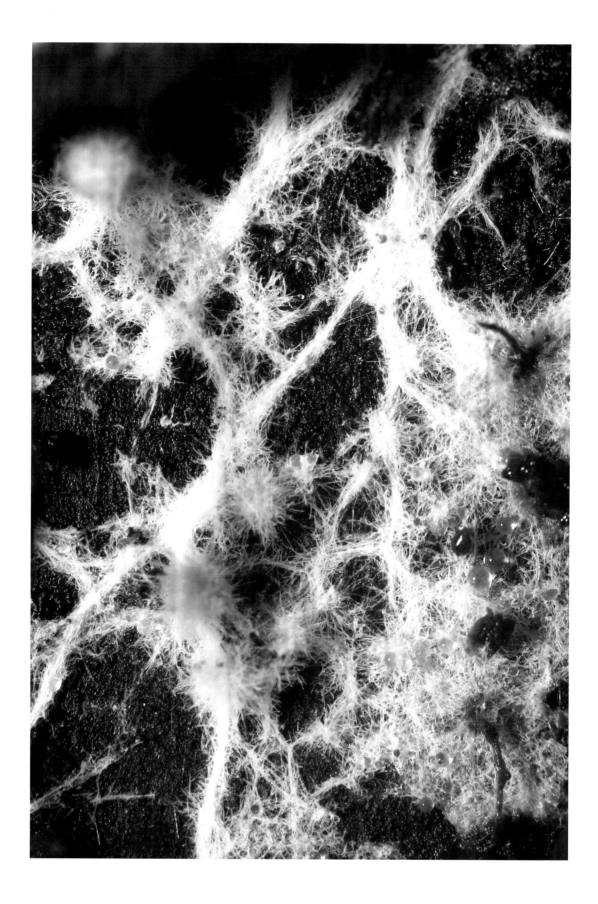

12 WHITE ROT

If you've ever gone hiking with a child (or very curious adult), there will be lots of rock flipping, log turning, and stump peering, and in the midst of all that looking around, you may stumble upon a white, squishy, fibrous substance. While it might appear harmful at first glance, these fungi are performing a crucial task—one that scientists are trying to replicate to help prevent climate change.

White rot is a type of wood decay caused by certain types of fungi. These species break down lignin and cellulose—compounds that give wood its strength, rigidity, and color. Lignin is also a significant carbon reservoir, accounting for 30 percent of the organic carbon in the biosphere. Unlocking the carbon stored in lignin could inform new methods to capture and store carbon—a strategy that could be harnessed to help mitigate climate change. But degradation of this resilient compound is notoriously challenging, a task that white-rot fungi have evolved specifically to handle.

As the fungi break down these complex molecules, they feed on the energy released, causing the wood to lose its structure and turn spongy. It is this feeding process that produces the characteristic whiteness of white rot by allowing the growth of fungal hyphae, the threadlike structures that make up the body of the fungus.

Recently a research team at the National Renewable Energy Laboratory discovered that certain white-rot fungi, such as *Trametes versicolor* and *Gelatoporia subvermispora*, are indeed feeding on the carbon locked within the lignin. This reveals a possible avenue for carbon sequestration and an opportunity to collaborate with nature to address one of our planet's most pressing challenges.

(244, 244, 244)

Fungal mycelium growing on decayed organic matter.

13 LEAD WHITE

Whites are far from the dullest colors on the cosmic palette. In fact, there is quite a breadth to the white pigments we use in our day-to-day lives. Sometimes those minute differences are exacerbated in the art world, where the specific white being used can make or break an artist's vision. This is why lead white secured itself as one of the most important—and deadly—whites used throughout art history.

Its dense appearance and ability to dry quicker than most oil paints made it a must-have in the artist's arsenal as early as the fourth century BCE. Lead white was prepared by crushing mineral lead into a fine dust, which often resulted in what was called painter's colic, or what we now know as lead poisoning. The soft warm undertone of lead white gave it a glow that was incredibly popular among later artists like Vermeer and Van Gogh, but its use was eventually discontinued due to its toxic nature and replaced with safer pigments, such as titanium-based whites.

We can't discuss the relationship between humans and color without addressing some instances in which color has been abused to perpetuate racist ideas and behaviors, and lead white is as good a place to do this as any. Starting in the sixteenth century, lead white was incorporated into cosmetics known as Venetian ceruse or spirits of Saturn. A mixture of lead, water, and vinegar would be stirred into a pigment and used as a skin whitener that would slowly poison the unsuspecting user, resulting in skin and nervous-system damage, hair loss, and eventually death. It's a tragic metaphor for the dangerous and destructive nature of white supremacist ideas and practices.

Lead's ability to infiltrate the nervous system and cause permanent and adverse health effects, including mental illness and death, was a risk artists were willing to take for centuries but not one that the general American public would tolerate. The use of lead carbonate paint in toys and household products was banned in the United States in 1978.

(240, 234, 214)

14 ULTRAWHITE

We love a color with a cause, especially one that aims to cool the planet. White light is the result of combined wavelengths, and when something appears white, it is due to a reflection of that light. But what if we were to maximize the potential of a material capable of reflecting sunlight? We'd get something so white it could possibly redirect energy away from buildings and structures and back into deep space. That was the goal of Dr. Xiulin Ruan, a professor of mechanical engineering at Purdue University.

Ruan and his team didn't originally set out to make the world's whitest paint, but they did have the aim of cooling the planet, or at least to play a small part in such a critical and lofty goal. They created ultrawhite, an incredibly powerful reflective white paint that can redirect up to 98 percent of the sun's rays, compared to readily available commercial whites that reflect only 80 to 90 percent. This additional 8 percent is enough to lower a surface's temperature below the ambient temperature—up to 8 degrees Fahrenheit cooler during the day and 19 degrees F at night—which has the potential to offset the environmental toll of air conditioning and indoor climate control. Coating just 1 to 2 percent of Earth's surfaces with this paint could keep global temperatures from further rising. That's a lot of paint, however, and a lot of roofs and human-made structures worldwide would need to be utilized to evenly distribute the effect without massively cooling just one specific area and sparking additional weather-related catastrophes.

There is more research to be done in regard to this pigment's potential. Environmental activists have cited that the environmental price of mining barium sulfate for the paint might not be worth its benefits, while Dr. Ruan notes that significant mining is required to produce commercial white paint anyway. So what if we made this the standard white instead?

Simulation of ultrawhite paint.

(255, 255, 255)

15
MISTAKE OUT

Humans create amazing things when met with necessity and frustration. Some of those inventions can appear quite simple but serve a vital function to enhance our lives. Such is the case with the first ever correction fluid, or depending on how you look at it, one of office space's most useful colors.

Mistake Out, later renamed Liquid Paper, was invented by Bette Nesmith Graham in her home kitchen in the 1950s. She worked as an executive secretary and used typewriters. Mistakes were frustrating to navigate, as they meant that the entire page had to be retyped, which really hampered overall workflow. So Graham designed a tool that had a simple application: cover the mistake with a white-based liquid and type over it. It was easy, brilliant, and enhanced her productivity immediately. Graham started by dispensing bottles of the product to coworkers, but Mistake Out was so rapidly and widely adopted, she founded a company that quickly became her main business. Graham's empire was eventually purchased by Gillette Corporation for over $47 million in 1979.

The main ingredient responsible for correction fluid's color is titanium dioxide, which is a common compound used in many white-based paints, from tempera to oil and acrylic. Due to its high refractive index and ability to scatter light, titanium dioxide is one of the brighter white pigments used in the color industry (aside from more reflective pigments like ultrawhite, page 35).

(255, 255, 255)

16 IVORY

Ivory, a term usually reserved for the tusks and large teeth of animals like elephants and walruses, is made of dentin—the same material that forms your teeth.

The natural color of ivory is a creamy white with a slight yellowish appearance. This color is due to the presence of organic and inorganic substances in the tusk layers, the most abundant of which is a calcium apatite mineral called hydroxyapatite. The specific composition and coloration of the ivory can vary depending on several conditions, such as species, age, genetics, diet, and environment.

A unique instance of ivory can be found in the fantastic existence of the narwhal, a whale species that possesses only two teeth, one of which—typically the left tooth—protrudes from the male's upper jaw like a ten-foot-long spiraled ivory horn. This is more than just a physical oddity; the narwhal's tusk contains thousands of nerve endings, allowing it to detect changes in its environment, possibly helping it find food or navigate through Arctic waters. Meanwhile, the narwhal's right tooth often remains inside the jaw, serving no apparent purpose.

Historically, ivory's aesthetic allure led to its widespread use in luxury items such as piano keys, chess sets, and billiard balls. The high demand for ivory consequently inflated its value and led to overhunting, pushing many species perilously close to extinction. In response, international trade of ivory was outlawed in 1989. The implementation of increasingly tight restrictions in various countries since then has helped diminish demand and protect these vulnerable species.

Despite the ban, the fascination with ivory has continued but in a more sustainable way. Today, various alternatives to ivory made from synthetics and other organic materials are available, ensuring we can appreciate the beauty ivory products offer without endangering wildlife.

(255, 255, 240)

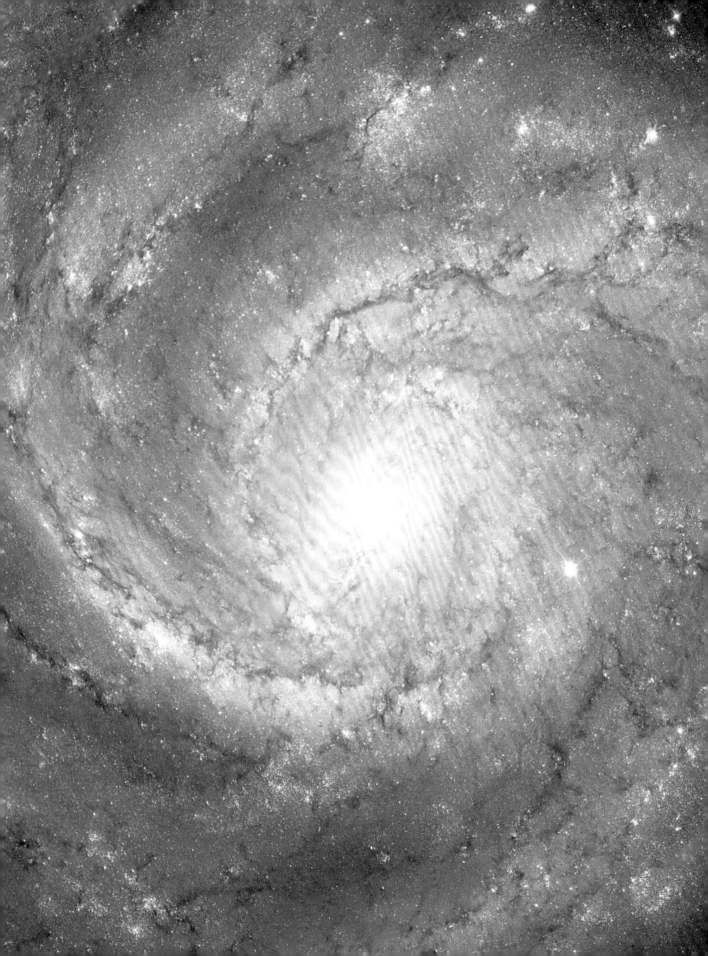

17 COSMIC LATTE

If you asked the average person what they suppose the color of the universe is, you wouldn't be surprised to hear "black" or "nothing." While most of the observable universe is composed of a nearly impossible-to-detect material known as dark matter, what we're looking for is the color of things we can observe, which is every cosmic phenomenon that emits light.

Astronomers at the Johns Hopkins campus observatory noted the average color of light emitted from over 200,000 galaxies and found it to be a nice eggnog-like color. Before settling on the name cosmic latte, this observation was put to a vote: competing names included skyvory, cappuccino cosmico, cosmic khaki, and primordial clam chowder. It is worth noting that this particular "color of the universe" is from the perspective of Earth and could very well appear different based on where in the universe you're observing from and what life form is observing it. For the purposes of this book, which is being read by humans who reside here on Earth, this milk-frothy hue is the average color of our observable universe. Cosmic latte came into existence during the Stelliferous era, the period our universe is currently in. The dawn of stars shed light throughout the cosmos in a brand-new way, whereas prior color was attributed to black-body temperatures. This creamy celestial beverage won't last forever, however, and will eventually fade into darkness when the last stellar lights flicker.

(255, 248, 231)

The dense center of the Pinwheel Galaxy, which is estimated to contain at least one trillion stars.

18 LANDLORD WHITE

Landlord white is a color perhaps as dripping with existential dread as the deepest corners of the cosmos. This particular hue of white, often referred to as eggshell, earns its place here because it is the one pigment that coats nearly all contemporary human shelter. Its functions are to keep the average renter from easily opening their windows or using their outlets, and it can be found dripping from sills and molding like paint stalactites.

This paint color is so common that it is one of the few that can be purchased in premixed five-gallon buckets at your local home-improvement store. Why is it so prevalent? The short answer is that white spaces just look nice. They bounce natural light, appear clean, and make a space feel larger, all of which are vital illusions when it comes to landlords selling us shelter. The caveat, however, is that a true white gets dirty, and it doesn't hide the existence of former tenants very well. Smoke stains, grime, and mold contrast against and through it, so a derivative of white became popular in the 1970s that could easily conceal the state of a prospective living space while still appearing bright and spacious. It's a vicious cycle: because landlord white is one of the most widely produced paints in the world, it's also the cheapest, and because of that, it is the most widely used. The brute forces of capitalism have created a single color that will homogenize the interiors of human shelters for the foreseeable future—and allow landlords to avoid acknowledging how much work is left to do on their properties.

(210, 199, 187)*

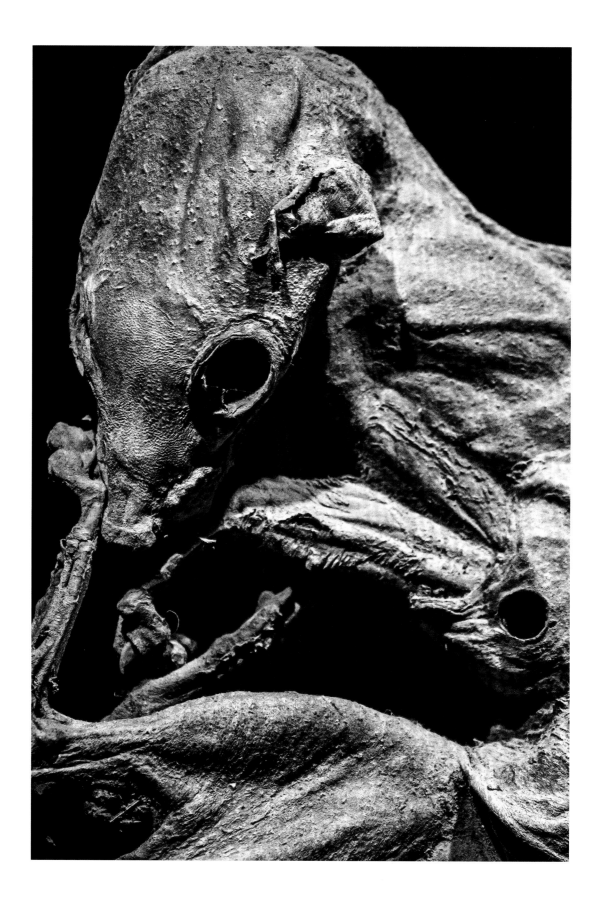

19 MUMMY BROWN

Humans have sunk to questionable depths to obtain the perfect colors. Whether it's squashing thousands of insects and snails, poisoning themselves, or robbing graves, very little will get in the way of humankind's pursuit of prized pigments.

Mummy brown was popular among painters for its varying degrees of ocher and umber. The yellowish-brown hues were desired for depicting dark scenery and capturing nature, but this came at a cost: the looting and pillaging of burial sites—usually burial sites of non-white bodies. Egyptian tombs were often raided for the mummies needed to create this pigment, and when they were in short supply, the bodies of enslaved persons were unearthed and used instead. On certain occasions the bodies of mummified animals were also taken.

Mummy brown was a fairly thin pigment, meaning it could be laid over other tones for shading or coloring purposes. It also contained fats, which meant the natural compounds of mummy brown would react with other colors, altering their appearance.

Eighteenth and nineteenth century artists Eugène Delacroix, Sir William Beechey, and Edward Burne-Jones were known to use mummy brown, with Burne-Jones reportedly burying his bottle in his garden after learning the truth of its contents. As the supply of looted bodies began to dwindle and the popularity of mummy brown waned, it was replaced with a more ethical alternative made of kaolin, quartz, goethite, and hematite.

Mummified ferret specimen.

(176, 133, 105)*

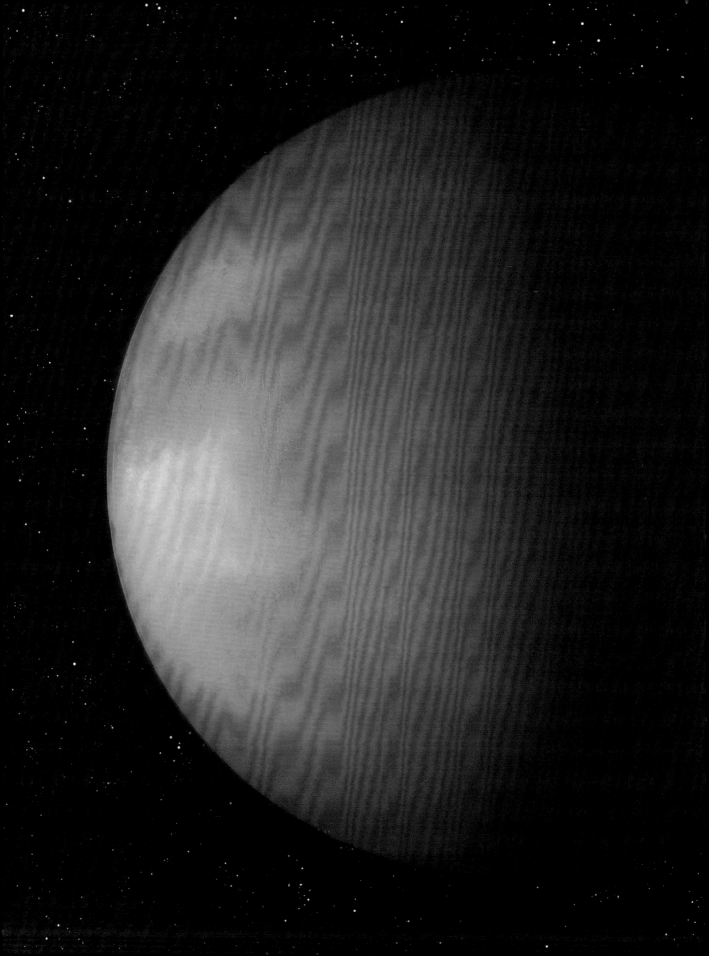

20 BROWN DWARF

Brown dwarfs occupy a cosmic niche, sitting comfortably between the heaviest planets and the lightest stars. They're not massive enough to sustain hydrogen fusion like true stars, but they do fuse deuterium and lithium, making them more than mere planets.

Their namesake color, a muddled blend of dark-orange and reddish-brown hues, can be attributed to their relatively cool surface temperatures—ranging from 250 to 1800 Kelvin—far cooler than the sun's surface temperature of around 5500 K. These cooler temperatures allow for the formation of molecules that contribute to their distinctive brownish color.

Brown dwarfs also have an intriguing trait: they're luminous in the infrared spectrum. Their cooler temperatures and smaller sizes mean they emit the majority of their light in these longer wavelengths, making them more detectable to infrared telescopes rather than traditional optical ones.

These unique objects continue to challenge our understanding of stellar evolution and formation, forcing us to expand our definitions and reminding us that the universe is filled with myriad objects, each with its own unique tale to tell.

Artist's rendering of a brown dwarf star.

Varies

21 FEUILLE MORTE

(199, 117, 70)*

Respectfully, we owe a lot to dead leaves. Practically everything, in fact, since without the death and decay of organic matter, life on Earth as we know it would not exist. Everything relies on the nutrients released by death. Which is why we have a word for this color: feuille morte. It's so widespread that it is immensely beneficial for other organisms to utilize the color for camouflage, including the satanic leaf-tailed gecko, copperhead snakes, and various brown moths, all of which are capable of mimicking dead leaves.

When plants and leaves decay, the cells that make up the chloroplasts die, removing the presence of green. What remains are molecules and pigments known as carotenoids and anthocyanins (page 19). These organic molecules are responsible for the reds, purples, oranges, and yellows we observe in dying leaves. Eventually those molecules break down as well, leaving the brown crunchy remains of an organism that once lived to devour sunlight. While feuille morte stands as its own color, it also represents a crucial stage in the process of living, and seeing as Earth is currently the only known planet to harbor life in the universe, this makes it a particularly rare but important color on the cosmic palette. The decay of leaves and other green matter sparks a vital chain of events that soon becomes the nutrients and food source for the plants, trees, and fungi we humans rely on. These plants filter and supply our world with breathable air, hold the soil and ground intact, provide shelter, and feed the herbivores among us. Every living moment you have is owed to the fact that something decayed in order for you to exist and acknowledge this (let alone read this book).

Despite its importance, this yellowish-brown hue may appear unappetizing to some (and will likely haunt new parents, as it resembles nothing so much as the contents of a newborn's diaper). But if we can come to terms with the all-natural existence of excrement and decay and expulsion, then perhaps we can find comfort in the fact that ultimately, it represents the cycle of life that this color embodies.

22 CARMINE

There are some colors that we consume regularly, in both the capitalistic sense and the edible sense. Carmine red is one of these. This deep-crimson extract has found its way into our foods, beverages, toys, packaging, and manufacturing. However, its first use as a dye dates back to 700 BCE.

While the word *carmine* can refer to a general family of deep, almost bloodlike, reds, it originated as an extraction from the scale insect *Dactylopius coccus*. The female insects are gathered and boiled in a sodium carbonate solution to remove any metals and contaminants, leaving behind carminic acid, which is separated from the solution to yield crimson lake. This fine red powder is the basis for dyes used in paints, pigments, and foods. It is then combined with a mordant similar to that of avocado tannin to ensure it binds to natural fibers and fabrics. To this day, carmine red is used in foods and even medicines. The dried remains of billions of scale insects pass through our bodies and lives on a daily basis—if you read the ingredients for your favorite red candy or snack, you might find "cochineal extract" on the label. (Perhaps the idea of printing "dissolved insects" there seemed unappealing to the food and drug industry. . .) There are exciting developments afoot with the production of these red dyes, however, such as manipulating microorganisms into producing the pigment, which is more acceptable for use in vegan diets.

Dried and crushed cochineal insects.

(150, 0, 24)*

23 ANCIENT CHLOROPHYLL

About a billion years ago, ancient Earth looked drastically different than it does today. Large organisms were nonexistent and the food chain was a limited and intimate menu. Even complex microscopic organisms such as algae were struggling to take hold in the primordial oceans full of cyanobacteria, which absolutely dominated the living world. Cyanobacteria are a class of microorganism that use certain pigments such as carotenoids and chlorophyll to absorb energy from sunlight, much like the large plants and algae we know and grow today. These cyanobacteria are thought to be the first organisms to produce oxygen, which, after hundreds of millions of years, catalyzed the atmosphere into a much more familiar one. Not only were these cyanobacteria atmosphere-transforming organisms, they also possessed the oldest scientifically documented pigment on Earth.

Nur Gueneli, a paleobiogeochemist, brought us this exciting revelation in 2015 after studying a vast array of molecules extracted from the fossils of cyanobacteria. The rocks in which these fossils appeared were collected in the Sahara Desert, part of what was once an ancient ocean. The rocks were crushed and their molecular structures were analyzed at the National MagLab to determine the presence of pigment molecules known as porphyrins. The porphyrins were derived from the chlorophyll of the pervasive ancient cyanobacteria. In their concentrated form, the pigments appear a rich reddish purple, but when diluted, they take on a soft salmon or pink color.

Simulated representation of ancient chlorophyll.

24 FALU RED

We humans are not only skilled at sourcing, pursuing, and discovering new colors, but we're pretty good at repurposing the waste we produce to create colors that enhance our quality of life. This is especially true when it comes to the mining and smelting industry through which tons of waste is produced and strewn about the environment. It's in these tailings that humans find a use for what would otherwise be considered mineral trash.

If you drive through the Swedish countryside, see a quaint postcard depicting Sweden, or even glance at a hip farmhouse inspiration board, you will inevitably stumble upon Falu red. During the seventeenth century, the town of Falun, Sweden, was home to the largest copper mine in Europe and produced over 60 percent of the western world's copper. This was before the mine eventually collapsed in on itself in 1687, exhausting its resources. Not wanting to completely discard any potential usefulness, the town starting sifting through remnants of the mine only to discover the iron-rich ore they had discarded in search of copper. The tailings of copper and loose iron oxide ore of these retired mines were used by smelters to produce a sludge that was then heated to create the bright-red color. This colorful yield was mixed with water, flour, and linseed oil to produce a surprisingly resilient and weatherproof red paint that was then applied to decorate the barns and wooden buildings dotting the Swedish countryside.

The practice of coating buildings in Falu red spread to Norway and Finland as well and became an iconic representation of the peaceful, quaint lifestyle of rural Scandinavia and practically anywhere you find large red barns. Funnily enough, despite its present-day pastoral association, the original goal of the bright red paint was to mimic the brick exteriors of expensive houses. Even today, the tradition of producing this red paint and applying it to countryside homes continues.

(128, 24, 24)*

25 HYDROGEN-ALPHA

When the light emitted from a celestial body like a star is analyzed and spread out into a spectrum, lines appear that reveal which chemical elements are present. These spectral lines are like the fingerprints of atoms. Each type of atom and molecule emits or absorbs light at certain wavelengths, which show up as lines at distinct positions in a spectrum. These spectral lines are a valuable tool for scientists to analyze stars, galaxies, and nebulae.

The hydrogen-alpha (or H-alpha) line is a brilliant-red spectral line, with a wavelength of precisely 656.46 nm, that is emitted by hydrogen atoms. It is one of the most prominent in the spectra of astronomical objects rich in hydrogen.

The H-alpha line originates from a specific transition within a hydrogen atom. When an electron falls from the third energy level to the second, the atom emits a photon that produces the characteristic red H-alpha light. (For more on atomic emissions, see page xxi.)

Photons emitted from transitions involving other hydrogen energy levels create different colors, collectively known as the Balmer series of hydrogen spectral lines. However, these other lines are either outside human visibility or much fainter than H-alpha.

Although hydrogen alpha is shining on us continuously, it is usually overshadowed by other wavelengths. By using a special filter to isolate the H-alpha wavelength, even amateur astronomers can unveil vast expanses of star-forming nebulae millions of light years away.

(250, 0, 0)

Above: The visible hydrogen emission spectrum lines in the Balmer series. H-alpha is the red line at the right.

Left: The Cone Nebula as seen through an H-alpha filter.

26 DRAGON'S BLOOD

The medicinal treatments that can be found in nature are impressive. Even more impressive is the fact that ancient people discovered many of these remedies through trial and error (our deepest thanks to those that experienced the error).

In tropical regions around the world, you can find several species of trees that belong to the *Dracaena genus*, commonly referred to as dragon trees. When the bark or leaves of these trees are injured, they "bleed" a deep red resin called dragon's blood. This resin has been cultivated and used since ancient times by various cultures, including the Chinese, Romans, and Greeks, for a host of applications, such as dye, paint, and medicine.

In recent years, modern medical research has started to take a closer look at some of the medicinal uses for dragon's blood. Although research is in the preliminary stages, the studies look promising. The resin has shown antimicrobial properties that may have some benefit with bedsores and digestive health issues. It also exhibits antioxidant properties, indicating potential as an anti-inflammatory. Moreover, multiple studies have even shown dragon's blood could assist in treating or preventing diabetes. While much more investigation is needed (don't take this as medical advice!), the initial findings about the potential benefits of dragon's blood are encouraging.

(147, 25, 3)*

Dragon's blood sap suspended in water.

27
POMPEIAN RED

In the mid-eighteenth century, as archaeologists gradually uncovered the ancient Roman city of Pompeii that was buried under ash and pumice in the eruption of Mount Vesuvius in 79 CE, they discovered a city brimming with opulence. Notably, the city boasted many frescoes featuring characteristic red backgrounds now known as pompeian red. The local clay, rich in iron content, was thought to be the source of the vivid red pigment used throughout the city.

As the aesthetic significance of Pompeii was popularized, this color became associated with the sophistication and luxury of the city's past. The discovery of pompeian red ignited a design movement known as Pompeian Revival. The trend, which coincided with a period of extensive archaeological work at Pompeii through the early twentieth century, had a particularly significant impact in the United States and Europe, where it influenced design of everything from furniture to architecture. The movement was distinguished by slender structural elements and large swaths of the signature red.

However, recent research introduces an intriguing twist in this color's tale. Careful analysis suggests that the iconic red walls may have originally been a shade of yellow. The pigment yellow ocher is known for its ability to change to a reddish hue when subjected to intense heat, a transformation that could feasibly occur during a volcanic eruption. This would imply that the Vesuvius eruption not only destroyed the city of Pompeii, but may have also forged what we now consider the city's iconic color.

(196, 2, 51)*

Fresco of the Portico, created between 62 and 79 CE, from the Temple of Isis in Pompeii.

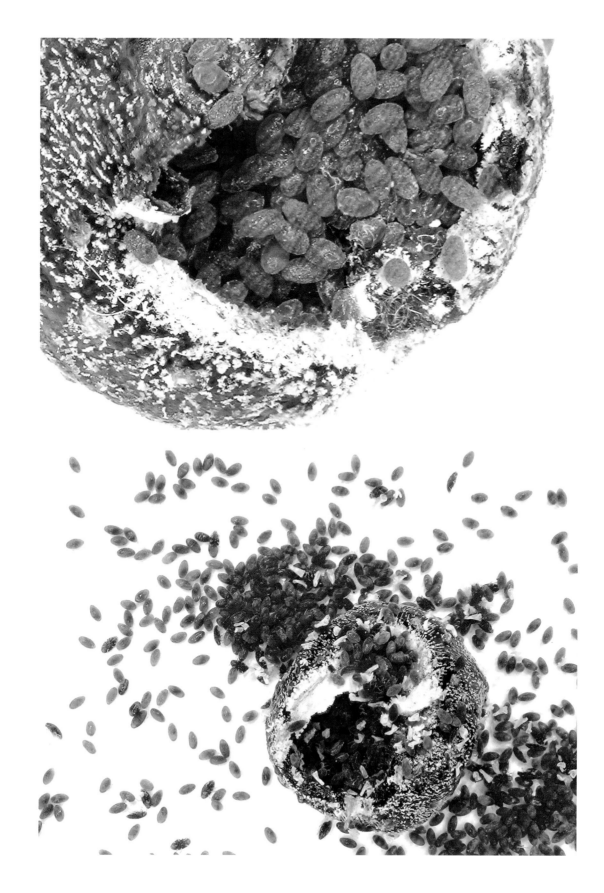

28 KERMES RED

Kermes red belongs to a family of dyes with a meticulous and brutal legacy. Known for its vibrant and long-lasting crimson color, it was once highly sought after. While it reached its pinnacle in the fifteenth century, when textiles dyed kermes red were considered the most regal throughout much of Europe, its roots trace back to biblical times and earlier. Interestingly, there is a gap in the interim record of any mention of kermes red, although it is unclear if it was forgotten, called by another name, or if documentation simply didn't survive.

The dye was derived from the bodies of female *Kermes vermilio*, tiny scale insects primarily found on Mediterranean oak trees. The process would begin with collecting the insects by hand while they fed on tree sap. According to researchers, the reddish pigment these insects produce may ironically be intended to serve a camouflage. Pigment production is highest when adult females are carrying an egg, which is reportedly the optimal time to catch them to achieve the most vibrant color. Once caught, the kermes were then dried and ground into a powder before being cooked into dye.

By some estimates, it would require 50,000 to 60,000 insects to yield one kilogram (about two pounds) of dye. The painstaking process made kermes red a luxury commodity, reserved primarily for the wealthy. That is, until the discovery of a new insect, the cochineal (see page 51), led to a shift in the dye industry. The cochineal provided a more intense red and was easier to cultivate and harvest, effectively making kermes red obsolete.

(162, 32, 65)

Dissected brood chamber of a dead *Kermes vermilio* female filled with crawlers.

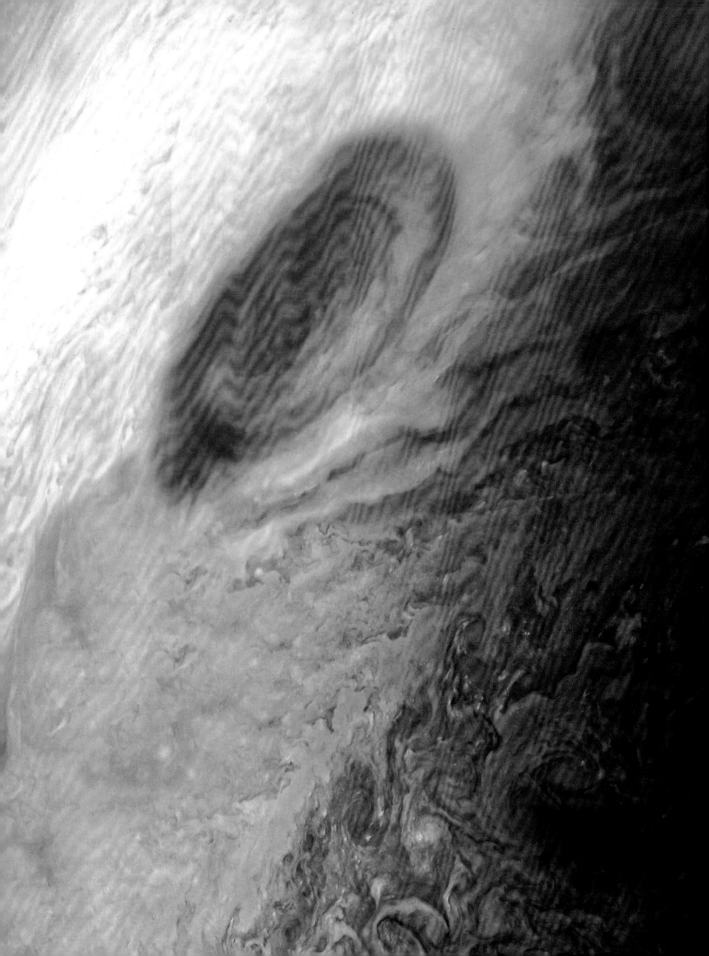

29 THE GREAT RED SPOT

Jupiter, the fifth planet from the sun, is more massive than all the other planets in our solar system combined. The planet's dynamic atmosphere comprises colorful gases that form distinct bands of wind rushing in opposite directions.

The most prominent feature visible on Jupiter is the Great Red Spot, an anti-cyclone larger than Earth's diameter that has been raging for at least several centuries. The Juno spacecraft has acquired the most detailed data of the Great Red Spot to date, providing valuable insight into its structure and longevity. However, the source of the storm's distinctive brick-red color remains a mystery.

NASA posits that a possible explanation might be a chemical reaction occurring within the storm. Sunlight could be converting ammonium hydroxide and other gases into red-tinted by-products. Alternatively, some researchers propose that the color could be attributed to gases being churned up from deeper layers within Jupiter's atmosphere.

Intriguingly, the storm appears to be shrinking. Its diameter in 2019 was a mere one-third of what it measured just fifteen years prior. The Great Red Spot, which has been around for much—if not all—of human history, may eventually fade away, taking its signature red hue with it.

(175, 82, 40)*

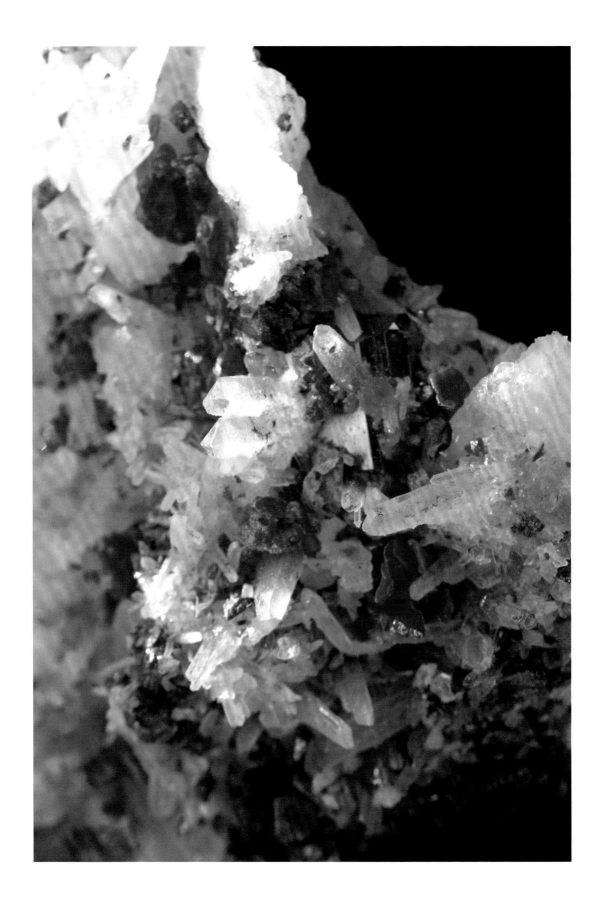

30 REALGAR

Realgar, also known as ruby sulfur, is an intense red mineral used for festive explosions and killing unwanted plants. It was also prized for being one of the only potent reddish oranges used in art until modern chrome orange was introduced. With the molecular formula of As_4S_4, this vibrant form of arsenic sulfide can be found naturally occurring in Hungary, Czech Republic, Utah, Nevada, and the mineral-laden geysers of Yellowstone National Park, alongside other arsenic minerals like orpiment (page 85), which shares a similar molecular makeup.

This toxic red mineral has found many uses throughout human history. Realgar was commonly used in the fireworks industry to create bright white fireworks until the more readily available metals aluminum and magnesium replaced it. The components of realgar were also used in the sixteenth century for the extermination of weeds, insects, and pests due to its arsenic properties. However, it is no longer advised to sprinkle arsenic compounds around your begonias! In Ancient Greece, it was used as a poison referred to as bull's blood and was thought to be the culprit behind King Midas's suicide.

As a pigment, realgar takes on a bright hot-orange appearance with the mineral itself turning into a toxic yellow powder after prolonged exposure to sunlight; it is sometimes confused for orpiment since the difference between the two is a single sulfur atom. Realgar is part of a toxic and carcinogenic palette of colors responsible for endangering the artists willing to wield them. It is recommended that knowledgeable collectors thoroughly wash their hands after holding or handling realgar, especially if there are signs of yellowing. These crystals are often kept in dark closed containers in mineral collections to preserve their clarity.

(175, 34, 27)*

Mineral realgar formed adjacent to calcite crystals.

31 REDSHIFT

Albert Einstein revealed that our universe is a unique place where experiences can change drastically depending on the viewer's position. Many of these differences stem from the peculiar behavior of light, and one such peculiarity is called redshift.

Imagine you're in a rocket ship flying away from Earth at a pace almost as fast as light itself. As you look back at Earth (which you now must view through a telescope), you start to notice something strange. The blue of the oceans starts to look green, and the white clouds take on a rosy hue. But here's the thing: this change in color is only happening from your viewpoint in the speeding rocket. If you turn the ship around and return to Earth, you'll find its colors much the same as when you left.

Redshift is somewhat like the change in pitch you hear from a passing ambulance—the sound seems to change as it moves toward you and then away from you, a phenomenon known as the Doppler effect. As two objects move apart at great speed, the light waves leaving each one are stretched out, causing all the wavelengths to shift toward the red end of the spectrum. This is happening everywhere, to everything, all at once.

The space that makes up the universe is always stretching out, pushing galaxies farther away from each other. The farther apart two galaxies are, the faster they are moving away from each other, and the more their light shifts toward red (at least from the viewpoint of someone in the other galaxy). Astronomers can measure this by looking at the light from a galaxy and seeing how much its colors have redshifted. This can tell us how fast and how far distant galaxies are moving away.

This effect isn't limited to objects moving apart. When objects move toward each other, the light between them gets squeezed, which makes the colors shift toward blue, which is, perhaps unsurprisingly, called blueshift.

As an object moves at great velocity, the light waves it emits are compressed in front of it and stretched behind it, causing the wavelengths to shift.

32 BLOOD MOON

The red of a blood moon is the perfect example of how two separate bodies can have a drastic yet temporary effect on one another. A few things have to line up just right for humans to enjoy the colorful display of a blood moon, starting with the fact that Earth is luckily just large enough to cast the moon completely in its shadow under the right conditions, also known as a full lunar eclipse. The second necessary component is our atmosphere. A blood moon is the result of Rayleigh scattering, a phenomenon also responsible for our sunrises and sunsets. When sunlight passes through Earth's atmosphere, particles in the air absorb certain wavelengths of light, leaving only yellows, oranges, and reds.

When a total lunar eclipse occurs, glowing remnants from Earth's atmosphere stretch through space and land on the surface of the moon. As the light stretches farther away from us, the wavelengths also lengthen, giving that light a red appearance. The quality of our atmosphere can also work to alter the appearance of a blood moon, such as volcanic eruptions deepening the red.

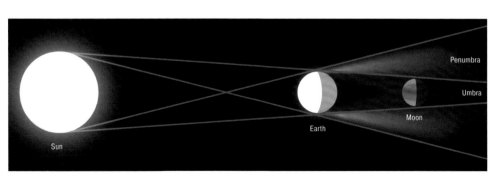

White sunlight, scattered by Earth's atmosphere, is diffracted into a circular rainbow around Earth. At the peak of a lunar eclipse, the moon moves into the center of this circle and red wavelengths cover its surface.

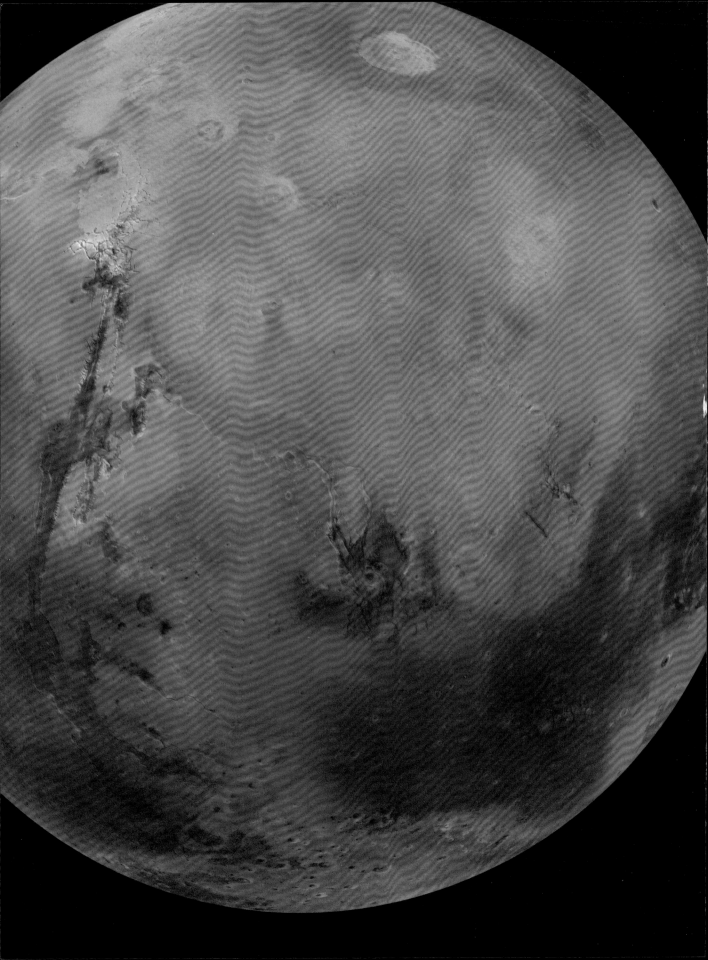

33 MARTIAN RED

Throughout history, Mars has been seen as a celestial emblem of fire, radiating a captivating red glow in the night sky. The Ancient Greek astronomers saw in it their god of fire, while the Hebrews called it "the one who blushes." Its Chinese name translates to "fire planet." Even the name Mars, from the Roman god of war, is a reference to its blood-red color. Mars' distinct color has been deeply meaningful in human culture.

In the modern era, Mars has become a symbol of curiosity and opportunity. Its iconic red landscapes, meticulously traced and photographed by robotic explorers, evoke a spirit of wonder and challenge. Some suggest that these barren Martian terrains could one day transform into lush, Earth-like habitats. Such a future would require an enormous effort of unrivaled ingenuity, but the distinctive red material itself might actually help us achieve this goal.

The rusty hue comes from the iron-rich composition of the surface material, or regolith. Despite numerous missions, as of this writing, we've not yet returned any physical samples from Mars to Earth. However, chemical engineers have created simulants of the material that exists on its surface based on analyses performed by rovers and remote sensing satellites. The result? An exact replica of the iconic reddish Martian dirt.

These simulants serve a crucial role in preparing for a wide range of future mission scenarios without leaving Earth. They've been used by scientists to investigate how crops might fare on Mars or if Martian soil could be used to manufacture bricks or other materials. Such insights could expand the possibilities for future Martian explorations and, with enough technological innovation and perseverance, possible settlement.

(253, 133, 95)*

34 POPPY RED

Poppies are some of the most iconic flowers out there. They are known for their delicate tissuelike petals, round rattling seedpods, and bright-red saturated blooms. These ephemeral plants come and go in short windows, but not before putting on a show and sowing thousands of seeds for next year.

Poppies owe their rich coloration to a class of natural pigments called anthocyanins (page 19), which range from reds to purples and blacks in the botanical world. Poppies come packed with this pigment, which for modern humans has become a symbol of remembrance for veterans and a reminder of bloodshed and the cost of war. Poppies took on this heavy symbolism after World War I, when the conditions were just right for prolific poppy growth. The tragic catalyst of constant bombardment and demolition churned the deep soils housing poppy seeds, bringing them to the surface where they were then fertilized with nitrogen from bombing and the release of minerals from destroyed buildings and structures. The blood-red flowers sprouting in such a blood-soaked place were acknowledged in the war poem "In Flanders Fields" by John McCrae.

(249, 53, 37)*

35 INTERNATIONAL ORANGE

When visibility is of the essence and you want to ensure something stands out, international orange is the color to consider. Affectionately called AMS-STD-595 12197 by the US government, this vivid hue was specifically designed for use in the aerospace industry (where it is sometimes called aviation orange) to provide maximum contrast against blue sky or water. Exhibit A: the iconic orange suits that NASA spaceflight crews wear during launch and reentry are international orange specifically to aid in potential water rescues.

This striking color also adorns one of the world's most iconic structures: the Golden Gate Bridge in San Francisco. However, the shade used on the bridge is a slightly reddish variant, aptly named GGB international orange, which emerged serendipitously. During construction, the steel was initially coated in a red-orange primer to protect it from corrosion. As the four-year construction process unfolded, both locals and visitors came to appreciate how the particular hue harmonized with the surrounding landscape, including the adjacent Marin hills.

When the time came to finalize the bridge's paint color, consulting architect Irving Morrow took inspiration from this primer. He proposed a tailored reddish version of international orange for the bridge. Morrow lauded the color's practical benefits, such as its high visibility against diverse backdrops of ocean, sky, and fog, as well as its aesthetic attributes. In his words, "The effect of international orange is as highly pleasing as it is unusual in the realm of engineering."

(255, 79, 0)*

36 THE FIRST COLOR

Feast your eyes upon the first color—not the first one in this book of course, but the first color in the universe. This bright-hot glowing peachy orange didn't exist until approximately 380,000 years after the birth of the universe, when it finally cooled to a comfortable 3000 Kelvin or 2727 degrees Celsius (4938 degrees Fahrenheit): cosmic tank top weather. Prior to this period, the plasma makeup of the infant universe was too dense for light to travel. That would require low enough temperatures for atoms to form before the universe could hope to produce anything that could be defined as a color.

Nowadays the average temperature of the universe sits just below a chilly 3 Kelvin, a steep decline from the primordial 3000 Kelvin. This was deduced from studies of the cosmic background radiation, a blueprint of the universe left behind from the big bang. The early universe had an evenly distributed temperature with wavelengths attributed to a blackbody: an object or thing that exhibits color based only on its temperature rather than the material it is made of. If humans had been able to observe this color as it permeated the space-time of the early universe, it would be similar to a warm orange campfire. That bright orange would slowly darken and fade until the universe was roughly 100 million years old, when the first stars were born, resulting in the universe we recognize today.

(255, 209, 220)*

A map of the oldest light in our universe, as detected by the Planck spacecraft.

37 FULVOUS

The word *fulvous* was first used to describe a coppery color in 1664 and was soon applied to various species of the animal kingdom. Just in terms of birds, we have the fulvous whistling-duck, the fulvous-headed brush-finch, the fulvous-dotted treerunner, and the fulvous-chested jungle flycatcher. There are plenty more mammals, fish, invertebrates, and fungi taxonomically described as fulvous. Additionally, many plants utilize the potent color to attract pollinators, such as the small carnivorous bladderwort plant *Utricularia fulva* and the coppery *Iris fulva*. It seems that biologists had just been sitting around waiting for the perfect word for this color; suddenly everything was fulvous.

While there are many shades and hues to be found in the menagerie of fulvous animals and plants, ranging from dark yellows to tawny tones and even warm browns, the average color most of these organisms have in common can be described as a warm coppery brownish orange. Something resembling the peel of a clementine you took to work but left in your car for a week or two.

What's interesting about fulvous is that it's not the result of a specific molecule across the biological board. The wide range of fulvous colors sometimes requires the presence of a combination of molecules, such as carotenoids and melanin, and can even be produced by the interplay of a surface's structure with light. A fulvous-looking bird could get its orange coloration from a carotenoid-rich diet or simply the nanosized structure of the feathers interacting with white light, whereas a fulvous plant could owe its pigmentation entirely to carotenoids. As long as it possesses that coppery brown-orange appearance, it could very well find itself in the domain of fulvous-looking living organisms, of which there are so many.

A fulvous whistling-duck.

(228, 132, 0)*

38 TIGER'S-EYE

Tiger's-eye is a golden-brown mineral in the quartz family that is known for its optical effect, called chatoyancy (French for "cat's eye"). The hallmark of the effect is a linear sheen that runs perpendicular to the fibrous structure of the crystal.

It was long thought tiger's-eye was created when quartz replaced another mineral. In this substitution theory, crocidolite—a form of asbestos characterized by long fibrous crystal strands—underwent a metamorphic transition that allowed quartz minerals to gradually replace the crocidolite fibers, much like how organic material is replaced by minerals during the fossilization process.

However, with the advent of electron microscopy, which allows geologists to view structures down to the atomic level, a completely different understanding of tiger's-eye formation has emerged. Contrary to the previous theory, scientists have found that the silky, fibrous appearance of tiger's-eye is likely due to a process called crack-seal crystallization. In this updated model, tectonic stresses cause quartz veins to fracture, creating narrow voids. These voids are subsequently filled by crocidolite. This is not a one-time event: the process happens repeatedly, resulting in a wavy, lustrous, fibrous structure characteristic of tiger's-eye.

(217, 152, 75)*

39
ORPIMENT

Some colors are so tantalizing that they conjure fantasies of immense wealth, immortality, or exalted states of hypercreativity. Any ore, mineral, or pigment that comes close to resembling metallic gold has entranced kings, alchemists, and artists throughout history, even if it meant such pursuits resulted in a horrendous death by poisoning. Orpiment is a vibrant naturally occurring orange mineral rich in arsenic (and often found near volcanic activity like realgar—page 67) that joins the exclusive club of colors that kill.

Everything about this mineral is dangerous, from the locations it was mined down to the very atoms that build its foundation. Like realgar, orpiment's arsenic sulfide makeup was incredibly dangerous and toxic, especially since direct heating was required to bring out its fiery golden oranges. Before the revelations of modern chemistry, ancient alchemists would hover over furnaces heating orpiment to unlock the coveted orange color in the pursuit of gold synthesis, often poisoning themselves in the process. And while the alchemists were dying in their labs, works such as Raffaello Sanzio's *The Sistine Madonna* and Giovanni Bellini's *The Feast of the Gods* were harnessing the vibrancy of this pigment to captivate the world. The toxic nature of both the orpiment harvesting and production processes would eventually create a demand for replacement with cadmium- and chromium-based yellows—safeguarding a great number of creative lives.

(252, 210, 28)*

Orpiment deposits surrounding Champagne Pool at the Wai-O-Tapu geothermal area in New Zealand.

40 BASTARD AMBER

Colors are often used in conjunction with lighting to set a tone or mimic an atmosphere in the film and theater industries. With its unforgettable name, bastard amber is one of the most popular and widely used color filters out there, capable of mimicking the warmth of sunlight.

To this day, theater and film productions utilize light gels to tone or color a set. These floppy films are applied over stage lighting and can be layered for different effects. Bastard amber belongs to a family of gels comprised of a single base tone with a small amount of complementary tones mixed in. These films supposedly earned their name when lighting designer Louis Hartmann stumbled upon a discarded stack of contaminated red gels in the early 1900s and referred to the unwanted films as bastard ambers. The gel color is primarily a warm pinkish orange to mimic natural sunlight with flecks of blues to complement both the light and the warm tones of actors on stage. It's the same technique applied when a painter begins with a warm undertone and uses cooler colors to depict shadows for a more realistic appearance. The warm amber without its complementary undertones would wash out the actors in a flat singular color, draining their skin of lifelike appearance. This is especially true for darker skin tones, which require additional films alongside bastard amber to reflect their warm tones. Nowadays good stage design and lighting experts go to great lengths to not only respect the skin tones of the actors on stage, but to give darker complexions the same treatment of beauty that white skin tones have been given throughout most of artistic and entertainment history. This is a stark contrast to the history of poisonous skin whitener lead white (page 33), and goes to show that we are capable of creating art and brilliance when all humans and skin tones are considered and respected.

(254, 200, 174)

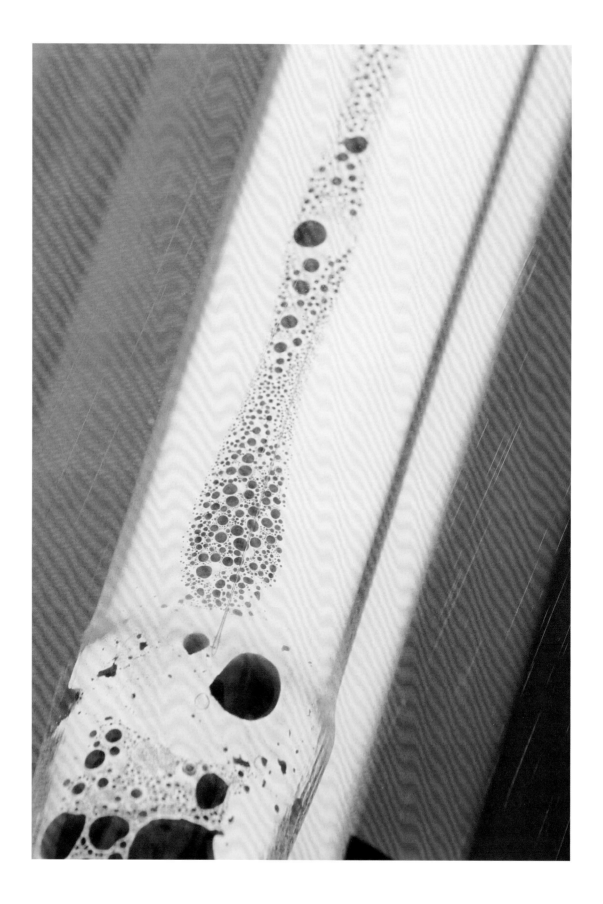

41
SODIUM-VAPOR LIGHT

Imagine the final leg of a long journey, seated on a plane descending into a city late at night. As you peer out the window, the darkness of Earth gradually gives way to countless twinkling yellow dots. More and more emerge, soon forming familiar city street grids beneath you. This comforting warm-yellow glow, now synonymous with cities at night, emanates from streetlights known as sodium-vapor lamps.

Since the 1930s, sodium-vapor bulbs have become widespread in municipalities around the world due to their high efficiency and long life span. Compared to other bulb types, they consume relatively little energy to produce an impressive amount of light, which falls in a range that our eyes are particularly sensitive to.

Additionally, the light a sodium-vapor bulb emits is monochromatic, so it won't disperse in moisture like white light, resulting in a strong glow even in fog, rain, and snow. However, the monochromatism comes with a side effect of making color differentiation challenging under sodium-vapor lighting. Light-colored objects all appear yellow, and dark-colored objects appear black. But color differentiation isn't a primary concern in locations where these lamps are typically used.

Sodium-vapor lighting is also preferred by astronomers, who can effectively filter out most urban light pollution by blocking a minimal region of the spectrum.

(255, 226, 0)

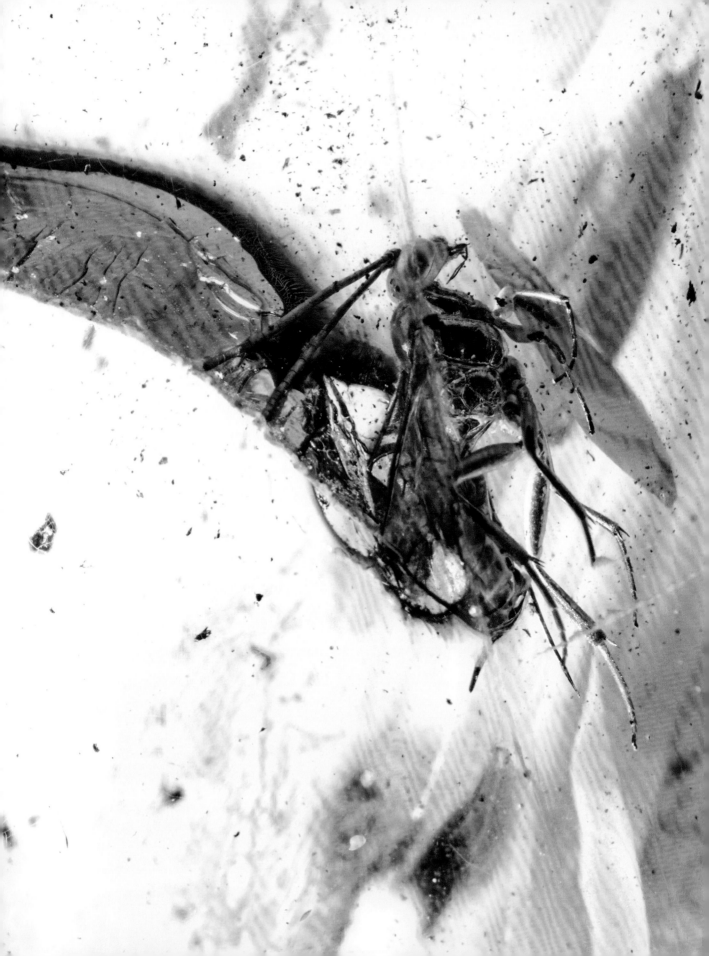

42 BALTIC AMBER

About 40 million years ago, resin oozed from a tree branch in what is now the Baltic region of Europe. Insects landing on the goo to investigate quickly found themselves stuck. The resin slowly engulfed them, permanently preserving their bodies and providing us with our most detailed samples of the insect fossil record.

Amber, in scientific terms, is a fossilized tree resin. Over millions of years, heat and pressure catalyze a series of biochemical changes that transform the resin into a hard, translucent material. Amber's unique ability to dehydrate and preserve organisms with exceptional detail makes it an important tool for paleontologists and other scientists studying the history of life on Earth.

The most prevalent type of amber is Baltic amber, also called succinite, which originated between 37 and 48 million years ago. The color of Baltic amber ranges from a yellowish to golden hue, but it was likely clear when initially excreted from trees. Amber's unique coloration is attributed to various organic compounds present in the resin, such as terpenoids and succinic acid. Over time, these compounds undergo polymerization and oxidation, which contribute to the amber's characteristic color.

Extracting the DNA from prehistoric mosquitoes trapped in the amber to clone dinosaurs à la *Jurassic Park* remains scientifically unfeasible. DNA degrades over time, and current methods are not capable of reconstructing an entire genome from such ancient specimens . . . yet.

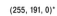

(255, 191, 0)*

43 VENUSIAN YELLOW

In 1982, Soviet scientists landed Venera 13, a spacecraft equipped with a color camera, on Venus. The images it returned were the first-ever photos of the surface of the planet, and they revealed a stark yellow world.

After the sun and moon, Venus is the brightest object in our sky, and its yellowish color has been documented since at least 1780. It was then that astronomer John Jerome Schroeter viewed Venus through a telescope and noticed evidence of a dense atmosphere. Indeed, Venus has a thick layer of gases, with a surface pressure ninety-two times greater than that of Earth, obscuring much of the planet from outside observations. If it didn't have this thick atmosphere, Venus might look a lot like Mars. However, unlike Mars, the color we observe on Venus is not due to the color of its surface material, or regolith. Instead, it is the sulfuric acid clouds in the Venusian atmosphere absorbing the blue and violet wavelengths of sunlight that result in the planet's yellow appearance.

Many scientists think that the acidic atmosphere of Venus is the result of a runaway greenhouse effect. The planet's surface may have once been covered in water, possibly even hospitable to life. Yet today, with temperatures around 465 degrees Celsius (870 degrees Fahrenheit), it seems unlikely any known life-form could survive on the surface.

Still, there has been speculation about the possibility of life existing in the upper Venusian atmosphere. Several scientists, including Carl Sagan, have suggested that there is a specific altitude where the atmospheric pressure, temperature, and composition are similar to those on Earth. At this point, the hypothesis goes, airborne creatures could potentially survive by residing high above the yellow haze.

(255, 211, 0)*

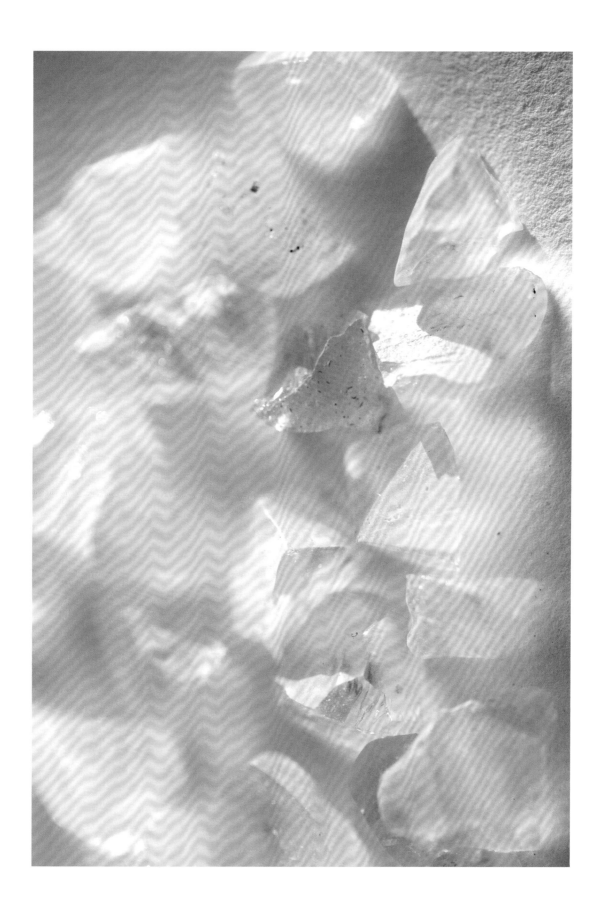

44
LIBYAN DESERT GLASS

Among the treasures discovered in the tomb of Egyptian pharaoh Tutankhamun was an ornate breastplate adorned with an array of gemstones. The centerpiece of the artifact is a large scarab intricately carved out of a radiant yellow stone—a material we now know as Libyan desert glass. It was the product of one of the many meteorite impacts in Earth's history; this one occurred nearly 29 million years before the precious stone was entombed with King Tut. The meteorite's collision in the Libyan Desert, located in the northeastern region of the Sahara, would have created a vast crater, ejected debris, and sent seismic shock waves coursing through the earth. The intense heat and pressure from the impact not only would have caused devastation in the area but also melted the surrounding quartz sand at temperatures exceeding 1650 degrees Celsius (3000 degrees Fahrenheit), hotter than any igneous rock–forming process on Earth. This resulted in an abundance of natural glass strewn across the desert landscape, prized by geology collectors to this day.

What sets Libyan desert glass apart from other natural glasses (which are full of impurities) and contributes to its characteristic color is its remarkably high silica content, which makes up over 97 percent of its composition and results in a nearly pure form of glass.

(234, 192, 137)*

45 IMPERIAL YELLOW

Humans have long used color to portray status, wealth, and power. For example, certain colors were reserved for specific individuals or positions within Chinese society, even going so far as to reserve one specific pigment only for the emperor.

Starting during the Zhou dynasty in China between 1046 and 256 BCE, a set of customs and rules regarding colors, patterns, and garments began to unfold. Certain colors and patterns were reserved for different seats in court or within royal families. And the rarer the color and more difficult to produce, the more likely it would be deemed suitable for the highest seat of power.

Yellow is one of the colors in the five elements theory that defines traditional Chinese medicine; it represents the earth. Yellow became central within the theory when its association with the emperor was established. The earliest record of an emperor donning yellow was Emperor Wen of Sui prior to 600 CE. Between 649 and 683 CE, during the reign of Emperor Gaozong of the Tang dynasty, it was established that only the emperor and high members of the family and court could don any amount of yellow. The color also had a close association with the sun, and laws were soon established forbidding anyone else from wearing clothes pigmented with reddish yellow. This Confucian adage sums it up: "Just as there are not two suns in the sky, so there cannot be two emperors on earth." These laws persisted until 1912 when the Qing dynasty fell after the Xinhai Revolution.

The royal appeal of yellow was also due to the time-consuming and intensive process of creating this pigment, which required harvesting large amounts of Chinese foxglove tubers that were ground into a fine paste and applied to fabric. Approximately seven cups of dye were required to stain just fifty square feet of fabric, making this pigment rare and expensive.

(249, 190, 33)

A silk panel depicting a dragon dyed with finely ground imperial yellow.

46
GOLD

Among the pure metals, gold is easily discernible due to its unique color. But why exactly is gold yellow rather than silver like most other metals?

Within an atom, electrons are arranged around the nucleus based on their energy level. Electrons closer to the nucleus are less energetic, but due to the mass of gold, these electrons are traveling significantly close to the speed of light. According to special relativity, as the velocity of any object approaches the speed of light, its mass increases.

This relativistic effect is felt all the way out in the farthest electrons from the nucleus, where the energy level required to transition between orbitals is significantly reduced (for more on this see page xxi). This level is important because it ultimately determines which colors are absorbed and which are reflected by the atom.

In most metals, electrons absorb energy in the ultraviolet range, which doesn't fall within the visible light spectrum. As a result, all visible colors are reflected back to our eyes, giving the metal a silvery-white appearance. However, the unique atomic structure of gold causes its electrons to absorb energy farther into the visible spectrum, specifically the violet and blue wavelengths. Because these colors are absorbed, they are not included in the light reflected to our eyes. This leaves predominantly yellow wavelengths coming from the material, which we perceive as its distinct golden hue.

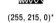

(255, 215, 0)*

······· Without relativistic effects
⎯⎯ With relativistic effects

Above: The high kinetic energy of the innermost electrons of the gold atom causes the contraction of inner orbitals and expansion of outer ones. Consequently, the transition energy of electrons in the outer shell are in the range of blue photons.

Left: Metallic gold from the Zlate Hory gold mine in the Czech Republic.

47 INDIAN YELLOW

The world's most widely used pigments and dyes were originally ones readily available through natural processes. The saturated pigment known as Indian yellow was one of these. This potent yellow has origins dating back to the 1600s when it was primarily used as a dye, though it was also incorporated into paintings. The color was popular for its vivid appearance and ability to fluoresce, which gave it enhanced brightness in daylight. This pigment's past is somewhat mysterious, however, as it was primarily produced in the city of Munger in the Indian state of Bihar by a small group of people whose history, process, and craft disappeared with the outlawing of Indian yellow production.

It was speculated that Indian yellow was originally sourced in rural India from cow urine, specifically cows that were malnourished and fed a strict diet of mango leaves. The urine was then collected in small amounts and subjected to several different filtering and drying processes to produce the yellow-orange bricks used in paintings and dyes. The process of manufacturing Indian yellow was detailed to botanist Sir Joseph Hooker by T. N. Mukharji, who was a curator for the Indian Museum in Calcutta. He also sent physical samples to Hooker for analysis and study. Without much actual research into the supply chain, the process of synthesizing Indian yellow was viewed as cruel and outlawed in 1908. Its true origin is still a source of speculation, with mostly oral history as evidence; however, chemical analysis showing the presence of hippuric acid seems to lend credence to the fact that this color very well might have its roots in animal urine.

(227, 168, 87)*

48 LETHARIA VULPINA

Letharia vulpina, commonly referred to as wolf lichen, is a vibrant green and yellow lichen that can be found growing in parts of Scandinavia as well as North America in the Pacific Northwest and the Rocky Mountains. Wolf lichen belongs to a limited group of naturally occurring specimens capable of producing bright yellow dyes and is utilized by indigenous peoples like the coastal Tlingit nations.

Vulpinic acid is the compound responsible for the bright yellow pigment and dye. By heating wolf lichen at steadily low temperatures, the pigment is released as a concentrated yellow color that can be applied to yarns, fabrics, and other textiles. This dye is used by the Tlingit weavers to create Chilkat blankets, which primarily feature black and yellow hues and utilize one of the most complex weaving techniques in the world.

Wolf lichens prefer to grow alongside dead conifers and pines and thrive in places like Gränslandet, a rich nature preserve of old forests and bogs bordering Sweden and Norway, but *Letharia vulpina* is Red Listed and considered at risk of extinction in parts of Scandinavia. The neon color of wolf lichen against the backdrop of snow and dead conifers makes it a heavily photographed and visually attractive subject matter for photographers and artists visiting the area.

In parts of Europe, this lichen was used to poison scavenging animals by stuffing meat or reindeer carcasses with crushed lichen and glass; the vulpinic acid from the lichen would then seep into the organs of the animals. It is thought these lichens developed and maintained this compound as an antifeedant to deter grazing deer.

(171, 191, 74)

49 LUCIFERIN

Fireflies are celebrated for their entrancing light shows on warm summer evenings—a spectacle of bioluminescence. The bright-green-colored glow particular to fireflies distinguishes them in the world of luminescent creatures.

The mechanics of a firefly's glow are based on a biochemical reaction within their light-emitting organs, usually located on their abdomen. There, oxygen combines with a substance called luciferin under the influence of an enzyme known as luciferase, producing a chemical called oxyluciferin. When the oxyluciferin returns to its normal state, it releases energy as a photon (a particle of light). This process is impressive, generating light with nearly 100 percent efficiency—almost no energy is lost as heat, making fireflies one of the most effective light producers in the natural world.

The distinct green glow of a firefly, which typically falls into a wavelength between 510 and 570 nm, is thought to be the ideal color for communicating in their environment. The green hue can penetrate the ambient twilight or the foliage in their habitat, ensuring the signals reach potential mates.

Luciferin and the process of bioluminescence represent a fascinating example of convergent evolution since they are employed by a diverse array of organisms besides fireflies. Deep-sea fish like the anglerfish use blue luminescence to lure prey, while other creatures, such as some jellyfish and beetle larvae, glow to deter predators. Still other organisms' purpose for glowing remains a mystery, like the green foxfire fungi.

What sets fireflies apart in the realm of bioluminescent creatures is not just their ability to turn their light on and off—something a few other organisms can also do—but the complexity and specificity with which they control the timing and intensity of their glow. Fireflies have evolved an intricate visual language mainly used for communication between males and females during mating rituals. This nuanced control over their bioluminescence has led to the evolution of species-specific flash patterns, enabling them to distinguish mates from members of other firefly species.

(189, 255, 0)

50 FLUORESCEIN

Glacier hydrologists face the challenging task of monitoring the flow of meltwater. Often it travels into obscure, hard-to-follow areas like crevasses, channels within the ice, or dark, hidden caves. However, hydrologists have a tool for these situations: a special water-activated dye that glows vibrant yellow, illuminating water veins within the ice. This dye, fluorescein, is capable of fluorescing in the dark and renders any outflows visible.

The creation of fluorescein dates back to 1871, and it has since found use in many niche applications, particularly scientific research, thanks to its unique coloring and ultraviolet fluorescence. If you've ever used a bubble level to straighten a picture frame or build a shelf, you've probably seen fluorescein's intense, almost luminescent yellow-green color in the liquid chamber.

While fluorescein itself is insoluble in water, its salt derivative, called uranine, is water-soluble. Both start as red-orange powder but fluoresce readily in solution, as the name alludes to. Fluorescein molecules are primarily excited by blue light, which decays into a lower state emitting the characteristic light between 520 and 530 nm. This effect is amplified in ultraviolet light, which triggers a striking green radiance usually only seen in the pulpiest science fiction.

Beyond its hydrological applications, fluorescein dye has medical uses as well. It can be injected into the body to help detect and diagnose corneal injuries, and it can help certain parts of the eye become more visible during medical procedures.

Fluorescein dye suspended in water.

(206, 255, 0)*

51 URANIUM GLASS

For hundreds of years before the effects of radiation were well understood, artisans commonly used uranium to color glass and ceramics. By incorporating a small amount of uranium oxide into their recipes, craftspeople could create glass in shades of yellow and green. These pieces became particularly popular in the Victorian era.

Something the Victorians didn't realize about their lovely uranium glass tea sets was that they could emit a spectacular neon-green glow when exposed to ultraviolet (UV) light. But don't hold it against them: electric lights in general had only just been invented.

The green glow, called photoluminescence, was caused by radiation—something else the Victorians didn't know about yet. Ultraviolet light isn't visible to the human eye, but when these high-energy photons interact with uranium atoms, the atoms become energetically excited. Upon returning to their ground state, they emit a photon of a lower energy than the absorbed ultraviolet photon. This emitted photon falls within the green range of the visible spectrum, making uranium glass appear to glow green.

As research into the harmful effects of radiation progressed, it became evident that uranium was pretty dangerous, and growing concerns about its use resulted in a significant decline in uranium glass production.

Fast-forward to the late twentieth century. Our understanding of radiation has advanced enough to assure us that uranium glass emits harmlessly low levels of radiation. Moreover, the accessibility of UV lights has become widespread. Suddenly your great-grandmother's antique vases, chandeliers, and dish sets can light up a dark room like a scene in *Blade Runner*. This effect has spurred renewed interest in uranium glass. But because it is no longer widely produced, most uranium glass found today is vintage, manufactured before regulations came into effect in the 1970s.

Uranium glass continues to charm collectors and enthusiasts with its distinct glow and atomic-age appeal.

(137, 255, 0)*

Uranium glass balls fluorescing green under ultraviolet light.

52 RADIUM DECAY

Radium, a naturally occurring radioactive element discovered by Marie and Pierre Curie in 1898, is best known for its striking luminescent property. Under the right conditions, radium emits a soft, mesmerizing green glow. But what causes this luminescence? It's a product of the radioactive decay of radium, specifically a process known as radioluminescence.

As radium decays, it releases particles with high energy. When these particles interact with a phosphor material—usually zinc sulfide—they transfer their energy to the atoms within it, pushing their electrons to a higher energy level. As these electrons fall back to their original state, they release the absorbed energy in the form of visible photons, producing a captivating glow. The wavelength of these photons falls within the visible spectrum of 495 to 570 nm, which is perceived as green by the human eye. This glow can be sustained as long as the radioactive decay continues, which, in the case of radium, is over several thousand years due to its long half-life.

The luminescence of radium found a commercial application in the early twentieth century when radium-based paint was used on watch dials and other instruments to make them glow in the dark. The young women who were employed to apply this paint became known as radium girls; they would routinely lick the bristles of their fine-tipped brushes to maintain a point, unknowingly ingesting dangerous amounts of radium.

Initially, the hazards of radium were not well understood, and the women were told the substance was harmless. Unfortunately, many of them later developed severe health complications that frequently led to early death, including anemia, bone fractures, and necrosis of the jaw—a condition so severe and common it became known as radium jaw. The women's plight led to significant changes in labor laws and was instrumental in heightening awareness about the dangers of radioactivity. Their tragic stories add a somber note to the history of radium, serving as a poignant reminder of the ethical responsibilities that come with scientific discovery.

(135, 255, 42)*

A phosphorescent compound containing radium exhibiting radioluminescence.

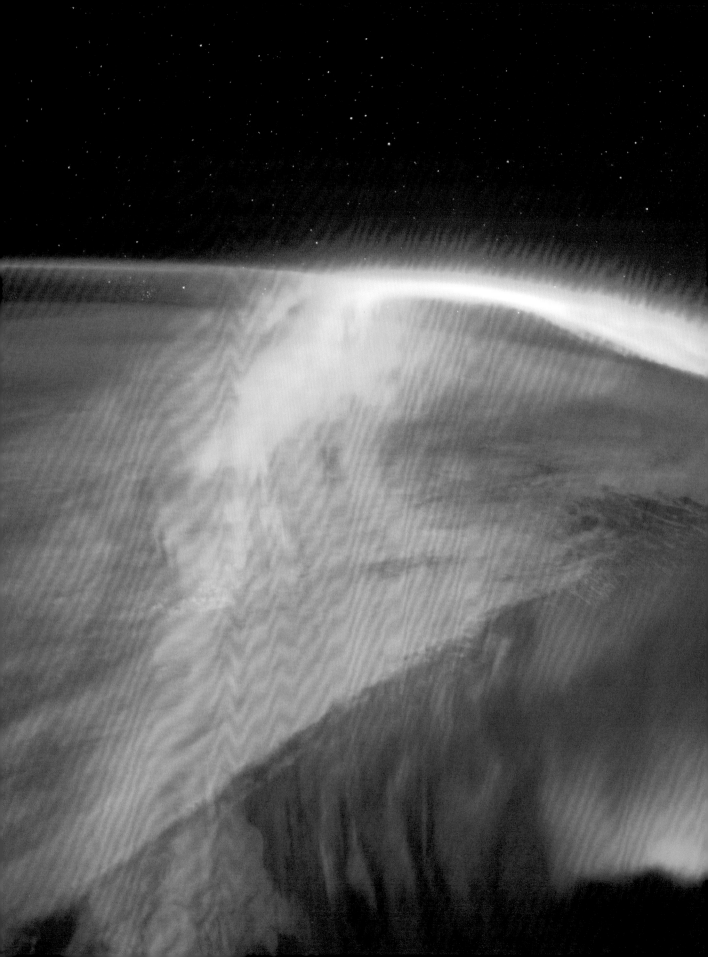

53 EARTH AURORA GREEN

An aurora is a colorful celestial performance that takes place in our atmosphere. Seeing one tends to make it on the average bucket list, but what exactly causes an aurora and why are Earth's auroras so green? Whereas plenty of sky phenomena, such as rainbows, require the interaction between visible light and moisture, auroras require something a little more exciting—literally. Different gases have their own electron arrangement. When those electrons are energized, they are excited to higher energy levels temporarily. The shifts between these energy states releases that excess energy, which we perceive within the visible light spectrum as color. Different gases produce different colors. Looking at an aurora, we perceive it as holographic overlaid colors, which clues us in to the fact that various gases exist within their own zones of the atmosphere dependent on their molecular weight and density.

When fast-traveling ions from solar winds enter the atmosphere, they collide and smash into the gaseous atoms above us. These collisions are responsible for exciting the electrons in the gases, causing the display of color we see in the night sky. We are essentially watching countless brilliant explosions at the atomic level all occurring in unison. Earth's auroras take place in the thermosphere, which is mostly composed of nitrogen and oxygen. When the electrons of oxygen atoms are excited, they release bursts of energy we perceive as green light. The dominance of oxygen and nitrogen usually gives us auroras with layers of colorful curtains of greens and pinks. It's easy to see how these atmospheric shows have hypnotized, captivated, and inspired humans since we first looked up at them.

(189, 255, 0)

54 HELENITE GREEN

On the morning of May 18, 1980, a magnitude 5.1 earthquake churned a mile beneath the surface of Mount Saint Helens, a stratovolcano in Washington State. Over the preceding months, magma had been pressurizing the mountain's interior, forming a noticeable bulge that ruptured within seconds of the quake. The resulting explosion tore the mountain in half and unleashed a chain reaction of widespread devastation across the region. Millions of tons of ash were ejected and scattered for hundreds of miles.

According to several accounts, cleanup workers noticed the ash melted into a green glass under the flame of their cutting torches. This phenomenon was later reproduced under laboratory conditions by heating the ash to approximately 1482 degrees Celsius (2700 degrees Fahrenheit) and cooling it rapidly. Scientists found that the greenish hue resulted from a small amount of chromium and copper in the ash. The unique glass created as a result of the eruption was named helenite.

Other elements in the ash, like silicon, oxygen, calcium, and magnesium, generally do not have the atomic structure needed to absorb photons in the visible range and are therefore colorless in that form. The exact shade of green varies depending on the concentration of iron ions and other trace elements, as well as the conditions under which the helenite was formed, such as the cooling rate and ambient pressure. Today helenite is used as a gemstone in jewelry, serving as a reminder of the power of nature to create and destroy.

(139, 173, 83)*

55 SCHEELE'S GREEN

Scheele's green takes the cake as one of the more unfortunate pigments to grace this book. One of the deadliest greens ever invented, this bright and almost acrid-looking color was invented in 1775 by German Swedish chemist Carl Wilhelm Scheele, who identified several elements and heavy metals throughout his life. The poisonous Scheele's green was created by combining copper, oxygen, and arsenic, which yielded cupric arsenite. This novel hue found uses in paint for children's toys, clothing dyes, wallpapers, and just about anything else that could be painted or dyed during the Victorian era.

Scheele's green is notorious for its presence in a lethal wallpaper, as it is speculated that certain organisms could feed on the paper itself and cause arsenic-related off-gassing that would slowly poison the inhabitant. (Some fungi, such as *Scopulariopsis*, are capable of growing in damp conditions that contain arsenic.) It is believed that Scheele's green wallpaper was responsible for Napoleon's death because high levels of arsenic were found in his body.

History is lined with tales of laborers dying painful and unimaginable deaths from arsenic poisoning, ranging from the miners tasked with sourcing the cupric arsenite for the pigments to the children who worked in dimly lit workshops dusting fake foliage with Scheele's green powder to make them appear more alive. The pigment's tragic effects were eventually acknowledged, and public disapproval combined with government regulation and fading trends eventually laid this green to rest.

(158, 165, 79)*

Vintage wallpaper illustrating one of the many uses of Scheele's green.

56 FUCHSITE

It's truly astounding what can be created with a combination of intense heat, immense pressure, and a long time. The world of geology is filled with rocks and minerals of just about every color imaginable. Normally color alone isn't enough to identify a particular mineral, but there are some exceptions. Fuchsite is one.

Named after mineralogist Johann Nepomuk von Fuchs (whose last name rhymes with "books"), fuchsite is known for its distinct shimmering green, often compared to the sheen of fish scales. It's a variety of muscovite in which some of the aluminum atoms in the crystal lattice are replaced with a type of chromium atom. This subtle change in the chemical makeup produces fuchsite's unique hue. But this change is no simple task. One of the most common mechanisms for transforming aluminum-rich minerals into fuchsite is under the heat and pressure generated during the collision of tectonic plates.

It's not surprising that chromium is responsible for the color. The metal, gray in its pure form, is renowned for creating vibrant colors when combined with other elements. The word *chromium* comes from the Greek word for *color*.

That explains the green, but what about the shimmer? This is the result of fuchsite's thin, semitransparent, flakelike crystal structure—a characteristic of the mica group of minerals to which fuchsite belongs. The combination of this structural glittering effect, along with the green pigmentary color, makes fuchsite a complex and appealing stone, and also one easy to identify.

(165, 193, 152)*

57 CHALKBOARD GREEN

For nearly thirty years, most traditional learning occurred against a background of one color: chalkboard green. This color brings up visceral memories for a lot of us, from the color itself to the atmosphere in which it was experienced and even the sound of scraping and clacking of calcium carbonate against the enamel-plated metal. It is commonly referred to as a blackboard (even when it is green), which offers a hint about its history.

Blackboards originated in the nineteenth century as thin, evenly cut sheets of slate, a dark homogeneous metamorphic rock. The smooth surface was perfect for translating marks undisrupted while the contrast allowed writing in lighter minerals to be viewed with ease. Blackboards were an essential technology for education, since paper and ink were increasingly expensive, while slate and chalk were readily available and naturally accessible with no need for complex manufacturing processes.

These blackboards were vital to sharing knowledge until the 1960s, when there was a simple yet effective shift. Slate was very heavy and fragile to ship. The costs of transporting blackboards were rising, so that's when an alternative was invented—the green chalkboard. Sheets of steel were coated with a porcelain enamel to give it a softer color and appearance and less contrast with smudges and stray marks. It served practically the same function as slate, allowing mark-making in real time, on a large surface, with the express purpose of recording and sharing ideas. The green chalkboard became synonymous with academia and education for decades until dry-erase whiteboards began to dominate the modern school system in the late '90s. There is still a level of prestige and charm that comes with using a green chalkboard that a dry-erase whiteboard will never match.

(42, 107, 87)*

58 SMARAGDINE

How can you describe an object's color without using its own name (which is typically used to describe its color)? Take emeralds for example: our first instinct when describing one might be to say it's "emerald green," which is, of course, little use to someone who perhaps has never seen an emerald before. So it's handy that we have the science fiction–sounding word *smaragdine*.

This term was used to describe the color of emeralds before *emerald* was used to describe other objects that share their color. In fact, it was the go-to word to describe most green minerals or stones. The word *smaragdine* has Latin roots meaning *green gem* and may trace all the way back to Sanskrit. It wasn't until the fourteenth century that emerald was first described, from Middle English *emeraude*.

So what makes an emerald smaragdine? When the mineral beryl is forming, varying traces of chromium, vanadium, and iron give the mineral its color. In isolation, chromium and vanadium produce rich greens, specifically the +3 oxidation state of vanadium. The presence of iron is responsible for the varying hues of blues that are seemingly trapped in a matrix of green.

(80, 200, 120)*

59 MALACHITE

In its various oxidation states, copper is capable of displaying a few different colors, from a soft green to a deep blue and even black, depending on the anion (a negatively charged ion accompanying the copper-based molecule). In its carbonate form with an accompanying hydroxide ion, copper becomes the blue-green mineral malachite, which can be found worldwide from the Urals in Russia to the southwestern United States. It has been mined for copper ore and was also used as an early pigment in art and sculpture before more stable and hardier synthetic greens were utilized.

As a source of copper ore, malachite is typically dissolved in acids or treated to heat and carbon dioxide to produce a black copper oxide that is then used to yield solid copper metal. The role copper serves in human life is a large one, and it has led to an incredible amount of environmentally destructive mining for malachite, even today.

As a pigment, malachite has had a presence in the arts since antiquity. As far back as Ancient Egypt, it was ground and used as an eye paint and to decorate tomb walls. Malachite green also enjoyed popularity in Japanese and Chinese art beginning in the seventh century due to its ability to be finely ground and mixed into fresco and tempera mediums. The pigment also appears in European art during the Renaissance.

Famous works of art that utilize malachite include Watanabe Kazan's 1824 *Portrait of Sato Issai*, Spinello Aretino's 1380 *Virgin Enthroned with Angels*, and Tintoretto's 1555 *Saint George and the Dragon*. The fascination behind malachite in the art world is that it's one of those naturally occurring colors that we chase but struggle to catch. The idea of the rich blue-greens of the natural mineral applied to a painting to depict a landscape or robes would give any artist a sense of euphoria. However, the pigment synthesis is a delicate one, as overworking the mineral or grinding it too fine often results in a duller gray coloration.

(12, 173, 138)*

60 MERCURY E-LINE

Astronomers can discern a great deal about distant stars and galaxies just by analyzing the light emitted. Information about a star's temperature, chemical composition, density, mass, distance, velocity, and direction of movement (toward or away) are all encoded in this light. To accurately decrypt the information, precise calibration is essential. Introducing the Mercury e-line.

When heated, all chemical elements emit light at specific and constant wavelengths, serving as unique fingerprints. Since all visible matter, including that of distant stars, consists of known elements, these fingerprints, called atomic spectra, can be universally recognized with the proper equipment. Scientists can then use them as reference points to ensure the reliability of their measurements of distant starlight. German physicist Joseph von Fraunhofer first mapped the wavelengths of hundreds of such spectral lines starting in 1814. He gave many corresponding letter identifiers, including "E" for the Mercury line.

The chemical element mercury is a popular choice for this calibration process because it emits an especially bright-green light with a wavelength of precisely 546.07 nm. This light can be easily produced in a laboratory using a mercury-vapor lamp, thereby providing a known reference value.

Because Mercury's e-line is so bright and well defined, it's like a signpost in the light spectrum. By comparing the observed Mercury light from distant stars and galaxies with its laboratory value, astronomers can validate their measurements to deepen our understanding of these distant objects.

(150, 255, 0)

The visible mercury emission spectrum lines. Fraunhofer's e-line is the bright green line in the center.

61
GREEN PEA GALAXIES

In the cosmic garden of the universe, many oddities sprout among the stars, but none are quite as peculiar as the so-called green pea galaxies. As the name suggests, these compact little galaxies glow with an enchanting green hue.

Green pea galaxies are rare—so rare that only about 250 of them have been spotted to date. Though small, at least by galaxy standards, they are bustling with new star formation. Named for their distinctive green body in color-enhanced images, they sit billions of light-years away from us.

These tiny galaxies are cosmic nurseries, with intense levels of star formation happening at a much higher rate than in our own Milky Way. This flurry of star birth results in large amounts of ionized oxygen, which glows green when it cools and returns to its neutral state.

In the grand cosmic scheme, green pea galaxies are quite young at 1.5 to 5 billion years old. (To put this into perspective, our Milky Way is about 13.5 billion years old.) They represent a phase when galaxies were commonly small and full of activity, offering us a vibrant glimpse into the universe's early days.

The green pea galaxies, in all their verdant splendor, are not just galactic anomalies but valuable scientific tools. They offer astronomers a looking glass into our universe's past, helping us understand the conditions and processes that led to the formation of galaxies like our own. Through their unique green glow, these little peas are helping to fill in chapters of our cosmic history.

A green pea galaxy viewed at roughly 170 million light years away.

62 MIRROR

Have you ever found yourself between two mirrors facing each other, caught in an optical echo of yourself trailing off into the distance? If so, you may have observed an interesting phenomenon in which colors shift subtly toward a greenish hue the farther your reflections go. What's happening here? Is this the color of space-time revealed through a physics loophole?

It turns out this has less to do with the act of reflection and more to do with the reflector itself—the mirror. It helps to first understand what a mirror is. One typically consists of a thin layer of reflective metal deposited onto one side of a sheet of glass. When you gaze into a mirror, your reflection is bouncing off the metal layer, but not before it travels through the glass both on the way to the metal and back.

Most mirrors are made of soda-lime glass due to its cost-effectiveness and high clarity when thin. Pure soda-lime glass appears clear, but thicker sections can reveal a bluish-green hue when viewed against a white background. You may have noticed this if you've ever looked at the thick base of a clear jar or bottle. This greenish tint arises from iron impurities in the raw materials used to make the glass. During the heat-intensive manufacturing process, iron reacts with other components in the glass to form iron oxide. The level of green coloration depends on the amount of iron and the duration of heat exposure.

So when you peer into an "infinite" mirror tunnel, your reflection isn't simply bouncing back and forth—it's passing through the glass again and again, each time taking on a bit more of its pale color. It may not be revealing space-time, but rather the true color of the mirrors themselves.

(52, 113, 112)*

Reflections from two mirrors.

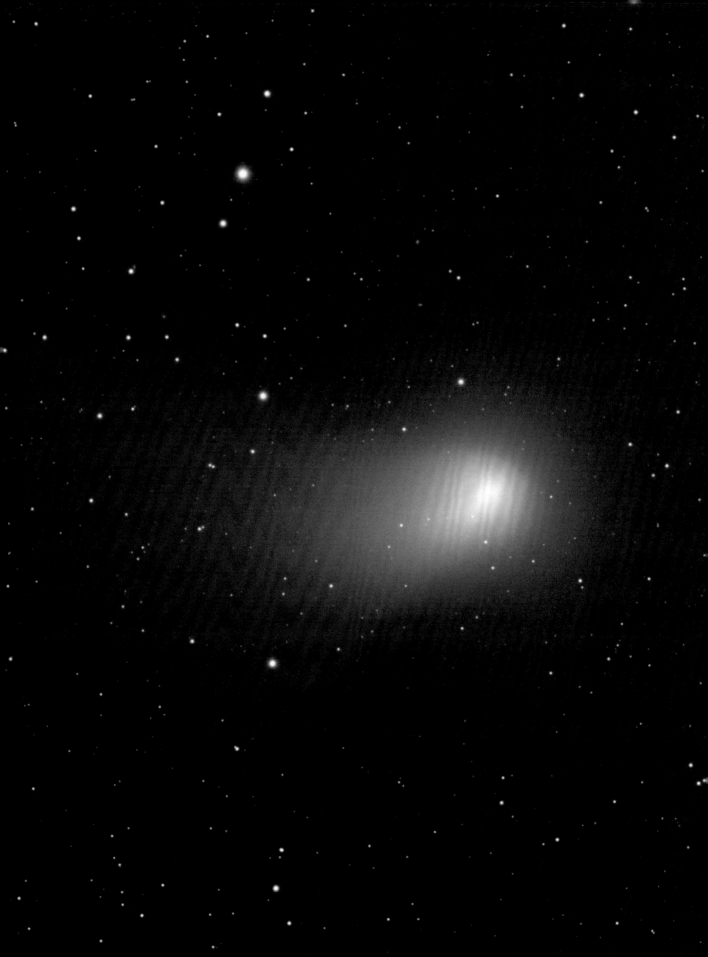

63 COMET C/2002 E3 (ZTF)

We love a new discovery, especially one that puts on a show. Comet C/2002 E3 (ZTF) is a brilliant-green event that humanity got to experience in February 2023. This green-glowing icy entity (say that five times fast) was first discovered by astronomers Bryce Bolin and Frank Masci using the Zwicky Transient Facility survey on March 2, 2022. The ice age was the last time this comet passed through the inner solar system, and its timing with modern human technology this go-around couldn't have been more perfect.

The green glow of this comet isn't necessarily rare, but it is uncommon for a comet emitting this glow to approach Earth so closely, giving us the chance to capture its colorful brilliance with our technology. The color of this comet is due to its high gas content and cyanogen—or diatomic carbon. These carbon molecules are evaporated from the nucleus of the comet and react with sunlight to produce the ghostly green glow. If Comet ZTF has a strong enough orbit, we may see it approach Earth again in 50,000 years. However, it is possible that this comet is weakly hyperbolic, meaning any change in its speed could alter its course and send it zipping out of our solar system. That would make the experience of this particular phenomenal hue a one-and-done experience for modern humanity. Good thing we have amazing cameras.

(119, 215, 201)*

64 ZELYONKA

Some colors have properties that can be exploited for malicious purposes. Take, for example, the various ways people use zelyonka dye. The active ingredient in zelyonka is brilliant green, a bright-green-colored antiseptic dye commonly used to treat skin infections and wounds in Eastern European countries. Beyond the realm of first aid, brilliant green has other utilitarian functions, from serving as a stain in microbiology to its use in textile dyeing and even fish farming. However, in recent years, zelyonka has made headlines after being weaponized in a series of attacks across Russia and Ukraine. Assailants throw the dye at their targets, primarily anti-government Russian opposition leaders and Ukrainian politicians, staining their skin green for up to a week due to the dye's resilient properties. These incidents have come to be known as zelyonka attacks. While the dye is generally safe for skin exposure, it can cause blindness if it makes contact with the eyes at full strength. Ironically, it can be useful for eye infections like conjunctivitis in diluted form.

Rather than deterring political activism, the attacks have often served to strengthen unity among protesters. In a show of solidarity, some have even been known to paint their own faces green in support of those targeted.

(13, 167, 164)*

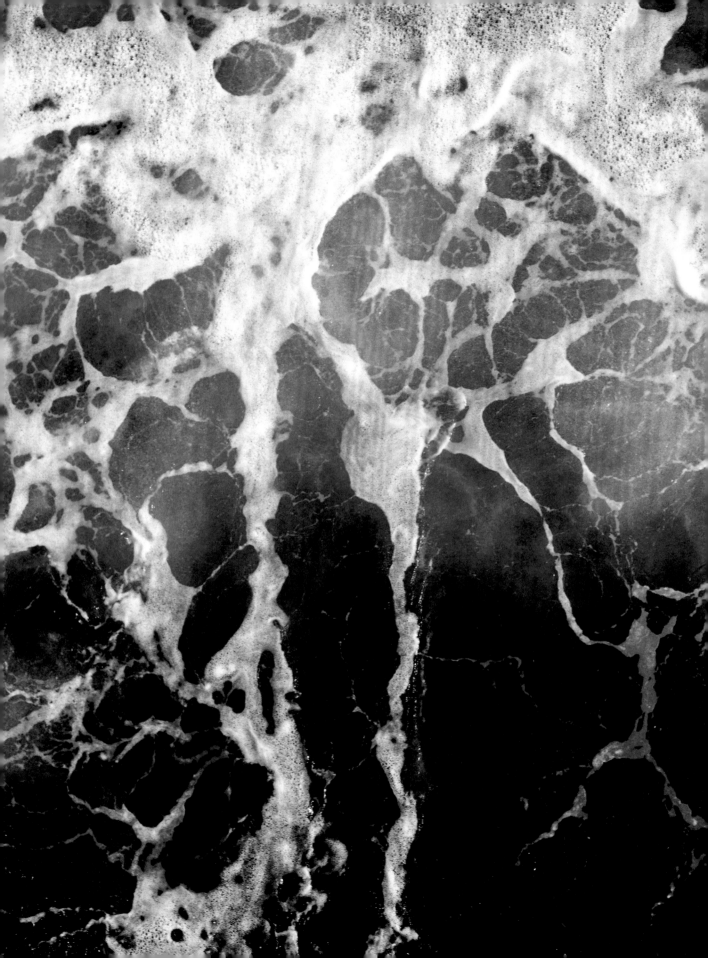

65 WATER

Water is the most important substance for life on Earth. It has been analyzed in every possible way by scientists. So you'd think we'd all agree on its color, right?

Both the Royal Society of Chemistry in the UK and the US National Institutes of Health describe water as colorless, but is it really? You might be thinking that it's obviously blue, but could you prove that?

Interestingly, water molecules do absorb the slightest amount of light from the red part of the color spectrum, suggesting that water should exhibit a very pale shade of blue-green. However, water also slightly absorbs violet and green wavelengths, making blue the most prominently scattered and observed color. But it's so faint that it requires optimal conditions to be observed, such as a large pool with a white bottom.

To confirm water's true color, researchers went to great lengths, constructing a ten-foot-long apparatus to observe it, since it is barely perceptible in shallow depths. The apparatus consisted of two parallel vertical tubes made of aluminum with a transparent cap on the bottom end. One tube was filled with pure water and the other with a control substance called deuterium, or heavy water. Heavy water is similar to regular water, but with one small difference: its hydrogen atoms also include a neutron in the nucleus. This subtle difference adds mass to each hydrogen atom, changing the light absorption properties of the water. Specifically, it shifts the absorption line out of the visible spectrum, making the deuterium appear perfectly clear.

When the researchers observed sunlight through both tubes, they saw a noticeable difference. One tube showed a slight blue color, while the other was perfectly transparent, confirming that water is indeed blue.

(135, 189, 203)*

66 MAYA BLUE

The pursuit of color has intrigued human curiosity since time immemorial. Maya blue was a clever recipe put to regular use by the Maya and Aztec peoples at least as early as 800 BCE. This bright-blue material was created through a combination of indigo dyes mixed into palygorskite, a type of magnesium aluminum silicate clay found in the southeastern United States and Mexico. This pigment found widespread use in Ancient Mesoamerican art, culture, and spiritual practices, with its astounding longevity being the reason we know so much today.

Maya blue is incredibly resistant to fading, chemical erosion, and weather damage, with precolonial art exhibiting an unaltered vibrancy as if the pigment were recently applied. Samples of pottery, sculptures, and murals still maintain the original quality of Maya blue, including paintings found at the Mayan site of Bonampak. This durability has helped modern chemists and historians understand a great deal about the culture and people. Maya blue can be found in the Dresden Codex, one of the oldest surviving books written in the Americas as well as the Books of the Chilam Balam, which detail the historical, spiritual, and medicinal practices of the Maya. It is amazing that a color can preserve data for history.

A culturally significant cenote (water-containing underground chamber) located at Chichén Itzá in the Yucatán peninsula of Mexico was found to hold over ten feet of sediment containing remnants of Maya blue, leading anthropologists and scientists to believe that this revered color was also reserved for spiritual practices and sacrifices. Ritualistic bowls preserved at the bottom of this cenote were found to hold traces of Maya blue paint as well as bones and human remains. It is thought that sacrifices were coated in the pigment before being offered up to the sacred well. The pristine preservation of these artifacts helps paint a picture of the pigment's role in Maya and Aztec cultures. In 2023, for the first time in nearly two centuries, the color was recreated by indigenous Mayan artist Luis May Ku in his self-made laboratory and confirmed by scientists in Italy and Mexico as being the authentic historical blue.

(115, 194, 251)*

Mayan murals painted in the eighth century, from Bonampak, Mexico.

67 UNAPPETIZING BLUE

You're eating a delicious meal in a dimly lit room. Everything tastes like it has been perfectly cooked with the freshest ingredients. When the lights come up, you realize all the food on the table is unnaturally colored. Does that change how appetizing it is?

This scenario is the premise of the blue steak experiment of the 1970s, often cited to support the hypothesis that blue-colored food is unappetizing to look at or eat. Proponents of this idea suggest it may be because blue food is uncommon in nature, or that humans have an instinctual repulsion to it, since spoilage often presents as blue color on food. When confronted with the existence of blueberries, the argument is that the fruit is, in fact, more purple than blue.

In the common retelling of the experiment, when the lights were raised and it was revealed that their delicious steaks were actually blue, the diners were instantly repulsed, with reactions ranging from vomiting to throwing plates at walls. However, the alleged experiment can only be traced to a single mention in a 1972 trade magazine for the food marketing industry, and the mention itself is a mangled secondhand account of a similar dinner hosted by a color consultant in the 1950s. Actual experiments that have since been conducted determined that people are simply hesitant to eat foods that aren't the color they are familiar with. No vomiting has reliably been reported.

Nonetheless, the steak story has become so deeply embedded in food industry lore that some restaurants specifically avoid using blue dishes, just in case there is any truth to the unappetizing power of blue.

(31, 117, 254)*

SKETCH SHOWING NEW OUTSIDE COVERING
FOR OLD TOWER AT ISLE OF SHOALS,
ME.

Rotary Top

SCALE ¼"=1'-0"

Canvas Roof.

Canvas Roof.

1½" Vertical sheathing

3 x 4

4 x 6

ELEVATION.

TOWER.

OIL ROOM.

PLAN.

— NOTE —
Put in receiver to suit
present pipe and
stay chim. to rods
Chim. drawn Sept. 1912
R.L.

Clearout Door

Covered Way.

B-123

68 PRUSSIAN BLUE

While many colors find their niche in specific domains—be it as a pigment, a medical treatment, or a chemical component—Prussian blue stands out for its multifaceted historical impact across a range of disciplines.

Prussian blue was first created accidentally in 1706, when a paint manufacturer named Johann Jacob Diesbach was making red carmine pigment (page 51), and a contaminated ingredient in the recipe caused an unintended chemical reaction, producing iron ferrocyanide. To Diesbach, this chemical was uninteresting except for its distinct shade of blue, which he astutely marketed as an economical alternative to the expensive ultramarine.

Over a century later, the British engineer and inventor Joseph Whitworth used the same Prussian blue to create engineer's blue, a type of grease which, when applied to metal where perfectly flat surfaces are required, can highlight tiny imperfections for correction. This invention dramatically aided in the development of high-precision instrumentation.

Then, in 1842, chemist John Herschel discovered a photosensitive method for producing Prussian blue. This process was notably useful for the rapid duplication of documents, especially large technical drawings that we now call blueprints. A family friend, botanist Anna Atkins, used Herschel's blueprint method to create images of her algae collection. She self-published these works in the first-ever book with photographs, titled *Photographs of British Algae*.

As if that wasn't enough, Prussian blue is also an effective treatment for heavy metal poisoning caused by thallium and radiocaesium. This means pharmaceutical-grade Prussian blue pigment is even available in pill form.

From revolutionizing the art world as an economical pigment to pioneering advancements in engineering and even serving as a lifesaving medical treatment, Prussian blue has proven its versatility time and again.

(0, 49, 83)

69 TSETSE FLY BLUE

We use pigments to easily spot those who are stranded or in danger, and in the case of white astronaut suits, to reflect deadly sunrays. But what about a color used to distract and entrap another species, and thereby protect human health? Throughout Uganda, this blue is doing just that by luring the dangerous tsetse fly away from humans and toward brightly colored traps lining the rivers.

The tsetse fly has become a dire issue in Uganda and other sub-Saharan African countries, impacting the most impoverished communities: those without access to clean tap water. The tsetse fly is responsible for transmitting a disease through its bite known as sleeping sickness, which leaves the individual suffering with an inability to sleep at night nor stay awake during the day, combined with mental anguish, headaches, joint paint, and severe mood swings. The disease also has a large impact on farming because it can be transmitted to cattle. The dangers the fly poses to the humans and livestock inhabiting these areas required immediate action—which has been taken in the form of large blue traps that line the rivers where these flies breed.

People must venture toward the river to collect water and firewood. Meanwhile, the tsetse flies are seeking out a target that contrasts with the abundant green vegetation lining the river. Bright blue happens to be a strong attractor for tsetse flies due its reflectivity. Dr. Dietmar Steverding at the Norwich Medical School suggests that tsetse flies mistake this shade of blue for shadows as it has a high reflectivity at 460 nm, and the spectral distribution of shadows caps at 460 nm. The tsetse fly eye has peak sensitivity at around 460 nm. These mistaken shadows could appear as the potential underbelly of hosts, their resting spots, or cover for the flies to mate. Large blue cloth traps are draped like flags and lined with fine nets covered in insecticides that kill tsetse flies within three minutes. The tsetse fly population dropped nearly 90 percent in areas using these traps, proving the color is incredibly effective.

(0, 0, 255)

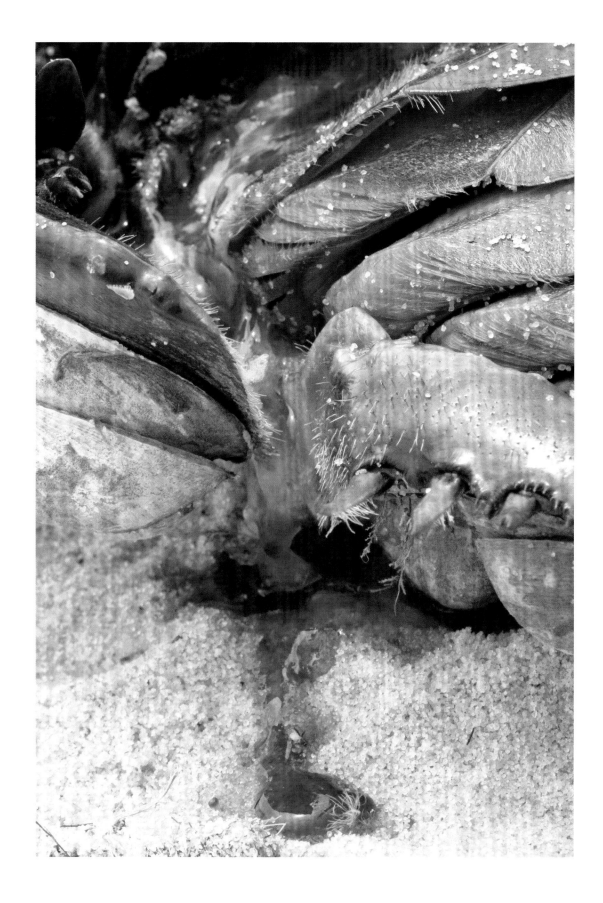

70 HORSESHOE CRAB BLOOD

In a laboratory somewhere, there are rows of horseshoe crabs strapped to a rack, each with a needle slowly drawing the crab's vibrant blue blood, called hemolymph, into a bottle. After a portion is collected, these crabs will be returned to the sea, and the blue liquid will be used to test the safety of human medicine.

The blue color of the crabs' blood comes from the presence of a pigment called hemocyanin, which is similar to the hemoglobin in vertebrate blood, except it uses copper instead of iron to bind to oxygen. When oxygenated, the blood turns blue. Horseshoe crabs aren't the only creatures with blue blood. Insects, spiders, crustaceans, snails, octopuses, and squid all carry this blue pigment in their circulatory systems.

The blue hemolymph of horseshoe crabs is especially prized because it contains a unique component—limulus amoebocyte lysate (LAL). This chemical is considered to be one of the most sensitive and reliable methods for detecting the presence of bacterial endotoxins, which can cause severe reactions in humans and animals. Any vaccine you've had since the 1970s was likely first tested in horseshoe crab hemolymph.

The medical value of hemolymph is substantial, and commercial blood collection can significantly impact horseshoe crab populations, particularly in regions where their populations have declined due to habitat loss and overfishing. To address this, conservation efforts are underway to protect horseshoe crabs and their habitats. Moreover, a synthetic alternative to horseshoe crab hemolymph, known as recombinant Factor C (rFC), has been developed to bypass the need to harvest altogether.

This alternative has recently gained regulatory acceptance, and many conservationists and scientists advocate for a hasty shift to reduce the impact on horseshoe crab populations. Although efforts are underway, transitioning the methodology of the entire pharmaceutical industry, especially in an area as critical as safety testing, is likely to be a long and expensive process.

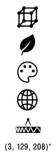

(3, 129, 208)*

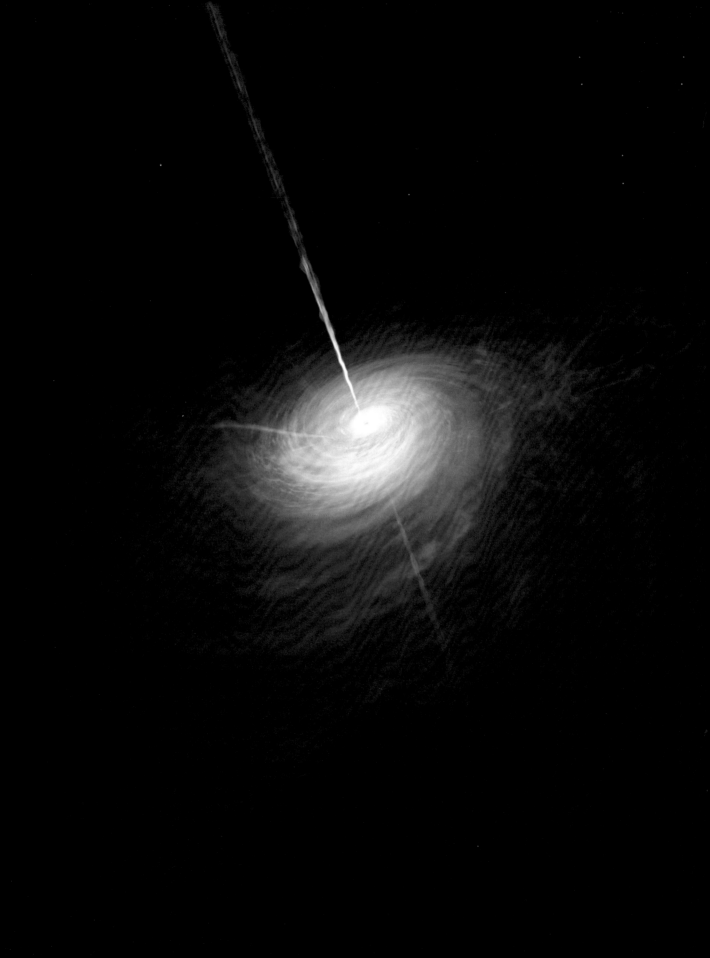

71
QUASAR BLUE

Quasars are the active cores of galaxies powered by supermassive black holes and are among the brightest objects in the known universe. Depending on their stage in evolution, they exhibit different colors.

Initial theories suggested that red quasars were simply blue quasars viewed at a different angle, but a groundbreaking 2019 study by Lizelke Klindt and four others at Durham University's Centre for Extragalactic Astronomy dismissed this idea. According to their findings, red quasars represent a specific stage in the life cycle of a quasar. During this phase, the supermassive black hole at the quasar's core releases enormous amounts of energy. This release occurs outside the event horizon, where gravity is intense but not strong enough to trap light.

This outflow of energy interacts with surrounding dust and gas clouds, briefly causing the quasar to appear red. As the expelled energy disperses these obscuring materials, the quasar's intrinsic blue coloration, which is associated with high temperatures, becomes visible. According to Wien's displacement law, the shorter the wavelength, the higher the temperature. So these blue quasars that illuminate the cosmos with brilliant radiance are declaring their extremely high temperatures.

In essence, quasars are dramatic celestial storytellers. The metamorphosis from red to blue doesn't just indicate a color shift—it's a testament to the dynamic and transformative nature of our cosmos. In their various hues, quasars provide a glimpse into the constant evolution inherent in our vast universe.

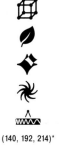

(140, 192, 214)*

Artist's rendering of a high-temperature quasar emitting energy.

72 CIEL

Ciel is one of those perfect pastel sky blues that demands very little from the viewer. It is not vibrant enough to cause excitement nor saturated enough to elicit any concentrated feeling or emotion. It's just soft enough to allow a sense of focus and acuity while contrasting well with other color fields. This is perhaps why it has been so thoroughly embraced by the healthcare field as one of the go-to colors for medical scrubs.

The adoption of scrubs is relatively recent, though. The tragedy and toll of the 1918 flu pandemic really highlighted a need for a better understanding of hygienic practices. Doctors began wearing masks to protect themselves, and twenty years after that, the medical community would come to better understand the science of wound infection within the patient. It wouldn't be until the 1940s before scrubs were utilized alongside advances in surgical antisepsis.

Around this time, a doctor or surgeon would have donned all white to portray cleanliness and health, but it was soon realized that an operating room filled with bright white clothing could be visually distracting. In the same way you see the outline of a light bulb hovering in your vision after averting your gaze, a surgeon might still see the bright white gown of their colleague hovering over the dark red field they were supposed to be operating on. The few seconds it took for the surgeon to re-adjust their vision throughout the operation could prove crucial and possibly fatal, so the medical field adopted a color that was less bright yet equally distinguishable from red: ciel. It didn't refract light nearly as brightly as pure white and was far enough from red on the color spectrum that it could still be distinguishable, helping improve doctors' eyesight and focus.

(119, 181, 254)*

73 EGYPTIAN BLUE

Egyptian blue, a captivating pigment, has a rich story that begins with the distinction of being the first known synthetic color in human history, dating back to the third millennium BCE. This vibrant azure adorned the monuments of the pharaohs as a symbol of the sky, water, and the river Nile. But beyond its historical significance, Egyptian blue possesses fascinating optical properties.

The pigment is produced by heating quartz, copper, alkali, and lime at temperatures up to 982 degrees Celsius (1800 degrees Fahrenheit) for several hours before grinding the product into powder. As simple as it may sound, this knowledge was lost for nearly 1,000 years, until scientists were able to reverse engineer known samples in the 1800s.

In normal light, it possess a soft matte blue appearance. However, under infrared light, Egyptian blue becomes intensely fluorescent, emitting infrared radiation more powerfully than any other known material. This unusual characteristic, unknown to Ancient Egyptians, makes it detectable by modern infrared imagery and helpful in identifying archaeological sites that were once abundant in this pigment.

Modern science has been quick to recognize its unique value. Today the blue's remarkable infrared properties are being explored for use in communication technologies, where it could serve to boost signal strength, facilitating faster and more efficient data transmission.

Egyptian blue's journey from ancient civilizations to the cutting-edge laboratory of today represents a fusion of past and future, a testament to the unanticipated path of scientific discovery.

(16, 52, 166)

Bas-relief sculpture in the temple of the goddess Hathor at Dendera, Egypt, constructed in the late Ptolemaic period.

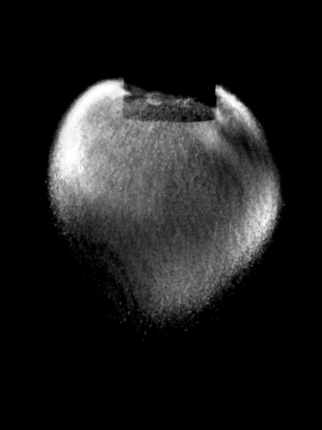

74 SONO- LUMINESCENCE

In a discussion of the spectrum of light and color that pervades the natural world, you may not expect a color created by sound, but that's exactly the case for the peculiar phenomenon of sonoluminescence.

The process involves flashes of light emitted from tiny gas bubbles trapped in a liquid when subjected to intense sound waves. The colors observed in sonoluminescence range from blue to ultraviolet. This is attributed to the blackbody radiation emitted by the hot gas inside the bubble, where higher temperatures produce shorter wavelength (bluer) light.

Sonoluminescence was first observed at the University of Cologne in 1934. This discovery was made after a series of experiments were conducted to hasten the development process of film photography. Ultrasound transducers were placed in a bath of developer fluid, which left small specks on the film afterward. It was deduced that tiny points of light were somehow produced during these experiments. The reason for this luminescence lies in the extreme conditions created within the bubble during its implosion. As the pressure of the sound waves squeezes, the gas inside compresses rapidly, leading to a significant increase in temperature and pressure. The heat within the imploding bubble can match those experienced on the surface of the sun—up to 20,000 Kelvin. That's enough to excite the atoms and molecules in the gas, causing them to emit a tiny flash of light, observable as a faint blue glow.

(46, 125, 251)*

Above: Sonoluminescence, bluish dot at center, in a NASA test apparatus.

Left: Magnified view of an underwater air bubble emitting light midexplosion.

75 CHERENKOV RADIATION

Everything in our universe is bound by strict physical laws. Sometimes phenomena occur that appear to violate these laws. However, after careful observation, physicists always find that physical laws can be bent—but never broken.

One such phenomenon is Cherenkov radiation, named after Soviet scientist Pavel Cherenkov, who first described it in 1934. Cherenkov radiation occurs when radioactive particles travel faster than light in a medium like water. Perhaps the most well-known physical law is that nothing can travel faster than the speed of light, but this rule applies to light in a vacuum. Traveling through denser media can reduce the speed of light. The speed of light through water is 75 percent of that in a vacuum.

In nuclear reactors, where Cherenkov radiation is often observed, charged particles from the reactor travel through the cooling water faster than this reduced speed of light. These particles crash through water molecules, displacing electrons in their path, causing the electric field within the substance to oscillate. As excited electrons in the medium return to their ground state, they emit excess energy in the form of photons. These photons are scattered at longer wavelengths than the original light, rendering them visible to the human eye as blue light—a beautiful, tangible manifestation of this phenomenon.

The blue glow of Cherenkov radiation emitted from an underwater nuclear reactor.

(11, 140, 197)

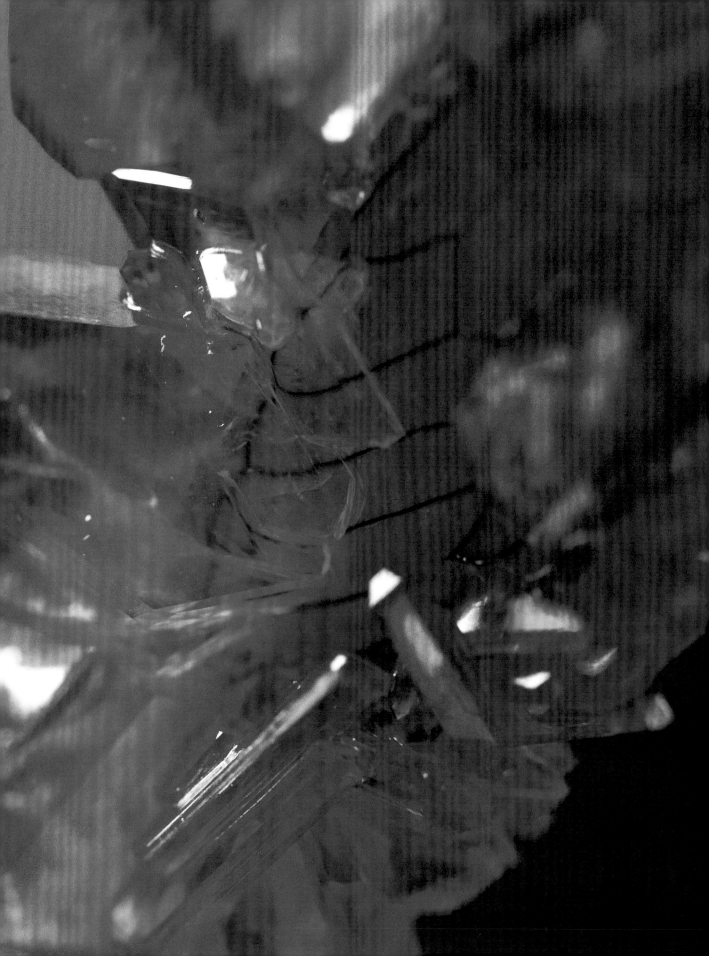

76 CHALCANTHITE

Let's take a look at chalcanthite, better known as copper sulfate, a water-soluble mineral capable of disassociating its ions and recrystallizing when the proper conditions arise. Chalcanthite is a bright-blue, sometimes blue-green, mineral consisting of a copper ion, a sulfate polyatomic ion (an ion with multiple atoms), and water molecules in its hydrated state, which are responsible for a specimen's clarity and vivid color. In its dehydrated state, a crystal of copper sulfate would appear dull and chalky and prone to crumbling into a toxic powder.

Chalcanthite is fairly quick-forming in both a controlled environment like a lab and as a byproduct from mining. The water, tailings, and runoff from copper ore mine operations can eventually become saturated with dissolved copper sulfate and will form crystals along surfaces such as beams and rafters and on discarded tools as the water evaporates. Within the United States, chalcanthite can be found in abandoned mines in arid regions like Arizona.

Despite its bright and enticing blue appearance, copper sulfate is considered toxic to living organisms, and if crystallized at home or in a school setting, it should be handled with that in mind. Copper sulfate is utilized by the agriculture industry as an herbicide and fungicide and is also used as a root killer in drain systems. Although it can possess a crystalline form, it is water soluble—unlike other naturally occurring minerals like quartz or amethyst—meaning the structure can be broken down and absorbed into the body. If you ever have the pleasure of seeing and handling these bright-blue minerals make a note to do so with gloves or wash your hands thoroughly afterward.

Preserved cicada wing crystallized with chalcanthite.

(0, 99, 235)

77
YINMN BLUE

YInMn blue is the kind of blue that makes its viewer question whether they have ever actually seen blue before. Outside of a few rarely occurring natural examples, humankind would be hard-pressed to find such a powerful and pure example of the color blue on our planet.

The name is pronounced "yin min" and is short for yttrium, indium, and manganese, the atoms that make up the material. This color was accidentally discovered by professor Mas Subramanian and graduate student Andrew E. Smith at Oregon State University. Smith was tasked with heating $YInO_3$ and $YMnO_3$ in an effort to synthesize a multiferroic material capable of exhibiting more than one ferroic property, such as an adjustable electric polarization or magnetization. When these oxides were heated to 1093 degrees Celsius (1999 degrees Fahrenheit), the surprise result was an award-winning blue solid. This eye-pulsing discovery would go on to challenge historically popular blues such as Prussian blue (page 151) and cobalt blue, both of which are vibrant but not the most durable blues the universe has to offer. YInMn blue is both incredible stable and nontoxic, while cobalt blue is a known carcinogen. In 2015 the Shepherd Color Company received the license to produce and sell this pigment, making it available for artists and manufacturers to utilize.

YInMn blue is interesting because it doesn't just serve a visual function but also a practical one. The hexagonal crystal structure of this compound makes it highly reflective of infrared radiation, bouncing heat and energy off a surface rather than absorbing it, making this color an amazing tool for energy-saving coatings. This blue discovery has quickly found its way into the plastics, coatings, and art industries, where its potential will likely expand within our lifetime.

(48, 106, 192)

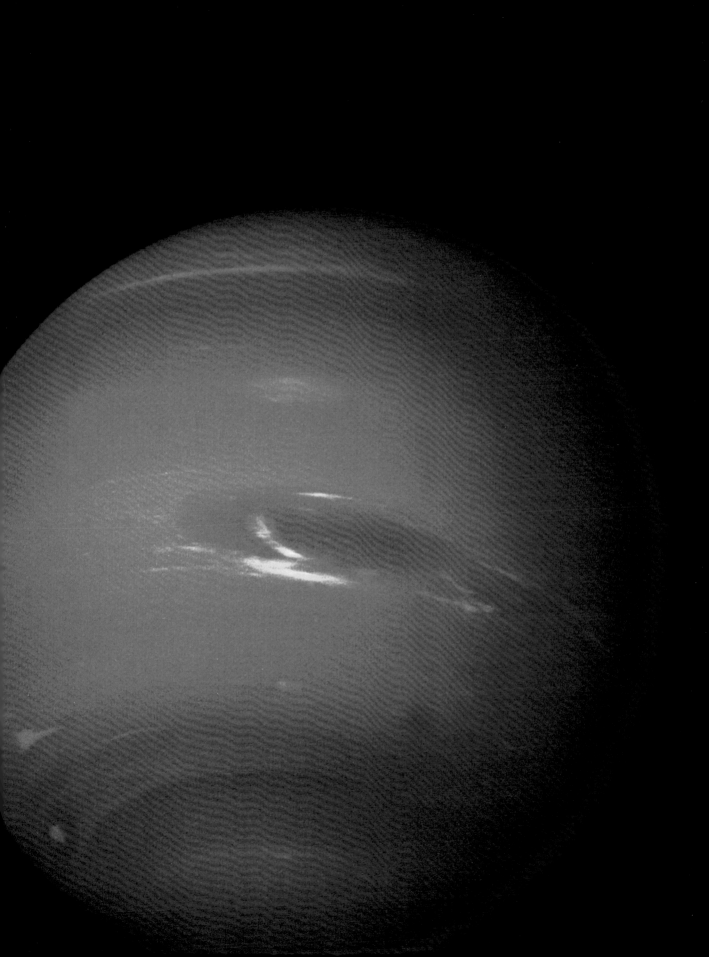

78
ICE GIANTS

Neptune and Uranus are the most distant known planets orbiting our sun. Their striking blue colors led to them being named after the Roman god of the sea and the Greek god of the sky, respectively. Together they are known as the ice giants, a term that refers not just to their generally colder cloud-top temperatures and lower thermal activity compared to the gas giants, Jupiter and Saturn, but also to their distinct composition.

Unlike gas giants, which are predominantly made up of hydrogen and helium, ice giants have a substantial presence of ice-forming molecules like water, ammonia, and methane. These substances exist in gaseous form in the planets' outer envelopes and may exist as high-pressure ices or fluids deeper inside. But the giants' rich blue is not due to a liquid sea—rather, it's the presence of methane in their dense atmospheres, which absorbs wavelengths in the red end of the visible spectrum. Methane is officially described as a colorless gas on Earth, but that's because its ability to reflect and scatter blue light is only observable over great distances.

Uranus shares a similar atmospheric composition to Neptune, but its color is slightly paler blue. This is because its atmosphere is less turbulent than Neptune's, resulting in a thick layer of haze that obscures the rich blue color. Neptune doesn't form this haze since it has the highest-measured wind speeds in the entire solar system at over 1,200 miles per hour (2,000 km per hour).

The planet Neptune photographed by the spacecraft *Voyager 2* in 1989.

(101, 150, 234)

79
NAVY BLUE

The science behind colors is important, not only so we can understand their origins and interactions with the physical universe but also to understand their effects on our minds. Color often plays a subtle role in mood, appetite, and even mental health. The color of the spaces we inhabit tug on our senses in ways we may not immediately notice. But what if we were to engage with color in ways that not only affect our nervous systems, but support them?

There have been several studies regarding how certain colors make humans feel. Reds typically excite us (and perhaps make us hungry). Greens and blues calm us and encourage us to slow down. One study found that a specific blue, navy blue, just might be the most relaxing color in the world. After polling over 26,000 participants from more than 100 countries, the University of Sussex found that a large amount of those polled declared that navy blue was considered "relaxing." Now, we understand that this is a broad statement and doesn't account for cultural, generational, or environmental differences, but it's worth taking note.

When discussing mental health, this sort of information can inspire some useful questions. How would your bedroom feel coated in a wash of dark blues as opposed to, say, scorched-earth orange? How can we use this information to enhance our rest and protect the comfort that certain parts of our living spaces are designed to offer? Blues remind us of tranquil natural elements: running water, an endless sky, and vast horizons. Navy blue takes it a step further—its light-absorbing nature makes it easy to look at. The color is relaxing because there's less information to process and less interaction required of us. Our brains and eyes aren't bombarded by reflected light. Our senses are calmed and therefore we are calmed.

Remember this dynamic the next time you feel in need of a reset for your nervous system, and consider a visual retreat to a still ocean, a clear night sky, or a room painted in a deep navy blue.

(0, 0, 128)

80 BLACKLIGHT

Wavelengths that can be defined as colors are usually limited to those that are visible to humans. Despite this, there are some wavelengths that we can't see but are visible or detectable by other creatures and play an important role in many of the colors we can see.

Ultraviolet (UV) light is a range of electromagnetic waves that exist just beyond the bounds of human visibility. As the name suggests, light in this range of frequencies is a step beyond violet in the light spectrum. Despite the characteristic violet glow of black lights, ultraviolet light is invisible to human eyes. We don't possess the receptors to perceive this kind of energy. The violet light you see from a black light isn't actually UV, but that doesn't mean UV light isn't also being emitted. Black lights emit a range of wavelengths, from the visible violet extending into the ultraviolet range. This is because there isn't a specific cutoff in the spectrum between violet and ultraviolet; instead, the difference in ranges lies in the human photoreceptor capability. The shortest wavelength of light detectable to the human eye is generally considered to be around 380 nm. So we define any shorter, unseen wavelengths as ultraviolet. (For more on spectral ranges, see page xx.)

Many animals, including bees and some birds, can see UV light. This ability opens up a unique visual world and provides them advantages, like detecting hidden patterns on flowers for pollination or using UV-reflective feathers for mate selection. In aquatic ecosystems, some fish species also use UV perception for tasks like prey detection.

Within the UV range, there are four subranges based on their potential effects. UVA is the least powerful or harmful and is used for black lights and other optical effects. UVB is associated with sunburns and an increased risk of skin cancer. UVC is even more harmful and commonly used as a disinfectant since it can destroy cells easily. VUV, also called vacuum UV or extreme UV, cannot penetrate our atmosphere.

A Gerbera daisy viewed under UV light.

(107, 50, 255)*

81
HAN PURPLE

Around 3,000 years ago, people in China crushed together crystals containing barium and copper with silica (sand) and cooked it with lead salt around 900 degrees Celsius (1652 degrees Fahrenheit) to produce one of humanity's first pigments. This barium copper silicate ($BaCuSi_2O_6$), also known as Han purple, is now iconic of art of the region spanning multiple dynasties, peaking during the Han dynasty of 206 BCE to 220 CE after which it is named. But this pigment is more than it appears. It turns out that the unique combination of materials holds some special properties related to quantum physics and superconductivity.

Researchers have discovered that when Han purple is exposed to an intense magnetic field—about 800,000 times stronger than Earth's—and cooled to near absolute zero, it transforms into a state of matter called a Bose-Einstein condensate. In this form, particles collapse into a single quantum state, displaying unusual properties such as superfluidity, zero viscosity, and the ability for multiple particles to exist in the same place at the same time.

But Han purple doesn't stop there. Scientists have also found a way to reduce the magnetic spatial dimensions of the pigment, causing the layers of atoms to stop behaving in three dimensions. Instead, they act more like a magnet in a two-dimensional plane—a phenomenon never before observed in any other material. These findings could pave the way for innovations in superconductive material design.

Detail of a mural from an eastern Han tomb.

(82, 24, 250)

82 TYRIAN PURPLE

Extreme measures were often needed to bring purple into human hands, which is why historically its use was often reserved for royalty, the wealthy, or ceremonial purposes. Tyrian purple is no exception—it was made at the expense of predatory sea snails.

Tyrian purple (also known as imperial purple or royal purple) was among the most expensive and intensive dyes to create. Tens of thousands of snails were required to produce just a couple grams of the raw dye, which was only enough to color a single trim for a garment, making it incredibly costly. It was said that a cloth stained with this pigment fetched its weight in silver. This color became such a powerful status symbol in Rome that just like imperial yellow (page 99), it too was eventually reserved for the emperor.

To make the dye, predatory sea snail mucus, the base ingredient, had to be procured. The snails secrete the mucus to sedate prey and coat their eggs—or when prodded by humans. The two methods for extracting this mucus were either through "milking" (the more renewable option) or by crushing the snail itself. The freshness of the dye was critical to creating the deep purples and burgundies it was known for, meaning most of the extraction had to occur as close to the snail's site as possible.

In November 2020, a team led by Byung-Gee Kim at Seoul National University was able to synthesize 6,6'-dibromoindigo, which is the molecule responsible for Tyrian purple. This was done by essentially tricking *Escherichia coli* bacteria into producing the molecule through engineering three separate enzymes into the bacteria and then centrifuging the 6,6'-dibromoindigo into compacted pellets that can be applied to fabrics—instead of annihilating thousands of snails.

(102, 2, 60)*

Underside view of the regal murex sea snail.

83
AMETHYST

If there's one thing that sets a mineral apart from its counterparts, it's impurities. We can take an entire group of minerals, all comprised of the same base arrangement and molecules, and the simple addition of a few impurities will produce a beautiful collection of unique specimens. Take SiO_2 for example, better known as quartz. In its purified form it appears colorless, with pristine glasslike clarity. But if you add trace amounts of irradiated iron, you get a syrupy-rich purple amethyst.

While impurities taint the perfect molecular structure of the crystalline network, they have a profound effect on the final result, often leading to brilliant colors and appearances distinctly different from their purified counterparts. The varying amount of iron present can determine just how saturated and purple the crystal appears, shifting from lighter pinks and lavenders to a near-black purple with even hints of red.

Something surprising happens when amethyst is heated: between 800 to 900 degrees Fahrenheit, the amethyst will shift to resemble the orange-yellow mineral citrine, which is incredibly rare to find in nature. This is because the conditions to produce amethyst must be readily available, as well as the process of heating naturally occurring amethyst without destroying it. Most citrine found at gem and mineral stores is heat-treated by humans to shift those iconic purple hues to yellows and oranges.

Geographically, amethyst has been known to form all around the world from Brazil to the Unites States to South Korea. This is largely due to the overall abundance of silicon in the earth's crust. Prior to the nineteenth century and the discovery of abundant deposits across South America, amethyst was considered rare, on par with precious gems like diamonds and rubies. Nowadays amethyst is so abundantly mined that it's a staple in many amateur gem collections. We can afford to carve this formerly precious mineral into little trinkets and knickknacks that are destined to pass from estate sale to estate sale until the last light of the universe fades.

(119, 65, 168)*

84 GENTIAN VIOLET

Some things just work. We don't know how they work, but they do. Gentian violet, also called crystal violet, falls into this category. This vibrant dye has been valued for its antifungal and antibacterial properties since 1861. However, despite the many hypotheses put forward over the years, the exact mechanism of its antimicrobial effects remains unknown.

The dye, chemically known as hexamethyl pararosaniline chloride, is synthesized through complex chemical reactions that yield violet-colored crystals. These crystals can be dissolved in water or alcohol to produce a vivid purple solution.

In the late nineteenth century, Albert Ritter von Mosetig-Moorhof, a surgeon in Vienna, reported successfully treating two cases of sarcoma with the dye, predating its use as a treatment of malignant melanoma by over 120 years. It then became widely adopted for use in a variety of ailments including trench mouth, thrush, and impetigo. As an antiseptic, it has largely been replaced by modern drugs; however, the rise in antibiotic resistance has triggered a recent resurgence in its use.

Probably the most common use of gentian violet is for histological staining. In 1884, Hans Christian Gram discovered that this dye was ideal for classifying microscopic bacteria into one of two broad categories based on their cell wall properties. It became the basis of the Gram stain procedure, a method still widely used for preliminary identification of bacterial organisms.

(119, 105, 150)

Yeast stained with gentian violet viewed under a microscope.

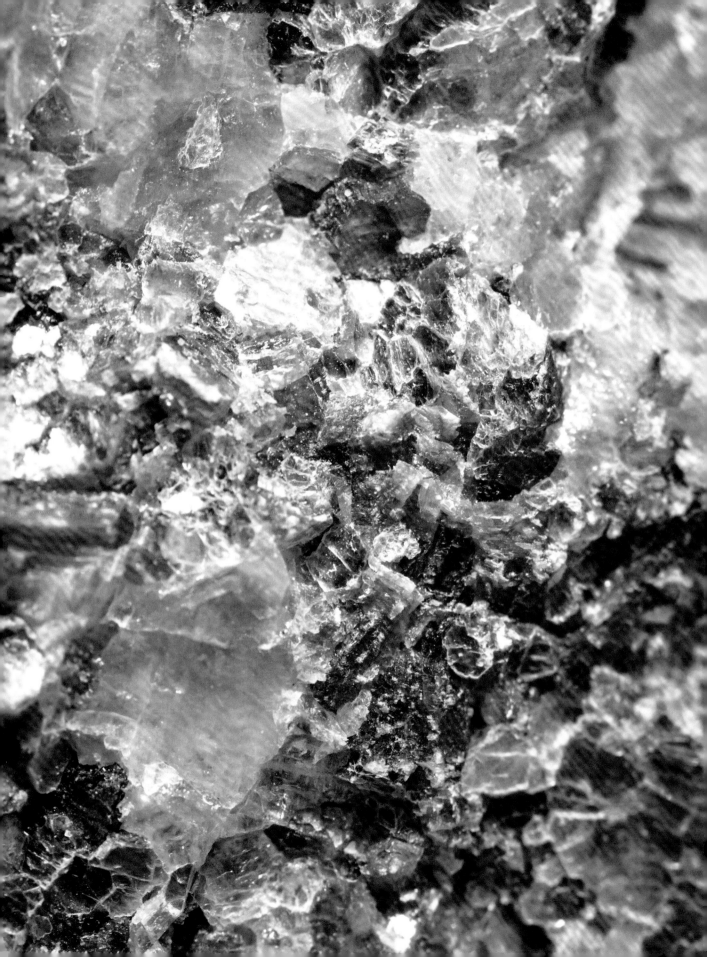

85 LEPIDOLITE

When you plug in an electronic device or your car, you probably don't imagine lilac-colored crystals charging up your tech. Yet lepidolite is the most abundant lithium-bearing mineral on Earth and a major source of not only lithium for batteries, but also the elements rubidium and cesium. In fact, rubidium was discovered in 1861 when German scientists Robert Bunsen and Gustav Kirchhoff were analyzing lepidolite and observed unique emission lines that led to the identification of this new element.

The color of lepidolite can vary from pink to purple depending on the manganese content. Lepidolite is considered a relatively rare mineral since the geochemical conditions and high concentrations of lithium required for its formation seldom occur. Looking at a periodic table, you'll find lithium near the top with an atomic number of 3. This means lithium ions are very small, and as a result, tend to form minerals late in the crystallization of magma. Over the course of eons, the residual fluids in magma become progressively more concentrated with lithium until lepidolite is finally able to form. When it does, lepidolite crystallizes into layered mica sheets separated by potassium ions.

The current methods of lithium extraction from lepidolite generate significant waste—approximately 200 tons for every ton of usable lithium. This raises environmental concerns, particularly the risk of water pollution in areas hosting extraction facilities. As lithium's demand escalates, driven by the proliferation of electric vehicles, the urgency for more sustainable extraction methods or alternative battery technologies likewise intensifies.

The intricate geological process that takes place over thousands of years now allows us to power our everyday lives. Who would have guessed a rock could hold such potential.

(187, 160, 193)

86 MAUVEINE

Mauveine, or Perkin's mauve, is born from the wondrous realm of accidents. Chemist William Henry Perkin stumbled upon this enticing pigment while trying to create a treatment for malaria. So many useful things have been discovered on the way to a loftier goal.

In 1856, at the age of eighteen, Perkin took on an assignment from his professor to attempt to synthesize quinine, the malaria drug of choice at the time. After repeated attempts, one of the failed samples left behind a black residue with bright purple remnants. Perkin immediately noted the unique potential of his accidental discovery and spearheaded its production. It quickly spread through the fashion and textile industry, with popularity soaring for nearly a decade before it was eventually replaced with similar synthetic dyes that came without the risk of working with aniline, a necessary component in synthesizing mauveine. (Exposure to the compound was observed to increase the risk of bladder cancer.)

Mauveine is known as one of the earliest lab-made synthetic dyes in history and helped pave a path for the synthetic dye industry as a whole. The possibilities and potential of synthetic dyes outshined the capabilities of natural pigments and soon overtook the market. Only twelve years after the creation of mauveine, there were over fifty producers of synthetic dyes all racing to create and offer their colors as cheaply and widely as possible, forever changing how we interact with, create, and ultimately profit from color.

(143, 101, 142)

The word *mauve* was derived from the Malva (mallow) flower.

87 PURPLEHEART

Purpleheart is a group of trees of the *Peltogyne* genus native to the tropical regions of Central and South America. They are primarily found in the high-moisture rainforests within Amazonia. These trees are known for their distinctive purple heartwood, which is not only beautiful but also prized for its durability and natural resistance to decay and insects.

Freshly cut purpleheart wood starts out as a pale gray-brown color. As it is exposed to light and air over a few days, the heartwood's natural pigments develop into a rich purple. The oxidation process behind the color change is similar to how a cut apple or avocado browns when exposed to air. The compounds responsible for purpleheart's unique color are akin to the tannins or lignins found in all types of wood, but the exact makeup of these compounds isn't fully understood yet.

Over time, the wood will continue to darken to a ruddy brown. To slow this change and preserve the desired purple color, items made from this wood are often coated with a UV-inhibiting finish. The specific shade and intensity can range from wine-red to eggplant to true violet depending on the species, growing conditions, and location.

Purpleheart's unique color, combined with its durability, has made it a sought-after material in a variety of applications, including fine furniture, flooring, and artistic pieces.

(165, 81, 95)*

88
AVOCADO DYE

Some of the most intriguing colors are ones that defy expectation. Let's take avocados for example: a pale green fruit whose usefulness isn't bound to the culinary world. The pit of an avocado is responsible for producing a soft blushful pink that contrasts almost too well with its pale green flesh.

When broken down, the pit releases an explosion of naturally occurring compounds known as tannins. These molecules are abundant in nature and can be leached from plant materials such as bark, seeds, and leaves. When boiled, avocado pits let go a reddish-brown tannin that can be used to dye fabric. After saturating a white fabric or color field, the earthy-red liquid can transform into a soft and natural pink similar to the popular millennial pink

Coincidentally, tannins also act as a natural mordant—meaning that they form complex connections to cellulose, essentially binding them incredibly well to natural fabrics like cotton, and making the addition of other mordants unnecessary in the dyeing process. Instead of tossing overripe avocados, consider scraping and salvaging the skin and stone, giving them a good rinse, and then using them to dye some fibers.

(86, 130, 3)*

89 MAGENTA

Beyond the rainbow of pure spectral colors exists an infinite sea of extraspectral colors. These colors are broad-gradient spectral colors blended with neutrals, resulting in shades, tones, and tints that are intrinsically less vivid than those that appear in the rainbow. Yet there is one remarkable exception that defies this drab categorization: magenta.

Unlike other extraspectral colors, magenta is a mixture of pure spectral colors that results in a hue just as vibrant as the ones in the rainbow. Magenta light is created by our brains when we perceive both ends of the visible spectrum—red and blue—simultaneously. However, these two colors occur at opposite ends of the rainbow, beyond which lie the invisible regions of infrared and ultraviolet, respectively. If you could loop the colors of a rainbow into a circle so the red and blue merged, the result would be a color wheel with magenta. Isaac Newton, the father of optics himself, illustrated the first color wheel in this exact manner. When he presented his experiments proving that white light is made of a full rainbow of colors in his 1704 book *Opticks*, he instinctively connected blue to red.

Even though it is made of spectral colors, since magenta doesn't exist on the electromagnetic spectrum, it has no corresponding wavelength, the property that tethers a color to the physical realm. In this sense, some argue that magenta doesn't exist; however, since we can perceive it, the counterargument could be made that it must exist—or perhaps, that no colors truly exist at all.

(255, 0, 255)

Above (left): The spectral hues are pure colors with a wavelength in the electromagnetic spectrum. These can be made without mixing any other colors.

Above (right): Magenta results from blending the opposite ends of the visible spectrum.

Left: Celosia flower.

90
ASTAXANTHIN

Some colors arise directly from a single molecule so potent that it can pass through and lend its brilliance to multiple bodies before breaking down. A bright-pink food chain will pass along astaxanthins to each successive consumer before decomposing into atoms that find a new composition and function.

Astaxanthins belong in the pigment group xanthophylls. Their appearance in nature is an illustration of an entire system constantly unfolding on our planet, one in which a life-form consumes another to sustain itself. First, algae synthesize astaxanthins (alongside many other pigments). The algae is then consumed by shellfish and crustaceans, where it can appear as a dull to soft pinkish orange as it's stored in the body. Those critters are consumed by larger animals, such as salmon and flamingos, in great quantities. There the molecule becomes further concentrated and stored to result in a powerful palette of bright orangish pinks. Without the presence of the astaxanthins, both salmon and flamingos would appear white. Captive and zoo-raised flamingos require a human-curated diet with these molecules to help them retain the pink color that park guests expect, and salmon that are tank-raised and farmed also require fish feed with artificially added pigment molecules to aid in consumer recognition. In a natural environment, these pigments are ever present and make up part of a rainbow of color that begins at the base of the food chain.

Flamingo feathers.

(207, 35, 2)*

91 BAKER-MILLER PINK

Imagine arriving at a prison expecting drab and gloomy colors only to be greeted by walls adorned in a most delightful shade of vibrant pink. As odd as it might seem, this is exactly what you'll find in the holding cells of many correctional facilities and police stations around the world.

In the late 1970s, researchers proposed that this specific bubblegum hue could trigger physiological responses that result in a calming effect. It was named Baker-Miller pink after the directors of a correctional facility who, after being so impressed with the initial reports, allowed their holding cells to be repainted in an experiment to record the color's effects on prisoners.

Preliminary results indeed reflected a slight reduction in violent episodes, and prisons around the world began painting holding cells and intake rooms in this color hoping to calm aggressive prisoners. Some football stadiums even painted the visiting team's locker room pink in hopes of pacifying opponents.

However, the initiative was met with some criticism. Some male inmates claimed they were being subjected to a form of humiliation due to the societal association of pink with femininity. The use of the color, they argued, played on gender stereotypes in an attempt to emasculate them.

Later studies suggested the calming effect was temporary and may have simply been a response to the novelty of the color in these settings rather than the color itself. Despite the criticisms and subsequent research, many cells still have pink walls to this day, standing as a relic of a well-intentioned but disputed experiment.

(251, 143, 171)

92 RUBY CHOCOLATE

The world has dark chocolate, milk chocolate, white chocolate, and as of recently, the new innovation called ruby chocolate, a pastel rosy-pink chocolate that some have coined the "fourth variety." It was unveiled in 2017 by Belgian Swiss cocoa company Barry Callebaut with a flavor profile distinct from other chocolates, often described as being sweet and sour, a little acidic and reminiscent of raspberries (which fittingly matches its color profile).

The process for creating ruby chocolate is mostly protected under patent, but there are a few details available to share: unfermented ruby cocoa beans are treated with an acid, such as citric acid, degreased, and then ground up and combined with sugar and dairy. A combination of this process and the natural red color of the cocoa beans results in the chocolate's iconic pink. Pinks are often associated with things that bring delight, like sweets, flowers, and spring. These associations with pastel pinks made the introduction of the chocolate an immediate sensation with companies all around the world vying to add the confectionary to their menu.

Still, hype and debate over whether or not this was an actual chocolate variety unfolded, with some claiming its origins weren't distinct enough. Taste tests were also conducted and found that of the four chocolates, ruby chocolate was the least preferred, most likely due to its intense and surprising flavor profile, unlike the other varieties of chocolate. Whether or not you enjoy the taste of ruby chocolate, much of its success and marketing can be attributed to its most salient quality—its color.

(188, 103, 110)

93 HYDRANGEA PINK

Hydrangeas are proof that grandmas around the world are no strangers to science. When a hydrangea's petals are pink, that color has been chosen and maintained by gardeners through intentional manipulation of the soil's pH.

Many hydrangea species are thought to originate in Japan, where their cultivation spread to neighboring Asian countries. The mass obsession for this plant didn't blossom, however, until physician Carl Peter Thunberg sought them out for medicinal purposes in the eighteenth century. As is the case with many plants that made their way to Europe, hydrangeas were acquired through not entirely honest means and were even poached via plant hunters hired by the Veitch Nursery of Exeter, England. The acquired specimens were then cultivated into the showier yard plants commonly seen today.

A fascinating property of the hydrangea is its ability to essentially function as a soil-pH indicator through color shifting. This phenomenon isn't shared among all hydrangea species and can only be observed if the flowers already possess a color (white hydrangeas typically stay white despite pH changes). More acidic soil yields blue flowers, while more alkaline soil yields reds and pinks; purple tones appear in soils with a more neutral pH.

On a molecular level, as the pH of the soil changes, so does the structure of the plant's anthocyanin molecules. This structural change shifts how light interacts with these molecules, in turn shifting which wavelengths of the visible spectrum get reflected back at the viewer. In an acidic environment, anthocyanins are protonated, meaning they possess additional hydrogen atoms that allow the molecules to absorb blue and green light, leaving reds to be observed by the human eye. When the environment becomes alkaline, the anthocyanins lose that additional hydrogen, not only changing the structure of the molecule but how it absorbs light, making blues and purples observable. (For more on anthocyanins, see page 19.)

This amazing phenomenon that visually demonstrates the intricate relationship between a living organism's very molecules and the environment in which it lays its roots has won many home and garden tours through horticultural history. The average hobbyist can even purchase aluminum-based mixtures to intentionally alter the color of their garden's hydrangeas, almost like giving your yard a paint job, but with chemistry.

(251, 210, 224)*

STRUCTURAL COLORS
Disruptors and Organizers of Light

So far we've discussed molecules capable of absorbing and reflecting visible light, resulting in the visible colors we assign to objects and materials. The innate nature of these molecules means that we can assume that as long as the molecule remains intact, doesn't change states, and there are no contaminants or impurities, it should always produce that same color. But what happens when a neatly arranged repeating array of particles interacts with light instead? In these instances, the arrangement will act as a filter for white light. Perhaps some of the wavelengths are absorbed, but rather than color and light being reflected, the various wavelengths within visible light are diffracted and separated, resulting in dazzling, often multicolored, interactions.

This means that instead of using a dye or pigment to give an object color, we can coat it in nanostructure materials that scatter light. Two examples of light-scattering nanostructures are photonic crystals and photonic glasses.

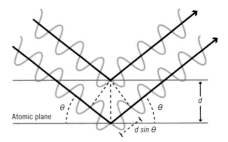

Bragg's Law of Diffraction

A **photonic crystal** is a lattice of well-organized nanoparticles with enough space between each particle to allow certain wavelengths of light to pass through. These are often iridescent and change color depending on the angle viewed. As the photonic crystal is rotated, the nanostructure filters the light in different ways; different angles mean different paths for light to meet the viewer's eyes. Larger particles allow for larger wavelengths to pass through, and smaller particles limit which wavelengths can be filtered through the lattice, as is the case for a mineraloid like opal.

Try a thought experiment that illustrates this: Imagine stacking up three cubic feet of golf balls—these will be the silica nanoparticles. Now drop a handful of marbles (each a different size to represent the different wavelengths of the rainbow of colors) onto the golf balls. The smallest marbles will be able to pass through the matrix. For the lattice to display larger wavelengths of light, you would need to increase the size of the nanoparticles. For example, if the lattice were comprised of both neatly organized bowling balls and golf balls, all perfectly stacked layer by layer, then all sizes of the marbles would be able to pass through at least some part of the matrix.

Photonic glasses are structures that aren't dependent on an angle to observe. They exhibit and diffract the same wavelength of light no matter where they're viewed from. This requires a structure that is a little less organized, such as butterfly wings or peacock feathers.

The mechanism of structural colors was first described in Robert Hooke's *Micrographia*, published in 1665, when detailing his fascination with peacock feathers. He wrote, "The parts of the Feathers of this glorious Bird appear, through the Microscope, no less gaudy then do the whole Feathers; for, as to the naked eye 'tis evident that the stem or quill of each Feather in the tail sends out multitudes of Lateral branches . . . so each of those threads in the Microscope appears a large long body, consisting of a multitude of bright reflecting parts."

What Hooke was acknowledging were the nanostructures responsible for manipulating light, and the fact that an independent feather was capable of such wonder. Everything that excites us about this bird is contained in a single feather. Hooke goes on to

How light interacts inside an individual silica nanoparticle. Different radii of silica result in different wavelengths escaping.

Left: Common opal, consisting of randomly packed silica nanoparticles of various sizes, does not produce brilliant opalescence.

Right: In precious opal, areas of orderly packed silica nanoparticles of similar sizes result in patches of uniform wavelengths.

Wavelength in the range of the particle size are diffracted

Larger particles correspond to longer wavelengths

Particle size determines the wavelength of diffracted light.

acknowledge that mother-of-pearl (nacre) behaves in a similar way, shifting color and light as the viewing angle is changed.

It is possible for an object to be both pigmented and structural. The peacock feather behaves in this way, possessing both melanin for brown pigmentation and the structures responsible for iridescent blues and greens. Some flowers possess reflectivity properties and films due to nanostructures as well as natural pigment molecules like carotenoids. These two mechanisms come together to paint a very complex picture, one in which each mechanism takes on a vital function that other aspects of nature find useful or advantageous.

There are even instances of variable structures, ones that can shift between two different states, drastically changing an object's or animal's appearance, such as the camouflaging mechanism of various cephalopods. Electrical charges will determine how tight or loosely formed a nanostructure is and as a result will determine how that structure scatters light.

The realm of structural color is one of immense possibility and both human and nonhuman creativity. It has inspired technology such as solar cells, light sensors, energy-conserving films, and holds an entire unknown future of amazing creations.

In the following pages, we will highlight just a few of the incredible structural colors the universe has to offer.

The vanes on the scales of the morpho butterfly's wings are spaced approximately half the wavelength of blue light, which is 400–480 nm. As a result, the reflected blue light waves are in phase with each other—meaning their peaks and troughs align to amplify the color—a phenomenon known as constructive interference.

94
OPAL

How fortunate are we to share a planet with such a natural master of color, a wielder of light, a kaleidoscope of countless photonic events: the opal. A labyrinth of filters perfectly designed for organizing visible light into neatly separated categories, this magical mineraloid is capable of displaying a feast of fiery colors.

Opal is interesting in the sense that it isn't just a single color, nor is it really colorful. Rather it can appear as every color given the right arrangement. Opals themselves don't possess color in the sense that a blue-copper-based mineral like azurite or chalcanthite (page 153) might. Instead they take white light and diffract it into distinct and separate wavelengths, displaying those colors almost like an art gallery for the viewer to enjoy. The best part? Those colors and their respective apparent location are unique to the vantage point at which the opal is viewed. The same piece of opal will showcase different colors as it is rotated in the viewer's hand, shifting through every vibrant color of the rainbow.

This is due to the neatly and tightly packed arrangement of silica nanoparticles. When these particles are arranged just right, it leaves the appropriate amount of space between spheres to allow white light to enter and be separated. Different-sized spheres produce different levels of diffraction, allowing larger and larger wavelengths through the lattice due to increased spacing between nanoparticles.

This is how the world's most precious opals behave, the ones that display an entire rainbow spectrum, as all wavelengths of light can pass through the structure.

Above: Tyler Thrasher's lab-grown opal viewed under a scanning electron microscope.

Left: Bands of precious opal diffracting visible light.

95 CYSTOSEIRA TAMARISCIFOLIA

As if our universe wasn't amazing enough, it goes and conjures up a common plant capable of mimicking one of the planet's most prized mineraloids. If you scour the European coasts, you'll stumble across a brown algae seaweed known as *Cystoseira tamariscifolia*, which has an internal structure capable of recreating the colorful light-diffracting properties of precious opal.

Researchers Dr. Ruth Oulton, Professor Martin Cryan, and Dr. Martin Lopez-Garcia unveiled this remarkable discovery in 2018, which opened up a biological treasure trove of technological possibilities. Much like opal, the algae utilizes neatly ordered nanostructures to diffract white light and disperse it into separate wavelengths; in this case layers of blues and greens due to the space between particles. The surprising difference, however, is that opal exists in this state constantly, while *Cystoseira tamariscifolia* is capable of shifting this property into an on-and-off state. When observed in the absence of light, this plant will arrange oil droplets stored alongside its chloroplasts in such a way that they take on a green and blue iridescence. But when hit with direct light, those ordered droplet arrangements are shut off and the plant appears a dark brown. It is believed that this act of light diffraction is a clever mechanism for dispersing what little light there is underwater throughout the rest of the plant.

This dazzling biological ability has nanoparticle scientists pondering about the technological possibilities. What if we could recreate this mechanism in a lab and make self-assembling light sensors or solar cells? An even wilder idea: imagine a home lined with self-replicating, self-healing, self-assembling biological nanostructures that could not only propagate through sunlight but could harness it to power buildings and devices. For now, that might be science fiction, but someday it could be coming home to you.

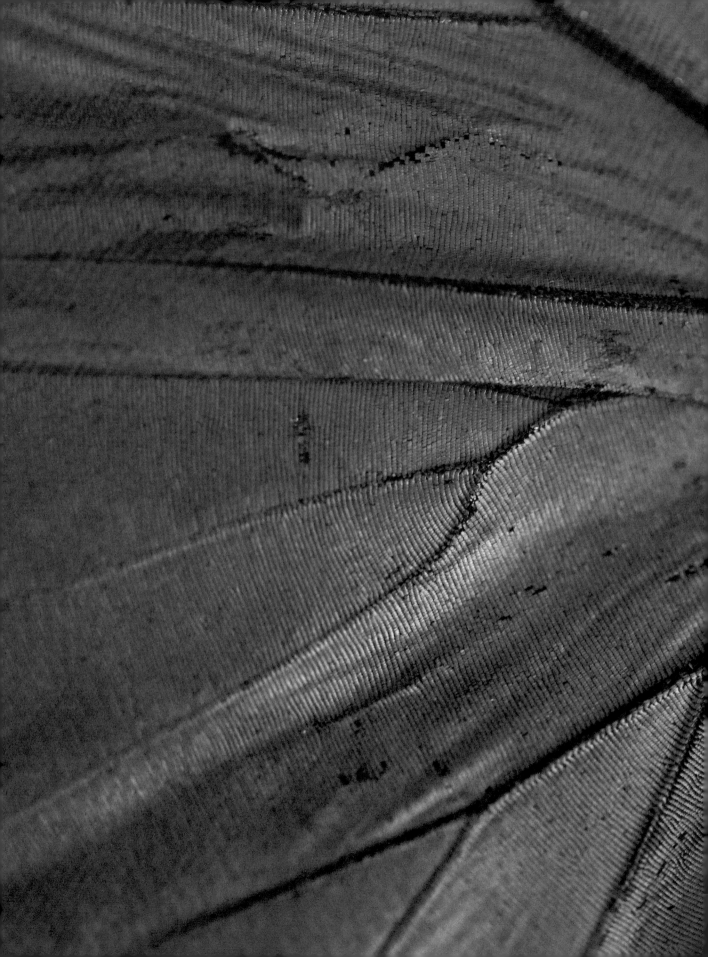

96 GIANT BLUE MORPHO BUTTERFLY

The giant blue morpho butterfly, *Morpho didius*, is a hallmark example of the fascinating behavior of structural colors. Not only does this creature possess one of the most brilliant blues found in nature, but the microscopic arrangement of its wings is something that captivates designers and materials scientists hoping to recreate and utilize its light-interacting properties. *Morpho didius*, native to Central and South America, is one of the largest morpho species and is sexually dimorphic, meaning males and females exhibit separate and identifiable traits. Females have a smaller spread of the structural blue appearance surrounded by a black border along the wings, whereas males have a wider spread of the structural blue coloring.

These wings take on an iridescent, almost metallic, shimmer when interacting with light, resulting in color shifts ranging from a deep saturated blue to the silvery sky blue often reserved for desktop computer backgrounds. To add to the fascination, blue is not the natural pigment of these wings. If the viewer were to illuminate the backside of the butterfly where light couldn't interact with the actual surface structure of the top, they would observe that the natural pigment itself is a dark brown, highlighting the coexistence and difference between the phenomenon of structural colors and pigment-based molecules. The brown pigmentation does assist the shimmery top layer though, as it absorbs the non-blue parts of the visible spectrum.

The iridescence is caused by a multi-layered interaction between light and the scales of the wings on the nanoparticle level. The structure of the wings is comprised of layered cuticle scales with air between each scale. These two components work perfectly together to determine the color and wavelength of light reflected back to the viewer, in this case blue. The thickness of the layers determines which wavelengths are reflected. It takes between six and ten layers to produce the rich vibrancy of this butterfly's blue—to change the thickness or number of layers would result in a completely different color and level of brightness.

(0, 0, 255)

97 MARBLE BERRY

Over millions of years of natural selection, some organisms have developed extreme characteristics to accomplish the simplest tasks. Consider, for example, the shimmery and wonderfully blue *Pollia condensata*, or marble berry. This berry has the distinction of reflecting more polarized light than any other living organism.

This seemingly metallic fruit possesses one of the bluest blues found in nature, which is due to its unique structure coupled with an outer layer that gives the entire fruit a mirrorlike appearance. The reflective and iridescent blue of the marble berry is a structural effect created by layers of cells that refract light in a similar way as some beetle shells and butterfly wings. The color corresponds to the many layers of parallel cellulose fibers, and it is the arrangement of these layers that produces the optical effects. Each layer is rotated relative to the one below it to form a helical stack, which allows the reflected light to be polarized linearly or circularly, in both clockwise and counterclockwise directions, a property that researchers have never observed in any other living tissue.

Additionally, the cell walls behave as small, curved reflectors, mostly reflecting the metallic blue color but also causing any non-blue cells to appear like individual pixels—another property never seen elsewhere in nature.

Why would such complex optical phenomena develop in a berry? Researchers hypothesize that there may be, or may have once been, a species of animal that feeds on these berries that can see circularly polarized light. The plant may have evolved specially to attract that forager in order to distribute its seeds. Marble berries aren't edible to humans, but they are quite sturdy. Even after being removed from the plant, and since their coloration isn't reliant on a pigment molecule that could break down over time, they retain their blue iridescence for years. Due to this durability, marble berries have found human uses in the world of decoration, fashion, and jewelry. It seems likely they'll go on to inspire innovations in the realm of paints and synthetic-color-based coatings.

The arrangement of the layers of cellulose (left) results in the reflection of circularly polarized light (right).

98 OIL OR SOAP & WATER

Ever notice a shimmery concentric rainbow spreading through a parking lot? Or perhaps after a fresh rain you find puddles of rainbows scattered throughout the street? It's mesmerizing but also showcases something we should probably feel guilty about: the polluting remains of oils and lubricants.

If you've ever wondered why a puddle of oil takes on an iridescent appearance as you step over it, this is due to a phenomenon known as thin-film interference. This occurs when two different substances share boundaries and light interacts with that boundary. In the case of oil film, an incredibly thin layer of oil, often only nanometers thick, floats on top of water due to their differing densities (oil being lighter than water). The boundary between the oil and water consists of their respective refractive indexes meeting. The property of refractive index details how much light is refracted and observed by the viewer and how much is absorbed by the medium interacting with light. The colors of an oil film are simply the wavelengths able to escape the stacked differing refractive indexes of both oil and water. This phenomenon falls under structural colors because its color is solely dependent on how the arrangement of the material as a whole interacts with light as opposed to being a single molecule.

The same effect of thin-film interference can be observed in soap bubbles where layers of soap and water meet. The thickness of the layers determines which wavelengths of light are separated and observed through constructive or destructive interference. When wavelengths of light bounce off different layers, some end up traveling a bit farther than others and can either add or subtract when they reconverge, potentially creating new wavelengths with distinct colors along the film of oil or soap.

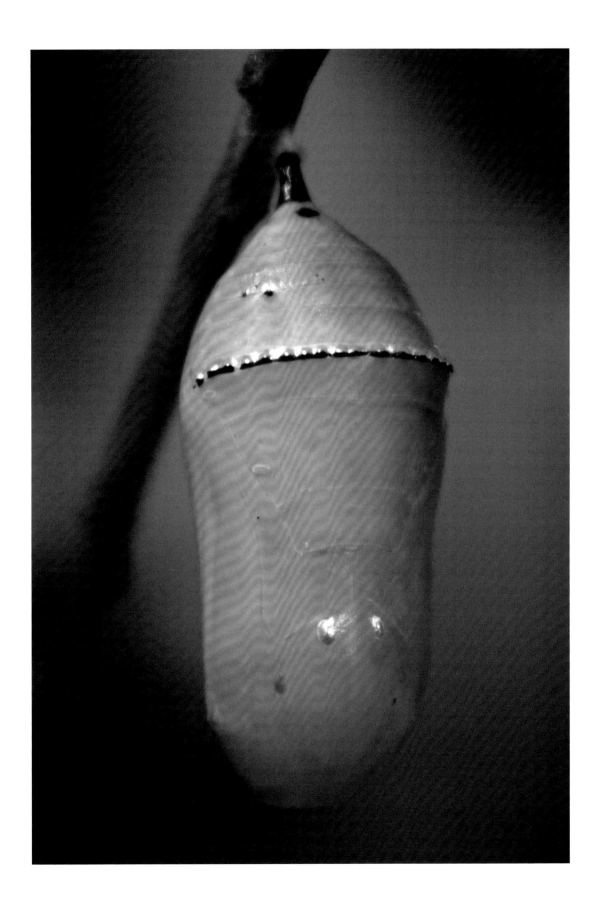

99 MONARCH CHRYSALIS GOLD

A medieval alchemist couldn't be blamed for trying to extract gold from the monarch butterfly's chrysalis. These intriguing multicolored objects are only made more fascinating by the presence of golden adornments along the edges. But while plenty of metals and metal ions are present within living organisms, these gold adornments contain no actual gold. Instead they are a combination of yellow pigmentation and a structural illusion that appears as metallic shimmery gold.

The yellow pigmentation of these spots is due to carotenoids, the same yellow pigment of autumn leaves. The raised areas absorb and reflect light, causing the metallic shimmer. There are a few standing theories regarding the benefit of these little gold adornments, including camouflage and warning predators. The metallic appearance reflects the chrysalis's surroundings, helping hide the vulnerable insect inside. It can also serve as a toxic warning to some predators. Biologist and environmental scientist Dr. Richard Stringer used X-ray technology to better understand the complexity of a monarch chrysalis; he learned learn that the raised gold dots serve as oxygen entry points for the growing butterfly.

Above: Electron microscope image of chrysalis spiracles, which allow oxygen transfer.

100 COLLOIDAL GOLD

At very small scales, materials can exhibit unique properties unseen at larger ones. One such example is colloidal gold, a mixture of gold nanoparticles in a liquid: it can appear as various colors primarily dependent on the size of the gold particles.

In a colloid, minute particles are suspended in a different substance. When gold nanoparticles—too tiny to be seen with the naked eye—are suspended in a liquid like water, the outer electrons of the gold atoms oscillate when irradiated by light. This causes shorter wavelengths of light to be reflected and scattered, while the longer wavelengths are allowed to pass through—a phenomenon called the Tyndall effect. The color of the gold particles can range from red to purple. Smaller particles mostly scatter short wavelengths, such as blue and green. This scattered light, coming in from many angles, gives colloidal gold its intense color.

This nanoscale optical property of colloidal gold has proven useful in a broad range of applications. In the medical field, it is used for targeted imaging, and even drug delivery for cancer treatments. The conductivity of the nanoparticles allows colloidal gold to be made into a printable ink for electrical circuits. Additionally, its sensitivity to environmental factors has led to its use in sensors for detecting gases and ions.

Approximate visible color based on gold nanoparticle size (saturation varies by concentration).

IMPOSSIBLE COLORS
What Are We Missing?

Now that you have an exciting palette of colors and phenomena to reference that spans the universe, we have to add one more wild twist. Unfortunately it's tough to give you a visual example (ironic, given that this is a book about colors), but we will do our best within the limitations of human perception.

Reality doesn't end with our senses, and given the experimental nature of evolution, there was never any guarantee that we humans would develop every tool needed to catalog all of reality. We simply won't get to perceive everything there is to perceive in the universe, but we can speculate about the facets of reality that lie outside the limits of human eyesight. Bear with us and keep an open mind.

You may have heard of impossible colors. (You certainly haven't seen any.) Perhaps in a daydream you have tried to imagine a color you've never seen. What would you experience if extraterrestrial life beamed down a gallon of paint containing a new color? What would it take for humans to experience—let alone acknowledge the existence of—a completely novel color? If, overnight, humans were all capable of experiencing the just-now-made-up color charpoodle, would we even notice, or would reality simply seem a little more detailed? This topic is not just reserved for late-night basement talks around a bowl of Doritos. There is science to help facilitate the discussion of three different types of impossible colors.

FORBIDDEN COLORS

The first class of impossible colors we'll explore are forbidden colors. These are not colors you'll be punished for viewing, but rather these are colors beyond the bounds of our visual capabilities. One theory to explain why we can't perceive certain colors or color combinations is called opponent process, which states that the colors we perceive are the reduced information we gather by not processing overlapping wavelengths. Our three types of cone cells (see page xxii)—red sensing, green sensing, and blue sensing—are sensitive to red, green, and blue light, respectively, but there is a bit of overlap in regard to the other wavelengths in the visible spectrum, such as yellows, oranges, bluish-greens, and so on. Two different cone cells can be capable of sensing the same in-between colors. Every overlap in perception yields more data for our system to process. The opponent process theory states that there are three opposing channels in our vision, red versus green, blue versus yellow, and white versus black. Every blue and yellow wavelength that overlaps would render another chunk of reality for us to process, the same for any time red and green wavelengths overlap. This theory suggests that it's actually more productive to process the differences in wavelengths our cones perceive than acknowledge the full literal picture of what we could be seeing, which would be entirely new color combinations. Our brains cancel out any overlap between red and green wavelengths or blue and yellow wavelengths, only allowing us to perceive one of the two from the opposing set. This can be tested on the following pages.

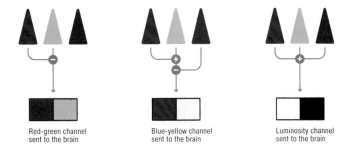

The opponent process explains how the signals in our visual system are interpreted by our brain and why there are certain color combinations we cannot perceive simultaneously.

Focus on the X in the fatigue template for about 20 seconds. Then quickly focus on the X in the target surface to observe the color of the after-image. Try to limit your head and eye movement while focusing to maximize the effect.

FATIGUE IMAGE

TARGET SURFACE

When you stare at a blue circle for roughly twenty seconds and then shift your gaze to a solid white surface, you'll most likely see a ghostly yellow after-image and vice versa. The same will be observed with green and red. What this experiment tells us is that when our cone cells are fatigued from viewing a single color for a period, we're more sensitive and receptive to an opposing color.

Remember, we're not discussing pigments, we're talking pure visible light and the tools that evolved to interact with it. You're probably thinking "blue and yellow make green," and if we're discussing paint mixing, you're correct. We have cones that are sensitive to greens; however, we don't have the ability to perceive a color that is both blue and yellow simultaneously. Trying to imagine such an observation quickly leads to disassociation and fatigue. The same applies for overlapping red and green wavelengths. A painter might declare the combination yields an umber or brown, but neither of those pigments exist on the pure spectrum of visible light.

Instead, there should be a whole separate experience when we perceive red and green wavelengths simultaneously. Both of those wavelengths factually exist. And there are instances in which the two could coexist with separate light-producing origins, but we simply cannot interpret what a reddish green truly looks like, nor a bluish yellow, at least in terms of the visible spectrum humans can acknowledge.

CHIMERICAL COLORS

The second class of impossible colors are called chimerical colors. Similar to forbidden colors, these are strange color-based phenomena that can't be experienced through straightforward observation, but we can, in a sense, hallucinate the experience through some self-induced trickery, such as cone fatigue.

To experience chimerical colors, the viewer must give their cones a specific stimulus and then quickly shift to another stimulus. The shift between these two experiences leaves just enough room to observe chimerical colors. By staring at a color of high intensity and saturation, you can fatigue your cones. If you shift your attention to a very different color, you'll see a ghostly afterimage and color as your cones adjust to the change.

Stygian colors are a perfect example of this interaction. These are color experiences that are simultaneously dark and incredibly saturated. This shouldn't be possible, as a dark field would absorb and hinder the vibrancy of a saturated color. Keeping in mind the information you've gathered regarding opponent process theory, let's test this idea. Start by staring at a circle to the left for twenty seconds and then shift your gaze to the square opposite. What do you notice?

By staring at the saturated yellow circle, we are exhausting the cone cells that are sensitive to yellow. Both red and green cone cells are sensitive to yellows, so if both of them are fatigued to some degree, that leaves our third cone cell (blue) to sort of fill in for the fatigue. The after-image you should've seen was a saturated blue circle hovering over the black square. Now that you know what to expect, give it another try.

FATIGUE IMAGE

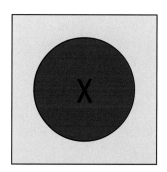

TARGET SURFACE

Next we have an experiment of **self-luminous colors**: colors that appear to emit light (which is impossible if there is not a luminous or light-emitting source). The opposite of the stygian color experiment, the self-luminous color experiment utilizes a field of white alongside fatigued cone cells.

Start by staring at the saturated green circle for twenty seconds and then shift your gaze to the white square. What did you see?

Similar to stygian colors, you are exhausting the green-sensing cone cells, leaving the red-sensing cone cells to step in, creating a temporary illusory red afterimage. That afterimage will persist until the green cone cells return to their normal state (in roughly thirty seconds). During the time that you were staring at the white field, you should be experiencing the red after-image. When placed over a bright-white field, however, the red illusory circle would almost seem luminous, as it would seemingly appear brighter than the white field behind it.

FATIGUE IMAGE

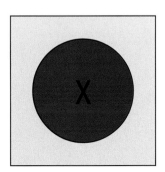

TARGET SURFACE

☐ X

☐ X

☐ X

☐ X

And if your cone cells haven't had quite enough, we have one last color experiment for you. This is an example of **hyperbolic colors**. Start by staring at one of the circles on the left. Hold your gaze for twenty seconds before shifting it to the opposite square. What do you observe?

Hyperbolic colors take the existence of a pure and saturated hue and gives the illusion that an even more saturated version exists outside of the color spectrum we see. If you stare at the saturated cyan color field, you'll fatigue the respective cones, leaving an orange afterimage. Overlay that orange afterimage onto a saturated orange field, and you shouldn't see anything. The oranges should blend together, but you have to remember that the orange circle you're seeing isn't necessarily real. It's the fallout of exhausting very specific cone cells. When staring at the orange square, you'll notice that the orange afterimage is still observable, suggesting that the circle you're seeing embodies an orange more vibrant and saturated than any orange we can observe naturally in the universe—which, according to human perception, doesn't exist.

FATIGUE IMAGE

TARGET SURFACE

IMAGINARY COLORS

If you're still with us, there is one last impossible color we'd like to share. Imaginary colors are those that mathematically exist, sure, but we'll never see them. No single object can possess or exhibit an imaginary color, but based on our rules and understanding, they do get a seat at the table. A suspiciously empty seat.

As mentioned on page xxii, the three cones we possess perceive wavelengths with a bit of overlap. All light-based phenomena excite more than one cone to some extent. Even the brightest greens we perceive recruit more than one cone. If a single cone were to be excited for one fleeting moment, we would experience a hyper or physically impossible iteration of that color. If our blue cones could be singled out, we would be witness to a blue so blue that it might spark a religious movement, a color so unavoidable and intense that reality would most likely not feel the same. We're not even sure how one would be able to remember such an experience or if it would permanently redefine blue for the viewer.

While imaginary colors can't be seen, they do exist within the mathematical mappings of colors, called color space. A color space is a tool for organizing colors, a visual graph that arranges all color into a useful diagram. Color spaces can differ depending on the device or program and the purpose of using color with said tool. The color profiles in each color space can be assigned numbers, letters, and other characters, such as the Pantone collection or Adobe RGB color system. In this example, we'll use the CIE 1931 color space, which maps out all possible real colors according to their respective wavelength. For more on color spaces, see page 4.

If you use three primary colors to define a parameter, you get a triangular region of possible colors. Theoretically, you should be able to mix any three of the colors that make up that triangular region in any ratio to get any of the colors contained within that triangle. This region of possible color mixtures is called a gamut.

The CIE 1931 color space chromaticity diagram includes all the colors perceivable to the average human eye—ignoring luminance.

The axes correspond to tristimulus values of the human cones. The outer edge of the horseshoe shape represents the spectral hues and their wavelengths. The line of purples along the edge, connecting violet to red, are non-spectral colors. (See magenta page 183.)

The points of the gamut are primaries, and all the colors within the shape formed by those points can be made by mixing the primaries in various proportions.

Any color that exists outside of that gamut cannot be created by mixing the three chosen colors. This is where things get imaginary, because the region that spans all possible colors as shown in the diagram at right is not a triangle. The triangle only exists when we select three primaries for mixing. Even if we increased our selection of primaries to four or five colors, the polygonal region still wouldn't encase all real colors. A color space that contains all possible real colors has curvature. If you wanted to create a gamut with three primary colors to mix that contained all possible real colors, there would be regions within that gamut that lie outside of the border of real colors—little corners tucked at the edges of our palette that don't have a defined color. You can run your brush through them and you know there should be paint there, but it's simply not loading into reality. These tiny pockets on the diagram are where you find imaginary colors.

Mathematically they're there, the information for their existence can be referenced on a graph, but we can't visualize them in any way. We will never be able to see them, but perhaps we could describe them based on their proximity to observable real colors: hyper blue, hyper green, and so on.

There is so much more to reality than we can see. And we can expect that our collective understanding of color and light will change as we learn more about our home planet and the universe. It is our goal, and we hope yours as well, curious reader, to stay open to these new understandings, embrace them with excitement, and share them with humankind. Let us move onward into an infinite universe with infinite color possibilities.

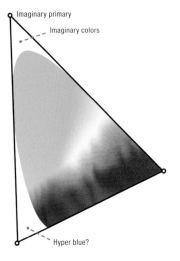

Imaginary primaries are required to form a gamut that includes all the real colors—and then some.

Acknowledgments

Science has always revolved around human collaboration. No single scientific mind will answer it all on their own, and every keen and shared observation comes on the shoulders of curious minds before. This book wouldn't be what it is without the hard work and dedication of countless scientists, thinkers, artists, and tinkerers who had the courage to share their minds and ideas. I want to take a moment to personally thank a few artists who inspire me to no end, J.A.W Cooper, Christina Mrozik, and Aaron Horkey, all of whom strike my mind with lightning and force me to be the best artist I can be. I also want to thank the science communicators who help share their love and wonder of the world; both Alexis Nicole and Hank Green remind me that it is one of the greatest honors of any human to share just why they love this universe so much.

I lastly want to thank every little black and brown mind that seeks to understand and appreciate the beauty in the world, the tiny scientists that embody the amazing potential of humanity. And of course thank you, reader, for supporting our work and helping spread the love of science and art. You rock.

—TYLER THRASHER

This book would not be possible if not for the many scientists who authored the papers and books referenced within, whose insights and discoveries have been pivotal. This acknowledgment extends to the scientists cited within our references, and those cited within theirs, and so on, cascading back to the dawn of curiosity.

Finally, profound gratitude for the brightest light in my universe—my dear wife—whose patience and support provides the unseen foundation behind my every endeavor.

—TERRY MUDGE

Glossary

Absorption: The process by which a material takes in light energy instead of reflecting it, often converting the energy to heat.

Additive color mixing: The process of creating new colors by adding together the primary light colors (red, green, blue).

After-image: The visual impression that remains after the original stimulus has been removed.

Atom: The basic unit of a chemical element, consisting of a nucleus of protons and neutrons, with electrons orbiting around it.

Blackbody radiation: The emission of electromagnetic radiation by an idealized radiator that fully absorbs all frequencies incident upon it.

Blueshift: A shift in the spectral lines of an astronomical object toward the blue end of the spectrum, generally indicating that the object is moving toward the observer.

Bragg's law: A mathematical equation that describes the angles at which scattering occurs in a crystal lattice, revealing the distances between planes of atoms.

Chimerical color: A color perception that arises from the combination of two different spectral colors not normally seen together, due to unusual lighting or material properties.

Chroma: The degree of deviation of a color from a neutral color of the same lightness.

Chromaticity: A measure of the quality of a color regardless of its luminance, often displayed in two-dimensional graphs that provide a representation of color output.

Chromophore: A group of atoms within a molecule that are responsible for the color of the molecule.

CIE chromaticity diagram: A two-dimensional plot that represents all possible colors in a particular color space, as defined by the International Commission on Illumination (CIE).

CMYK (cyan, magenta, yellow, key/black): A subtractive color model used in color printing.

Color constancy: The perceived color of objects that remains relatively constant under varying illumination conditions.

Color rendering index (CRI): A measure of the ability of a light source to reveal the colors of various objects faithfully.

Color space: A specific organization of colors that is enabled by a coordinate system that describes a range or gamut of colors.

Color temperature: A way to describe the appearance of a light source, measured in Kelvin (K).

Color vision deficiencies: Conditions that affect the perception of color, commonly known as color blindness.

Color wheel: A circular diagram representing the relationships between primary, secondary, and tertiary colors.

Colorimeter: A device used to measure the absorbance and transmittance of light through a liquid sample, often used to determine the concentration of a known solute.

Complementary colors: Colors that, when combined, cancel each other out, meaning they produce a grayscale color like white or black when combined in equal parts.

Cone cells: Photoreceptor cells in the retina responsible for color vision and that function best in relatively bright light.

Diffraction: The bending of light waves as they pass around an obstacle or through a narrow opening.

Dispersion: The separation of light into its component wavelengths (colors) as it passes through a medium.

Doppler effect: The change in frequency of a wave in relation to an observer.

Dye: A soluble colorant substance that can be used to impart color to a variety of materials, including textiles, paper, and food.

Electromagnetic spectrum: The range of all types of electromagnetic radiation, from radio waves to gamma rays, including visible light.

Electron: A subatomic particle with a negative electric charge, often involved in chemical reactions and electrical conductivity.

Emission: The production and discharge of light or other electromagnetic radiation.

Energy: The capacity for work or vigorous activity; in physics, a scalar physical quantity that describes the amount of work that can be performed by a force.

Extraspectral: A color that is not found in the visible spectrum of light, such as brown or pink.

Fluorescence: The emission of light by a substance that has absorbed light, where the emitted light has a longer wavelength.

Forbidden color: A hypothetical color that the human eye should not be able to perceive, such as a simultaneous perception of red and green or blue and yellow.

Gamma ray: Electromagnetic radiation of the shortest wavelength and highest energy, usually emitted by radioactive materials or high-energy astronomical events.

Gamut: The complete range of colors that can be reproduced or perceived by a particular device or color space.

HSL and HSV: Color models that describe colors based on hue, saturation, and lightness or value, commonly used in various applications of computer graphics.

Hue: The attribute of a color by virtue of which it is discernible as red, green, and so on.

Hyperbolic color: A conceptual term for colors that would exist in a mathematical model that extends the normal parameters of human color perception.

Imaginary color: A color that cannot be generated by any combination of wavelengths of light, existing only in the context of complex numbers in color theory.

Impossible color: A color that cannot be perceived in normal viewing conditions, such as those that would be produced by wavelengths outside the visible spectrum.

Infrared: Electromagnetic radiation with longer wavelengths than those of visible light but shorter than those of microwaves, often emitted as heat.

Interference: The interaction of waves that results in either an increase or decrease in amplitude.

Iridescence: The phenomenon of certain surfaces appearing to change color as the angle of view or the angle of illumination changes.

Luminance: A photometric measure of the luminous intensity per unit area of light traveling in a given direction.

Luminescence: The emission of light by a substance not resulting from heat.

Molecule: A group of atoms bonded together, representing the smallest unit of a chemical compound that retains the chemical properties of that compound.

Monochromatic light: Light that consists of a single wavelength.

Mordant: A chemical that fixes a dye in or on a substance by combining with the dye.

Nanometer (nm): A unit of length in the metric system equal to one-billionth of a meter, commonly used to measure wavelengths of light.

Nanoparticle: A particle with dimensions measured in nanometers, often used in applications ranging from medicine to materials science.

Paint: A liquid that contains pigments or dyes, along with binders and solvents, that dries to form a solid, adherent film.

Perception: The cognitive process by which the brain interprets sensory information received from the environment, leading to a conscious experience.

Phosphorescence: A type of photoluminescence where absorbed radiation is re-emitted at a lower energy level over a longer period of time.

Photoluminescence: The emission of light observed when a material absorbs photons and then re-emits them.

Photon: A quantum of electromagnetic radiation, the basic unit of light and all other forms of electromagnetic radiation.

Photonic crystal: A complex structure that can manipulate photons and affect the transmission or emission of light.

Photonic glasses: A disordered arrangement of transparent materials that manipulate the flow of light through their structure, affecting its speed, direction, and other properties.

Photoreceptors: Cells in the retina that are sensitive to light and relay signals to the brain, forming the basis of vision.

Photosynthesis: The biochemical process in which light energy is converted into chemical energy by plants, algae, and some bacteria.

Pigment: A substance that imparts color to other materials through selective absorption and reflection of specific wavelengths, primarily in the visible spectrum.

Polarization: The orientation of the oscillations of electromagnetic waves in relation to the direction of propagation.

Redshift: A shift in the spectral lines of an astronomical object toward the red end of the spectrum.

Reflection: The change in direction of a wave front at an interface between two different media, causing the wave front to return into the medium from which it originated.

Refraction: The bending of light as it passes from one medium to another with a different refractive index.

Refractive index: A measure of how much a material slows down light, impacting how much it bends when entering the material.

RGB (red, green, blue): A color model used in electronic displays and digital imaging.

Rod cells: Photoreceptor cells in the retina of the eye that are sensitive to low levels of light.

Saturation: The intensity of a color, expressed as the degree to which it is different from white.

Scattering: The process by which light changes direction or energy after interacting with particles or other elements in a medium.

Shade: A variation of a color produced by adding black or reducing illumination.

Spectrum: The range of colors or wavelengths observed when light is dispersed, as in a prism.

Stygian color: A theoretical color that represents the absence or complete absorption of light, often used to describe extreme darkness.

Subtractive color mixing: The process of creating new colors by subtracting colors from white light using filters or pigments (cyan, magenta, yellow).

Supernumerary ring: Additional faintly colored rings that may appear inside the primary rainbow due to wave interference.

Tetrachromatic: A condition of having four independent channels for conveying color information, as opposed to the typical three channels in trichromats.

Tint: A variation of a color produced by adding white, increasing its lightness.

Tone: A color that has been modified by the addition of both black and white (gray).

Trichromatic: The condition of possessing three independent channels for conveying color information, derived from the three different cone types that respond to blue, green, and red.

Ultraviolet: Electromagnetic radiation with shorter wavelengths than visible light but longer wavelengths than X-rays.

Value: The perceived lightness or darkness of a color.

Vibrance: The degree to which a color appears to emanate light or brightness, often enhancing its vividness without oversaturating it.

Wavelength: The distance between corresponding points on adjacent waves, often measured in nanometers (nm) for visible light.

X-ray: Electromagnetic radiation with shorter wavelengths than ultraviolet rays but longer than gamma rays, commonly used for imaging internal structures.

References

The Science of Color

"**Every color we perceive . . .**" Feynman, Richard P., Robert B. Leighton, and Matthew Sands. 2011. *The Feynman Lectures on Physics*. New Millennium Edition. New York: Basic Books.

"**At the heart of the electromagnetic spectrum . . .**" Griffiths, David J. 2004. *Introduction to Quantum Mechanics*. 2nd ed. Cambridge: Cambridge University Press.

"**Visible light, the small part of the spectrum . . .**" Nave, Carl R. 2017. "HyperPhysics." Department of Physics and Astronomy, Georgia State University. http://hyperphysics.phy-astr.gsu.edu.

"**At the atomic level . . .**" Tipler, Paul A., and Ralph A. Llewellyn. 2008. *Modern Physics*. 5th ed. New York: W. H. Freeman.

"**When an electron transitions . . .**" Sakurai, J. J., and Jim Napolitano. 2011. Modern Quantum Mechanics. 2nd ed. Boston: Addison-Wesley.

"**In addition to absorption and emission . . .**" Vukusic, Pete, and J. Roy Sambles. 2003. "Photonic Structures in Biology." *Nature* 424, no. 6950 (August 14): 852–55. https://doi.org/10.1038/nature01941.

The Perception of Color

"**Human eyes possess . . .**" Solomon, Samuel G., and Peter Lennie. 2007. "The Machinery of Colour Vision." *Nature Reviews Neuroscience* 8, no. 4 (April): 276–86. https://doi.org/10.1038/nrn2094.

"**One type of cone is most sensitive . . .**" Stockman, Andrew, and Lindsay T. Sharpe. 2000. "The Spectral Sensitivities of the Middle- and Long-Wavelength-Sensitive Cones Derived from Measurements in Observers of Known Genotype." *Vision Research*, vol. 40, no. 13 (June): 1711–37. https://doi.org/10.1016/S0042-6989(00)00021-3.

Common Color Misconceptions

"**In terms of light . . .**" Wyszecki, Günter, and W. S. Stiles. 2000. *Color Science: Concepts and Methods, Quantitative Data, and Formulae*. Wiley Classics Library ed. New York: John Wiley & Sons.

"**Black and white are not colors.**" Hunt, R. W. G., and M. R. Pointer. 2011. *Measuring Colour*. 4th ed. New York: John Wiley & Sons. https://doi.org/10.1002/9781119975595.

"**Dark objects absorb more heat . . .**" Born, Max, Emil Wolf, A. B. Bhatia, et al. 1999. *Principles of Optics: Electromagnetic Theory of Propagation, Interference, and Diffraction of Light*. 7th ed. Cambridge: Cambridge University Press. https://doi.org/10.1017/CBO9781139644181.

"**Everyone sees color in the same way.**" Palmer, Stephen E., and Karen B. Schloss. 2010. "An Ecological Valence Theory of Human Color Preference." Proceedings of the National Academy of Sciences 107, no. 19 (May 11): 8877–82. https://doi.org/10.1073/pnas.0906172107.

"**Animals see in black and white.**" Kelber, Almut, Misha Vorobyev, and Daniel Osorio. 2003. "Animal Colour Vision—Behavioural Tests and Physiological Concepts." *Biological Reviews* 78, no. 1 (February): 81–118. https://doi.org/10.1017/S1464793102005985.

"**Regarding the vision of mantis shrimps, with up to sixteen types of visual pigment.**" Cronin, Thomas W., Roy L. Caldwell, and Justin Marshall. 2001. "Tunable Colour Vision in a Mantis Shrimp." Nature 411, no. 6837 (May 31): 547–48. https://doi.org/10.1038/35079184.

"**The terms 'color,' 'hue,' 'shade,' and 'tint' are interchangeable.**" Fairchild, Mark D. 2013. *Color Appearance Models*. 3rd ed. New York: John Wiley & Sons. https://doi.org/10.1002/9781118653128.

1 Cosmic Void

"**These are the emptiest regions . . .**" Pan, Danny C., Michael S. Vogeley, Fiona Hoyle, Yun-Young Choi, and Changbom Park. 2012. "Cosmic Voids in Sloan Digital Sky Survey Data Release 7." *Monthly Notices of the Royal Astronomical Society* 421, no. 2 (April 1): 926–34. https://doi.org/10.1111/j.1365-2966.2011.20197.

"**Any light reaching you . . .**" Hubble, Edwin. 1929. "A Relation between Distance and Radial Velocity among Extra-Galactic Nebulae." *Proceedings of the National Academy of Sciences* 15, no. 3 (March 15): 168–73. https://doi.org/10.1073/pnas.15.3.168.

"**The voids are growing . . .**" Riess, Adam G., Alexei V. Filippenko, Peter Challis, Alejandro Clocchiatti, Alan Diercks, et al. 1998. "Observational Evidence from Supernovae for an Accelerating Universe and a Cosmological Constant." *The Astronomical Journal* 116, no. 3 (September): 1009–38. https://doi.org/10.1086/300499.

"**The gravitational force that holds . . .**" Binney, James, and Scott Tremaine. 2008. *Galactic Dynamics*. 2nd ed. Princeton Series in Astrophysics. Princeton: Princeton University Press.

"The driving force behind this expansion is uncertain." Perlmutter, S., G. Aldering, G. Goldhaber, et al. 1999. "Measurements of Ω and Λ from 42 High-Redshift Supernovae." *The Astrophysical Journal* 517, no. 2 (June): 565–86. https://doi.org/10.1086/307221.

"Some cosmologists are exploring links . . ." Gottschalk, Hanno, Nicolai R. Rothe, and Daniel Siemssen. 2023. "Cosmological de Sitter Solutions of the Semiclassical Einstein Equation." *Annales Henri Poincaré* 24, no. 9 (September): 2949–3029. https://doi.org/10.1007/s00023-023-01315-z.

"It's hypothesized that these voids . . ." Einasto, M., L. J. Liivamägi, E. Saar, et al. 2011. "SDSS DR7 Superclusters: Principal Component Analysis." *Astronomy & Astrophysics* 535 (November): A36. https://doi.org/10.1051/0004-6361/201117529.

3 Black Substance

"We all love dopamine . . ." Wise, Roy A. 2004. "Dopamine, Learning and Motivation." *Nature Reviews Neuroscience* 5, no. 6 (June 1): 483–94. https://doi.org/10.1038/nrn1406.

"It is this appearance that led to its name . . ." Zecca, L., D. Tampellini, M. Gerlach, et al. 2001. "Substantia Nigra Neuromelanin: Structure, Synthesis, and Molecular Behaviour." *Molecular Pathology* 54, no. 6 (December 1): 414–18. https://www.ncbi.nlm.nih.gov/pmc/articles/PMC1187172/.

"Substantia nigra plays a vital role. . . ." Obeso, José A., Maria C. Rodriguez-Oroz, Manuel Rodriguez, et al. 2000. "Pathophysiology of the Basal Ganglia in Parkinson's Disease." *Trends in Neurosciences* 23 (October): 18–19. https://doi.org/10.1016/S1471-1931(00)00028-8.

"It turns out there is a profound link . . ." Bernheimer, H., W. Birkmayer, O. Hornykiewicz, K. Jellinger, and F. Seitelberger. 1973. "Brain Dopamine and the Syndromes of Parkinson and Huntington Clinical, Morphological and Neurochemical Correlations." *Journal of the Neurological Sciences* 20, no. 4 (December): 415–55. https://doi.org/10.1016/0022-510X(73)90175-5.

"In a brain with Parkinson's . . ." Fahn, Stanley. 2006. "Description of Parkinson's Disease as a Clinical Syndrome." *Annals of the New York Academy of Sciences* 991, no. 1 (January 24): 1–14. https://doi.org/10.1111/j.1749-6632.2003.tb07458.

4 Eigengrau

"Even when there is little visual stimuli" "Eigengrau: The Shade You See When You Shut Your Eyes Isn't Perfect Black." *IFLScience*. (March 8). https://www.iflscience.com/eigengrau-the-shade-you-see-when-you-shut-your-eyes-isn-t-perfect-black-67875.

5 Black Pearl

"The presence of this black nacreous layer . . ." Lemer, Sarah, et al. 2015. "Identification of Genes Associated with Shell Color in the Black-Lipped Pearl Oyster, *Pinctada Margaritifera*." *BMC Genomics*, vol. 16, no. 1, (August): p. 568. https://doi.org/10.1186/s12864-015-1776-x.

6 Cuttlefish Ink

"Cuttlefish also deploy pigment . . ." Derby, Charles D. 2014. "Cephalopod Ink: Production, Chemistry, Functions and Applications." *Marine Drugs*, vol. 12, no. 5 (May 12): 2700–30. https://doi.org/10.3390/md12052700.

"The term is directly derived . . ." Hutton, Emily. 2021. "What Is Sepia: Exploring Its Past and Present." Image Restoration Center (blog). Last modified September 18, 2022. https://imagerestorationcenter.com/what-is-sepia/.

7 Anthocyanins in Black Plants

"The functions of anthocyanins vary between plants, with an understandable advantage being the higher absorption of light." Gould, Kevin S. "Nature's Swiss Army Knife: The Diverse Protective Roles of Anthocyanins in Leaves." *Journal of Biomedicine and Biotechnology*, vol. 2004, no. 5, Dec. 2004, pp. 314–20. PubMed Central. https://doi.org/10.1155/S1110724304406147.

"A photonic crystal is a lattice of well-organized nanoparticles with enough space between each particle to allow certain wavelengths of light to pass through." Paschotta, Dr Rüdiger. Photonic Crystals. https://www.rp-photonics.com/photonic_crystals.html.

8 Gray Matter

"As you read and absorb . . ." Binder, Jeffrey R., Rutvik H. Desai, William W. Graves, and Lisa L. Conant. 2009. "Where Is the Semantic System? A Critical Review and Meta-Analysis of 120 Functional Neuroimaging Studies." Cerebral Cortex 19, no. 12 (December): 2767–96. https://doi.org/10.1093/cercor/bhp055.

"Gray matter is a type of . . ." Fields, R. Douglas. 2008. "White Matter Matters." *Scientific American* 298, no. 3 (March): https://doi.org/10.1038/scientificamerican0308-54.

"Notably, though, the grayness is . . ." Nieuwenhuys, R. 1998. "Comparative Neuroanatomy: Place, Principles and Programme." In *The Central Nervous System of Vertebrates*, R. Nieuwenhuys, H. J. ten Donkelaar, and C. Nicholson, 273–326. Berlin, Heidelberg: Springer. https://doi.org/10.1007/978-3-642-18262-4_6.

"Despite making up only about 40 percent of your brain . . ." Azevedo, Frederico A. C., Ludmila R. B. Carvalho, et al. 2009. "Equal Numbers of Neuronal and Nonneuronal Cells Make the Human Brain an Isometrically Scaled-up Primate Brain." *The Journal of Comparative Neurology* 513, no. 5 (April 10): 532–41. https://doi.org/10.1002/cne.21974.

"Most of the remaining brain mass is white matter . . ." Stikov, Nikola, Jennifer S. W. Campbell, Thomas Stroh, et al. 2015. "In Vivo Histology of the Myelin G-Ratio with Magnetic Resonance Imaging." *NeuroImage* 118 (September): 397–405. https://doi.org/10.1016/j.neuroimage.2015.05.023.

"While the gray matter handles the computation . . ." Basser, Peter J., Sinisa Pajevic, Carlo Pierpaoli, Jeffrey Duda, and Akram Aldroubi. 2000. "In Vivo Fiber Tractography Using DT-MRI Data." *Magnetic Resonance in Medicine* 44, no. 4 (October): 625–32. https://doi.org/10.1002/1522-2594(200010)44:4<625::AID-MRM17>3.0.CO;2-O.

9 Glaucous

"The glaucous farina is also hydrophobic . . ." de Carvalho Faria, Marco Antônio, Marcos da Silva Sousa, et al. 2019. "Preparation and Characterization of Epicuticular Wax Films." *Heliyon* 5, no. 3 (March): e01319. https://doi.org/10.1016/j.heliyon.2019.e01319.

10 Lunar Dust

"**When they reentered the spacecraft . . .**" Winterhalter, Daniel, et al. 2020. "Lunar Dust and Its Impact on Human Exploration: A NASA Engineering and Safety Center (NESC) Workshop." (September). https://ntrs.nasa.gov/citations/20205008219.

"**It clung to their spacesuits . . .**" NASA Office of the Chief Health & Medical Officer (OCHMO). 2021. "Lunar Dust." NASA-STD-3001 Technical Brief, Rev A (December 30). https://www.nasa.gov/wp-content/uploads/2023/03/lunar-dust-technical-brief-ochmo.pdf

"**The moon's history is filled . . .**" Florenskiy, K. P., A. T. Bazilevskiy, and A. V. Ivanov. 1977. "The Role of Exogenic Factors in the Formation of the Lunar Surface." *NASA Special Publication* 370 (January 1): 571–84. https://ui.adsabs.harvard.edu/abs/1977NASSP.370..571F.

"**The charred particles end up . . .**" Che, Xiaochao, Alexander Nemchin, Dunyi Liu, et al. 2021. "Age and Composition of Young Basalts on the Moon, Measured from Samples Returned by Chang'e-5." *Science* 374, no. 6569 (November 12): 887–90. https://doi.org/10.1126/science.abl7957.

"**The regions' distinct grays . . .**" Ivanov, A. V., L. S. Tarasov, O. D. Rode, and K. P. Florensky. 1973. "Comparative Characteristics of Regolith Samples Delivered from the Lunar Mare and Highland Regions by the Automatic Stations Luna-16 and Luna-20." *Lunar and Planetary Science Conference Proceedings* 4 (January 1): 351. https://ui.adsabs.harvard.edu/.

11 Polar Bear Fur

"**This ability to bounce and reflect light . . .**" Selden, Steve. 2015. "Polar Bear Skin is Black." Churchill Polar Bears (blog). Accessed September 21, 2023. https://churchillpolarbears.org/tag/luminescence/.

12 White Rot

"**Lignin is also a significant carbon reservoir . . .**" Pan, Yude, Richard A. Birdsey, Jingyun Fang, et al. 2011. "A Large and Persistent Carbon Sink in the World's Forests." *Science* 333, no. 6045 (August 19): 988–93. https://doi.org/10.1126/science.1201609.

"**But degradation of this resilient compound . . .**" Floudas, Dimitrios, Manfred Binder, Robert Riley, et al. 2012. "The Paleozoic Origin of Enzymatic Lignin Decomposition Reconstructed from 31 Fungal Genomes." *Science* 336, no. 6089 (June 29): 1715–19. https://doi.org/10.1126/science.1221748.

"**Recently a research team . . .**" Del Cerro, Carlos, Erika Erickson, Tao Dong, et al. 2021. "Intracellular Pathways for Lignin Catabolism in White-Rot Fungi." *Proceedings of the National Academy of Sciences* 118, no. 9 (February 23): e2017381118. https://doi.org/10.1073/pnas.2017381118.

13 Lead White

"**A mixture of lead, water, and vinegar . . .**" Pilastro, Eleonora. 2023. "Beauty to Die for: The Most Toxic Makeup Ever." *Guinness World Records*. https://www.guinnessworldrecords.com/news/2023/3/beauty-to-die-for-the-history-of-the-most-toxic-makeup-737194.

14 Ultrawhite

"**They created an incredibly powerful reflective white paint . . .**" Wiles, Kayla. 2021. "The Whitest Paint Is Here—and It's the Coolest. Literally." Purdue News Service. https://www.purdue.edu/newsroom/releases/2021/Q2/the-whitest-paint-is-here-and-its-the-coolest.-literally.html.

15 Mistake Out

"**Graham's empire was eventually purchased . . .**" R, Brett. 2015. "Bette Nesmith Graham, Inventor of Liquid Paper." Now@MPL (blog). http://www.women-inventors.com/Bette-Nesmith-Graham.asp.

16 Ivory

"**Ivory, a term usually reserved . . .**" IFAW. 2021. "What Is Ivory and How Can We Protect Elephants?" https://www.ifaw.org/journal/what-is-ivory.

"**This color is due to . . .**" Baker, Barry, Rachel Jacobs, Mary-Jacque Mann, et al. 2020. *Identification Guide for Ivory and Ivory Substitutes*. 4th ed. Edited by Crawford Allen. World Wildlife Fund Inc.: Washington DC. Commissioned by CITES Secretariat, Geneva, Switzerland. 4-6. https://cites.org/sites/default/files/ID_Manuals/Identification_Guide_for_Ivory_and_Ivory_Substitutes_ENGLISH.pdf.

"**A unique instance of ivory . . .**" Nweeia, Martin T., Frederick C. Eichmiller, et al. 2014. "Sensory Ability in the Narwhal Tooth Organ System." *The Anatomical Record* 297, no. 4 (April): 599–617. https://doi.org/10.1002/ar.22886.

"**In response, international trade of ivory was outlawed in 1989.**" Convention on International Trade in Endangered Species of Wild Fauna and Flora. 1989. "Trade in Ivory from African Elephants." Seventh Meeting of the Conference of the Parties, Doc. 7.43.3 (October 9–20). https://cites.org/sites/default/files/eng/cop/07/doc/E07-43-03.pdf.

17 Cosmic Latte

"**Astronomers at the Johns Hopkins . . .**" "Cosmic Latte: The Average Color of the Universe." Science Mission Directorate. https://science.nasa.gov/cosmic-latte-average-color-universe.

18 Landlord White

"**So a derivative of white became popular in the 1970s . . .**" "Here's Why Every Apartment You've Ever Rented Is Painted in 'Landlord Off-White.'" *Apartment Therapy*. https://www.apartmenttherapy.com/landlord-off-white-paint-36948474.

19 Mummy Brown

"**Eighteenth and nineteenth century artists Eugène Delacroix, Sir William Beechely, and Edward Burne-Jones were known to use mummy brown.**" The Corpse on the Canvas: The Story of 'Mummy Brown' Paint | Art UK. https://artuk.org/discover/stories/the-corpse-on-the-canvas-the-story-of-mummy-brown-paint.

20 Brown Dwarf

"**They're not massive enough to sustain hydrogen fusion like true stars.**" Kulkarni, S., D. Golimowski, and NASA. 1995. "Astronomers Announce First Clear Evidence of a Brown Dwarf." Release ID: 1995-48 (November 29). https://hubblesite.org/contents/news-releases/1995/news-1995-48.

"Their namesake color . . ." Gargaud, Muriel, Ricardo Amils, José Cernicharo Quintanilla, et al., eds. 2011. *Encyclopedia of Astrobiology*. SpringerReference. Berlin, Heidelberg: Springer.

21 Feuille Morte

"What remains are molecules and pigments known as carotenoids and anthocyanins" "Science of Fall Colors." US Forest Service. https://www.fs.usda.gov/visit/fall-colors/science-of-fall-colors.

22 Carmine

"There are exciting developments afoot with the production of these red dyes" https://www.smithsonianmag.com/innovation/scientists-are-making-cochineal-a-red-dye-from-bugs-in-the-lab-180979828/.

23 Ancient Chlorophyll

"The rocks in which these fossils . . ." Gueneli, N., A. M. McKenna, N. Ohkouchi, and J. J. Brocks. 2018. "1.1-Billion-Year-Old Porphyrins Establish a Marine Ecosystem Dominated by Bacterial Primary Users." PNAS 115, no. 30 (July 9): e6978–86.

24 Falu Red

"During the seventeenth century . . ." Wei, Clarissa. 2020. "Why Are All Swedish Cottages Painted Red?" *Smithsonian Magazine*. https://www.smithsonianmag.com/travel/why-are-all-swedish-cottages-painted-red-180975914/.

25 Hydrogen-Alpha

"When the light emitted from . . ." Bohr, Dr. N. 1913. "I. On the Constitution of Atoms and Molecules." *The London, Edinburgh, and Dublin Philosophical Magazine and Journal of Science* 26, no. 151 (July): 1–25. https://doi.org/10.1080/14786441308634955.

"Photons emitted from . . ." Balmer, J. J. 1885. "Notiz über die Spectrallinien des Wasserstoffs." *Annalen Der Physik* 261, no. 5: 80–87. https://doi.org/10.1002/andp.18852610506.

"By using a special filter . . ." "Optolong H-Alpha 7nm Narrowband Filter Improved Version for Deepsky Nebula Imaging." Optolong Optics Co., Ltd. https://www.optolong.com/cms/document/detail/id/59.html.

26 Dragon's Blood

"This resin has been cultivated . . ." Dioscorides, P. 2005. *De Materia Medica*. Translated by Lily Y. Beck. Olms Press: Hildesheim, Germany.

"The resin has shown . . ." Ding, Xupo, Jiahong Zhu, Hao Wang, Huiqin Chen, and Wenli Mei. 2020. "Dragon's Blood from *Dracaena cambodiana* in China: Applied History and Induction Techniques toward Formation Mechanism." *Forests* 11, no. 4 (March 26): 372. https://doi.org/10.3390/f11040372.

"Moreover, multiple studies have even shown . . ." Fan, Jia-Yi, Tao Yi, Chui-Mei Sze-To, Lin Zhu, Wan-Ling Peng, et al. 2014. "A Systematic Review of the Botanical, Phytochemical and Pharmacological Profile of *Dracaena cochinchinensis*, a Plant Source of the Ethnomedicine 'Dragon's Blood.'" *Molecules* 19, no. 7 (July 22): 10,650–669. https://doi.org/10.3390/molecules190710650.

27 Pompeian Red

"The discovery of pompeian red ignited . . ." Nichols, Marden Fitzpatrick. 2012. "The Pompeian Revival Style in the United States." Center 32. National Gallery of Art: Center for Advanced Study in the Visual Arts. https://www.nga.gov/research/casva/research-projects/research-reports-archive/nichols-2011-2012.html.

"Careful analysis suggests . . ." Plutino, Alice, Gabriele Simone, and Alessandro Rizzi, eds. 2022. *Color Design & Technology—A Multidisciplinary Approach to Colour—Part 1*. Research Culture and Science Books, vol. 5: 58-71. IT: Gruppo del Colore—Associazione Italiana Colore. https://doi.org/10.23738/RCASB.005.

28 Kermes Red

"The dye was derived from . . ." Cooksey, C. J. 2019. "The Red Insect Dyes: Carminic, Kermesic and Laccaic Acids and Their Derivatives." *Biotechnic & Histochemistry* 94, no. 2 (February 17): 100–107. https://doi.org/10.1080/10520295.2018.1511065.

"Pigment production is highest when . . ." Amar, Zohar, Hugo Gottlieb, Lucy Varshavsky, and David Iluz. 2005. "The Scarlet Dye of the Holy Land." *BioScience* 55, no. 12 (December): 1080–83. https://doi.org/10.1641/0006-3568(2005)055[1080:TSDOTH]2.0.CO;2.

29 The Great Red Spot

"Jupiter, the fifth planet from the sun . . ." NASA Solar System Exploration Hub. "Jupiter." https://solarsystem.nasa.gov/planets/jupiter/overview.

"The Juno spacecraft has acquired . . ." Bolton, S. J., A. Adriani, V. Adumitroaie, et al. 2017. "Jupiter's Interior and Deep Atmosphere: The Initial Pole-to-Pole Passes with the Juno Spacecraft." *Science* 356, no. 6340 (May 26): 821–25. https://doi.org/10.1126/science.aal2108.

"NASA posits that a possible explanation . . ." Loeffler, Mark J., and Reggie L. Hudson. 2018. "Coloring Jupiter's Clouds: Radiolysis of Ammonium Hydrosulfide (NH4SH)." *Icarus* 302 (March): 418–25. https://doi.org/10.1016/j.icarus.2017.10.041.

"Alternatively, some researchers propose . . ." Simon, Amy A., Fachreddin Tabataba-Vakili, Richard Cosentino, et al. 2018. "Historical and Contemporary Trends in the Size, Drift, and Color of Jupiter's Great Red Spot." *The Astronomical Journal* 155, no. 4 (April 1): 151. https://doi.org/10.3847/1538-3881/aaae01.

30 Realgar

"The components of realgar were also used as far back as in the sixteenth century" *Dangerous Colors*. *Color Navigator*. https://blog.colornavigator.net/dangerous-colors.

31 Redshift

"Albert Einstein revealed that our universe . . ." Einstein, A. 1916. "Die Grundlage der allgemeinen Relativitätstheorie." *Annalen der Physik* 354, no. 7: 769–822. https://doi.org/10.1002/andp.19163540702.

"The space that makes up the universe . . ." Hubble, Edwin. 1929. "A Relation between Distance and Radial Velocity among Extra-Galactic Nebulae." Proceedings of the National Academy of Sciences 15, no. 3 (April 25): 168–73. https://doi.org/10.1073/pnas.15.3.168.

"This can tell us how fast and how far distant galaxies are moving away." Perlmutter, S., G. Aldering, G. Goldhaber, et al. 1999. "Measurements of Ω and Λ from 42 High-Redshift Supernovae." *The Astrophysical Journal* 517, no. 2 (June): 565–86. https://doi.org/10.1086/307221.

32 Blood Moon
"A blood moon is the result of Rayleigh scattering, a phenomenon also responsible for our sunrises and sunsets." Molly Wasser, Ernie Wright, and Tracy Vogel. "What You Need to Know About the Lunar Eclipse." *Moon: NASA Science*. https://moon.nasa.gov/news/185/what-you-need-to-know-about-the-lunar-eclipse.

33 Martian Red
"The rusty hue comes . . ." Morris, Richard V., D. C. Golden, James F. Bell, et al. 2000. "Mineralogy, Composition, and Alteration of Mars Pathfinder Rocks and Soils: Evidence from Multispectral, Elemental, and Magnetic Data on Terrestrial Analogue, SNC Meteorite, and Pathfinder Samples." *Journal of Geophysical Research*: Planets 105, no. E1 (January 25): 1757–1817. https://doi.org/10.1029/1999JE001059.

"However, chemical engineers have . . ." Cannon, Kevin M., Daniel T. Britt, Trent M. Smith, et al. 2019. "Mars Global Simulant MGS-1: A Rocknest-Based Open Standard for Basaltic Martian Regolith Simulants." *Icarus* 317 (January 1): 470–78. https://doi.org/10.1016/j.icarus.2018.08.019.

"They've been used by scientists . . ." Chow, Brian J., Tzehan Chen, Ying Zhong, and Yu Qiao. 2017. "Direct Formation of Structural Components Using a Martian Soil Simulant." *Scientific Reports* 7, no. 1 (April 27): 1151. https://doi.org/10.1038/s41598-017-01157-w.

34 Poppy Red
"The blood-red flowers sprouting in such a blood-soaked place . . ." "The WWI Origins of the Poppy as a Remembrance Symbol." History. (May 21). https://www.history.com/news/world-war-i-poppy-remembrance-symbol-veterans-day.

35 International Orange
"Affectionately called AMS-STD-595 12197 by the US government . . ." AMS G8 Aerospace Organic Coatings Committee. 2017. "Colors Used in Government Procurement." SAE International. February 10. https://doi.org/10.4271/AMSSTD595A.

"The iconic orange suits . . ." Jenkins, Dennis R. 2012. *Dressing for Altitude: U.S. Aviation Pressure Suits*, Wiley Post to Space Shuttle. NASA-SP-2011-595. Washington, DC: National Aeronautics and Space Administration.

Watson, Richard D. 2014. "Modified Advanced Crew Escape Suit Intravehicular Activity Suit for Extravehicular Activity Mobility Evaluations." International Conference on Environmental Systems. July 13. https://ntrs.nasa.gov/citations/20140010572.

"This striking color also adorns . . ." "Bridge Features." Golden Gate Bridge Highway & Transportation District. https://www.goldengate.org/bridge/history-research/bridge-features/color-art-deco-styling/#Color.

"He proposed a tailored . . ." Morrow, Irving F. 1935. "The Golden Gate Bridge: Report on Color and Lighting." Morrow & Morrow. April 6. https://www.goldengate.org/assets/1/6/report-colorlighting.pdf

36 The First Color
"This bright-hot glowing orange . . ." Koberlein, Brian, . "What Was the First Color in the Universe?" Phys.org. https://phys.org/news/2019-10-universe.html.

38 Tiger's-Eye
"It was long thought . . ." Wibel, Ferdinand. 1873. "Der Faserquarz vom Cap—eine Pseudomorphose nach Krokydolith." *Neues Jahrbuch für Mineralogie, Geologie und Paläontologie*: 367-80. https://archive.org/details/neuesjahrbuchfr55unkngoog/page/366/.

"However, with the advent of electron microscopy . . ." Heaney, Peter J., and Donald M. Fisher. 2003. "New Interpretation of the Origin of Tiger's-Eye." *Geology* 31, no. 4: 323–26. https://doi.org/10.1130/0091-7613(2003)031<0323:NIOTOO>2.0.CO;2.

39 Orpiment
"And while the alchemists were dying in their labs . . ." "Incredible Colors." *Chemical & Engineering News*. https://cen.acs.org/articles/84/i37/Incredible-Colors.html.

40 Bastard Amber
"These films supposedly earned . . ." Lau, Nicholas. 2018. "Bastard Amber." Medium (blog). April 11. https://medium.com/@nicholas1.lau/bastard-amber-466dbf94a7a9.

41 Sodium-Vapor Light
"Since the 1930s, sodium-vapor bulbs . . ." National Museum of American History. "Low Pressure Sodium Lamp, Type Na-10." https://americanhistory.si.edu/collections/search/object/nmah_751238.

"Additionally, the light a sodium-vapor . . ." Hunt, R. W. G., and M. R. Pointer. 2011. "Light Sources." In *Measuring Colour*. 1st ed. New York: John Wiley & Sons. https://doi.org/10.1002/9781119975595.

"Sodium-vapor lamps are also preferred . . ." Luginbuhl, Christian B., Paul A. Boley, and Donald R. Davis. 2014. "The Impact of Light Source Spectral Power Distribution on Sky Glow." *Journal of Quantitative Spectroscopy and Radiative Transfer* 139 (May): 21–26. https://doi.org/10.1016/j.jqsrt.2013.12.004.

42 Baltic Amber
"Amber, in scientific terms, is a fossilized tree resin." Grimaldi, David A., in association with the American Museum of Natural History. 1996. *Amber: Window to the Past*. New York: Harry N. Abrams.

43 Venusian Yellow
"In 1982, Soviet scientists landed . . ." Sagdeev, R. Z., and V. I. Moroz. 1982. "Venera-13 and Venera-14." Soviet Astronomy Letters 8 (July): 209–11. https://articles.adsabs.harvard.edu/pdf/.

"It was then that astronomer . . ." Jerome Schroeter, John. 1792. "Observations on the Atmospheres of Venus and the Moon, Their Respective Densities, Perpendicular Heights, and the Twi-Light Occasioned by Them." *Philosophical Transactions of the Royal Society of London* Series I 82 (January 1): 309–61. https://ui.adsabs.harvard.edu/.

"It is the sulfuric acid clouds . . ." Titov, D. V., H. Svedhem, D. McCoy, et al. 2006. "Venus Express: Scientific Goals, Instrumentation, and Scenario of the Mission." *Cosmic Research* 44, no. 4 (July): 334–48. https://doi.org/10.1134/S0010952506040071.

"Many scientists think . . ." Bullock, M., and David H. Grinspoon. 2001. "The Recent Evolution of Climate on Venus." *Icarus* 150, no. 1 (March): 19–37. https://doi.org/10.1006/icar.2000.6570.

"Several scientists, including Carl Sagan . . ." Morowitz, Harold, and Carl Sagan. 1967. "Life in the Clouds of Venus?" *Nature* 215, no. 5107 (September 16): 1259–60. https://doi.org/10.1038/2151259a0.

44 Libyan Desert Glass

"Among the treasures discovered . . ." "Tutankhamun." *The Metropolitan Museum of Art Bulletin* 34, no. 3 (1976): 1–48. https://doi.org/10.2307/3269009.

"It was the product of the many . . ." Cavosie, Aaron J., and Christian Koeberl. 2019. "Overestimation of Threat from 100 Mt–Class Airbursts? High-Pressure Evidence from Zircon in Libyan Desert Glass." *Geology* 47, no. 7 (July 1): 609–12. https://doi.org/10.1130/G45974.1.

"What sets Libyan desert glass apart . . ." Barrat, J. A., B. M. Jahn, J. Amossé, et al. 1997. "Geochemistry and Origin of Libyan Desert Glasses." *Geochimica et Cosmochimica Acta* 61, no. 9 (May): 1953–59. https://doi.org/10.1016/S0016-7037(97)00063-X.

45 Imperial Yellow

"Between 649 and 683 CE, during the reign of Emperor Gaozong of the Tang dynasty, it was established that only the emperor and high members of the family and court could don any amount of yellow." "Chinese Royal Ceremonial Clothing." Medium. January 24, 2019. https://cchatty.medium.com/chinese-royal-ceremonial-clothing-741cd432fa44.

46 Gold

"Electrons closer to the nucleus . . ." Pyykko, Pekka, and Jean Paul Desclaux. 1979. "Relativity and the Periodic System of Elements." *Accounts of Chemical Research* 12, no. 8 (August 1): 276–81. https://doi.org/10.1021/ar50140a002.

"According to special relativity . . ." Einstein, A. 1905. "Zur Elektrodynamik bewegter Körper." *Annalen der Physik* 322, no. 10: 891–921. https://doi.org/10.1002/andp.19053221004.

"This leaves predominantly yellow . . ." Saeger, K. E., and J. Rodies. 1977. "The Colour of Gold and Its Alloys." *Gold Bulletin* 10, no. 1 (March 1): 10–14. https://doi.org/10.1007/BF03216519.

47 Indian Yellow

"The process of manufacturing . . ." Ploeger, R., A. Shugar, G. D. Smith, V. J. Che. 2019. "Late 19th Century Accounts of Indian Yellow: The Analysis of Samples from the Royal Botanic Gardens, Kew." *Dyes and Pigments* vol. 160 (January): 418–31. ScienceDirect. https://doi.org/10.1016/j.dyepig.2018.08.014.

"Amber's unique coloration is attributed . . ." Wolfe, Alexander P., Ralf Tappert, Karlis Muehlenbachs, Marc Boudreau, Ryan C. McKellar, et al. 2009. "A New Proposal Concerning the Botanical Origin of Baltic Amber." *Proceedings of the Royal Society B: Biological Sciences* 276, no. 1672 (October 7): 3403–12. https://doi.org/10.1098/rspb.2009.0806.

"Extracting the DNA from prehistoric mosquitoes . . ." Poinar, Hendrik N., and B. Artur Stankiewicz. 1999. "Protein Preservation and DNA Retrieval from Ancient Tissues." *Proceedings of the National Academy of Sciences* 96, no. 15 (July 20): 8426–31. https://doi.org/10.1073/pnas.96.15.8426.

48 *Letharia vulpina*

"In parts of Europe . . ." "Wolf Lichen Letharia Vulpina Pigment and Poison." ActForLibraries.Org. http://www.actforlibraries.org/wolf-lichen-letharia-vulpina-pigment-and-poison/.

49 Luciferin

"The mechanics of a firefly's glow . . ." Hastings, J. W. 1983. "Biological Diversity, Chemical Mechanisms, and the Evolutionary Origins of Bioluminescent Systems." *Journal of Molecular Evolution* 19, no. 5 (September): 309–21. https://doi.org/10.1007/BF02101634.

"The distinct green glow of a firefly . . ." Lewis, Sara M., and Christopher K. Cratsley. 2008. "Flash Signal Evolution, Mate Choice, and Predation in Fireflies." *Annual Review of Entomology* 53, no. 1 (January): 293–321. tps://doi.org/10.1146/annurev.ento.53.103106.093346.

"Deep-sea fish like the anglerfish . . ." Haddock, Steven H. D., Mark A. Moline, and James F. Case. 2010. "Bioluminescence in the Sea." *Annual Review of Marine Science* 2, no. 1 (January 15): 443–93. https://doi.org/10.1146/annurev-marine-120308-081028.

50 Fluorescein

"However, hydrologists have a tool . . ." Smart, P. L., and I. M. S. Laidlaw. 1997. "An Evaluation of Some Fluorescent Dyes for Water Tracing." *Water Resources Research* 13, no. 1 (February): 15–33. https://doi.org/10.1029/WR013i001p00015.

"The creation of fluorescein dates back to 1871 . . ." Baeyer, Adolf. 1871. "Ueber Eine Neue Klasse von Farbstoffen." *Berichte der Deutschen Chemischen Gesellschaft* 4, no. 2 (June): 555–58. https://doi.org/10.1002/cber.18710040209.

"Beyond its hydrological applications . . ." National Center for Biotechnology Information. "PubChem Compound Summary for CID 10608, Fluorescein disodium salt." PubChem. https://pubchem.ncbi.nlm.nih.gov/compound/Fluorescein-disodium-salt.

51 Uranium Glass

"For hundreds of years . . ." Zoellner, Tom. 2009. *Uranium: War, Energy, and the Rock That Shaped the World*. New York: Viking.

"The green glow, called photoluminescence . . ." Gaft, Michael, Renata Reisfeld, and Gérard Panczer. 2005. *Modern Luminescence Spectroscopy of Minerals and Materials*. Berlin, Heidelberg: Springer. https://doi.org/10.1007/b137490.

"As research into the harmful effects . . ." Plant, Jane A., Peter R. Simpson, Barry Smith, and Brian F. Windley. 1999. "6. Uranium Ore Deposits—Products of the Radioactive Earth." In *Uranium: Mineralogy, Geochemistry, and the Environment*, edited by Peter C. Burns and Robert J. Finch. Berlin, Boston: De Gruyter. https://doi.org/10.1515/9781501509193-011.

"Our understanding of radiation . . ." Calas, Georges, Laurence Galoisy, Myrtille O. J. Y. Hunault, et al. 2023. "Spectroscopic Investigation of Historical Uranium Glasses." *Journal of Cultural Heritage* 59 (January–February): 93–101. https://doi.org/10.1016/j.culher.2022.11.008.

52 Radium Decay

"**Radium, a naturally occurring . . .**" Curie, P., M. Curie, and G. Bémont. 1898. "Sur une substance nouvelle radio-active, contenue dans la pechblende" ["On a New Radioactive Substance Contained in Pitchblende"]. *Comptes rendus de l'Académie des Sciences* 127 (December 26): 1215–17. https://history.aip.org/exhibits/curie/discover.htm

"**As radium decays, it releases particles with high energy.**" Murthy, K. V. R., and Hardev Singh Virk. 2013. "Luminescence Phenomena: An Introduction." *Defect and Diffusion Forum* 347(December): 1–34. https://doi.org/10.4028/www.scientific.net/DDF.347.1.

"**The luminescence of radium . . .**" Martland, Harrison S. 1929. "Occupational Poisoning in Manufacture of Luminous Watch Dials: General Review of Hazard Caused by Ingestion of Luminous Paint, with Especial Reference to the New Jersey Cases." *Journal of the American Medical Association* 92, no. 7 (February 16): 552–59. https://doi.org/10.1001/jama.1929.92700330002012.

53 Earth Aurora Green

"**The dominance of oxygen and nitrogen in our atmosphere usually gives us auroras with layers of colorful "curtains" of greens and pinks.**" UCAR. Auroras: The Northern and Southern Lights. Center for Science Education. https://scied.ucar.edu/learning-zone/sun-space-weather/aurora.

54 Helenite Green

"**On the morning of May 18, 1980 . . .**" Lipman, P. W., and D. R. Mullineaux, eds. 1981. "The 1980 Eruptions of Mount St. Helens, Washington." U.S. Geological Survey Professional Paper 1250.

"**According to several accounts . . .**" Wagner, Eric Loudon. 2020. *After the Blast: The Ecological Recovery of Mount St. Helens*. Seattle: University of Washington Press.

"**Other elements in the ash..**" Taylor, H. E., and F. E. Lichte. 1980. "Chemical Composition of Mount St. Helens Volcanic Ash." *Geophysical Research Letters* 7, no. 11 (November): 949–52. https://doi.org/10.1029/GL007i011p00949.

"**The exact shade of green . . .**" Nassau, K. 1985. "The Varied Causes of Color in Glass." MRS Online Proceedings Library 61: 427–39. https://doi.org/10.1557/PROC-61-427.

55 Scheele's Green

"**It is believed that Scheele's green wallpaper . . .**" Mari, Francesco, Elisabetta Bertol, Vittorio Fineschi, and Steven B. Karch. 2004. "Channelling the Emperor: What Really Killed Napoleon?" *Journal of the Royal Society of Medicine* 97, no. 8 (August). 397–99. https://www.ncbi.nlm.nih.gov/pmc/articles/PMC1079564/.

56 Fuchsite

"**Named after mineralogist Johann Nepomuk von Fuchs . . .**" Prandtl, Wilhelm. 1951. "Johann Nepomuk Fuchs." *Journal of Chemical Education* 28, no. 3 (March 1): 136. https://doi.org/10.1021/ed028p136.

"**It's a variety of muscovite in which . . .**" Whitmore, D. R. E., L. G. Berry, and J. E. Hawley. 1946. "Chrome Micas." *American Mineralogist: Journal of Earth and Planetary Materials* 31, no. 1-2 (February 1): 1-21. http://www.minsocam.org/ammin/AM31/AM31_1.pdf.

"**One of the most common mechanisms . . .**" Ghisler, M. 1976. "Fuchsite and Chrome-Epidote from Fiskenæsset." Rapport Grønlands Geologiske Undersøgelse 73 (December 31): 67–69. https://doi.org/10.34194/rapggu.v73.7423.

"**This is the result of . . .**" Deer, W. A., Robert A. Howie, and Jack Zussman. 2013. *An Introduction to the Rock-Forming Minerals*. 3rd ed. London: Mineralogical Society of Great Britain and Ireland. https://doi.org/10.1180/DHZ.

57 Chalkboard Green

"**Slate was very heavy and fragile to ship. The costs of transporting blackboards were rising, and so that's when an alternative was invented—the green chalkboard.**" Kankiewicz, Kim. "There's No Erasing the Chalkboard." *The Atlantic*. October 13, 2016. https://www.theatlantic.com/technology/archive/2016/10/theres-no-erasing-the-chalkboard/503975/.

59 Malachite

"**Malachite green also enjoyed popularity . . .**" hoakley. 2018. "Pigment: The Unusual Green of Malachite." The Eclectic Light Company (blog). June 1, 2018. https://eclecticlight.co/2018/06/01/pigment-the-unusual-green-of-malachite/.

60 Mercury E-Line

"**German physicist Joseph von Fraunhofer . . .**" Hockey, Thomas, Virginia Trimble, Thomas R. Williams, et al., eds. 2007. *Biographical Encyclopedia of Astronomers*. New York: Springer. https://doi.org/10.1007/978-0-387-30400-7.

"**Mercury is a popular choice for . . .**" Gray, David F. 2005. *The Observation and Analysis of Stellar Photospheres*. 3rd ed. Cambridge: Cambridge University Press.

"**Thereby providing a known reference value.**" Saloman, E. B. 2006. "Wavelengths, Energy Level Classifications, and Energy Levels for the Spectrum of Neutral Mercury." *Journal of Physical and Chemical Reference* Data 35, no. 4 (December): 1519–48. https://doi.org/10.1063/1.2204960.

61 Green Pea Galaxies

"**Though small, at least by galaxy standards . . .**" Cardamone, Carolin, Kevin Schawinski, Marc Sarzi, et al. 2009. "Galaxy Zoo Green Peas: Discovery of a Class of Compact Extremely Star-Forming Galaxies." Monthly Notices of the Royal Astronomical Society 399, no. 3 (November): 1191–1205. https://doi.org/10.1111/j.1365-2966.2009.15383.x.

"**They offer astronomers a looking glass . . .**" Reddy, Francis. 2023. "NASA's Webb Telescope Reveals Links Between Galaxies Near and Far." NASA. January 9. http://www.nasa.gov/feature/goddard/2023/nasa-s-webb-telescope-reveals-links-between-galaxies-near-and-far.

62 Mirror

"**One typically consists of . . .**" Hecht, Eugene, and Alfred Zajac. 1987. Optics. 2nd ed. Reading, MA: Addison-Wesley.

"**This greenish tint arises from . .** "Nassau, K. 1985. "The Varied Causes of Color in Glass." MRS Online Proceedings Library 61: 427–39. https://doi.org/10.1557/PROC-61-427.

"**So when you peer into an 'infinite' mirror . . .**" Born, Max, Emil Wolf, A. B. Bhatia, et al. 1999. *Principles of Optics: Electromagnetic Theory of Propagation, Interference and Diffraction of Light*. 7th ed. Cambridge: Cambridge University Press. https://doi.org/10.1017/CBO9781139644181.

63 Comet C/2002 E3 (ZTF)

"If Comet ZTF has a strong enough orbit . . ." Adler Planetarium. 2023. "Does Comet C/2022 E3 (ZTF) Have a Hyperbolic Orbit or a 50,000 Year Orbit?" Adler Planetarium (blog). January 20. https://www.adlerplanetarium.org/blog/does-comet-c-2022-e3-ztf-have-a-hyperbolic-orbit-or-a-50000-year-orbit/.

64 Zelyonka

"However, in recent years . . ." 2023. "Russian Lawyer Attacked With Green Dye in Moscow." *The Moscow Times*. July 7. https://www.themoscowtimes.com/2023/07/07/lawyer-attacked-with-green-dye-in-moscow-a81762.

"Russia Opposition Leader Alexei Navalny Attacked with 'Brilliant Green' Dye." 2017. *BBC News*. April 27. https://www.bbc.com/news/world-europe-39735867.

"Why Are Russian Opposition Leaders' Faces Turning Green?" *The Economist*. May 10, 2017. https://www.economist.com/the-economist-explains/2017/05/10/why-are-russian-opposition-leaders-faces-turning-green.

"While the dye is generally safe . . ." ThermoFisher Scientific. 2021. "Brilliant Green (Certified Biological Stain)." Safety Data Sheet, rev. 4 (December 24). https://www.fishersci.com/store/msds?partNumber=B42225&productDescription=BRILLIANT+GREEN+CERTIFIED+25G&vendorId=VN00033897&countryCode=US&language=en.

65 Water

"The US National Institutes of Health describe water as colorless . . ." National Center for Biotechnology Information. "PubChem Compound Summary for CID 962, Water." PubChem. https://pubchem.ncbi.nlm.nih.gov/compound/962.

"Interestingly, water molecules do . . ." Pope, Robin M., and Edward S. Fry. 1997. "Absorption Spectrum (380–700 nm) of Pure Water. II. Integrating Cavity Measurements." *Applied Optics* 36, no. 33 (November 20): 8710–23. https://doi.org/10.1364/AO.36.008710.

"To confirm water's true color . . ." Braun, Charles L., and Sergei N. Smirnov. 1993. "Why Is Water Blue?" *Journal of Chemical Education* 70, no. 8 (August 1): 612. https://doi.org/10.1021/ed070p612.

66 Maya Blue

"A culturally significant cenote . . ." "Maya Blue: The Sacred Color Pigment Used by Mayans." Chichén Itzá (blog). https://www.chichenitza.com/blog/maya-blue-the-sacred-color-pigment-used-by-mayans.

67 Unappetizing Blue

"This scenario is the premise of . . ." Spence, Charles. 2021. "What's the Story With Blue Steak? On the Unexpected Popularity of Blue Foods." *Frontiers in Psychology* 12 (March 2): 638703. https://doi.org/10.3389/fpsyg.2021.638703.

"Proponents of this idea . . ." Greenhalgh, Janette, Alan J. Dowey, Pauline J. Horne, et al. 2009. "Positive- and Negative Peer Modelling Effects on Young Children's Consumption of Novel Blue Foods." Appetite 52, no. 3 (June): 646–53. https://doi.org/10.1016/j.appet.2009.02.016.

"Humans have an instinctual repulsion to it . . ." Piqueras-Fiszman, Betina, Alexandra A. Kraus, and Charles Spence. 2014. "'Yummy' versus 'Yucky'! Explicit and Implicit Approach–Avoidance Motivations towards Appealing and Disgusting Foods." Appetite 78 (July 1): 193–202. https://doi.org/10.1016/j.appet.2014.03.029.

"However, the alleged experiment . . ." Tannenbaum, Joel Harold. 2020. "'Blue Steak, Red Peas': Science, Marketing, and the Making of a Culinary Myth." *Gastronomica* 20, no. 2 (May): 30–36. https://doi.org/10.1525/gfc.2020.20.2.30.

"Actual experiments that have since . . ." Mühl, Melanie, and Diana Von Kopp. 2017. *How We Eat with Our Eyes and Think with Our Stomach: The Hidden Influences That Shape Your Eating Habits*. New York: The Experiment.

68 Prussian Blue

"Prussian blue was first created . . ." Dunbar, Kim R., and Robert A. Heintz. 1996. "Chemistry of Transition Metal Cyanide Compounds: Modern Perspectives." In Progress in Inorganic Chemistry, edited by Kenneth D. Karlin, 1st ed.. New York: John Wiley & Sons. https://doi.org/10.1002/9780470166468.ch4.

"A type of grease which . . ." Chapman, W. A. J. 2019. Workshop Technology: Part I. 5th ed. London: Routledge. https://doi.org/10.4324/9781315030449.

"Then, in 1842, chemist John Herschel . . ." Herschel, John Frederick William. 1842. "XII. On the Action of the Rays of the Solar Spectrum on Vegetable Colours, and on Some New Photographic Processes." Philosophical Transactions of the Royal Society of London 132 (December 31): 181–214. https://doi.org/10.1098/rstl.1842.0013.

"She self-published these works . . ." Atkins, Anna. 1843. Photographs of British Algae: Cyanotype Impressions. https://digitalcollections.nypl.org/collections/photographs-of-british-algae-cyanotype-impressions

"Prussian blue is also an effective . . ." "Prussian Blue" Radiation Emergency Medical Management. https://remm.hhs.gov/prussianblue.htm.

69 Tsetse Fly Blue

"Dr. Dietmar Steverding at the Norwich Medical School . . ." Steverding, D. 2013. "Visible Spectral Distribution of Shadows Explains Why Blue Targets with a High Reflectivity at 460 nm Are Attractive to Tsetse Flies." Parasites Vectors 6: 285. https://doi.org/10.1186/1756-3305-6-285

70 Horseshoe Crab Blood

"The blue color of the crabs' blood . . ." Paquet, Marine, Toshiyuki Fujii, and Frédéric Moynier. 2022. "Copper Isotope Composition of Hemocyanin." *Journal of Trace Elements in Medicine and Biology* 71 (May): 126967. https://doi.org/10.1016/j.jtemb.2022.126967.

"The blue hemolymph of horseshoe crabs . . ." Novitsky, Thomas J. 2009. "Biomedical Applications of Limulus Amebocyte Lysate." In Biology and Conservation of Horseshoe Crabs, edited by John T. Tanacredi, Mark L. Botton, and David Smith. Boston: Springer US.. https://doi.org/10.1007/978-0-387-89959-6_20.

"To address this . . ." Maloney, Tom, Ryan Phelan, and Naira Simmons. 2018. "Saving the Horseshoe Crab: A Synthetic Alternative to Horseshoe Crab Blood for Endotoxin Detection." PLOS Biology 16, no. 10 (October 12): e2006607. https://doi.org/10.1371/journal.pbio.2006607.

"Moreover, a synthetic alternative . . ." Bolden, Jay, Chris Knutsen, Jack Levin, et al. 2020. "Currently Available Recombinant Alternatives to Horseshoe Crab Blood Lysates: Are They Comparable for the Detection of Environmental Bacterial Endotoxins? A Review." *PDA Journal of Pharmaceutical Science and Technology* 74, no. 5 (September): 602–11. https://doi.org/10.5731/pdajpst.2020.012187.

71 Quasar Blue

"Quasars are the active cores of galaxies . . ." Antonucci, Robert. 2013. "Quasars Still Defy Explanation." *Nature* 495, no. 7440 (March): 165–67. https://doi.org/10.1038/495165a.

"Initial theories suggested that . . ." Klindt, Lizelke, D. M. Alexander, D. J. Rosario, E. Lusso, and S. Fotopoulou. 2019. "Fundamental Differences in the Radio Properties of Red and Blue Quasars: Evolution Strongly Favoured over Orientation." *Monthly Notices of the Royal Astronomical Society* 488, no. 3 (September 21): 3109–28. https://doi.org/10.1093/mnras/stz1771.

72 Ciel

"A doctor or surgeon would have donned all white to portray cleanliness and health, but it was soon realized that an operating room filled with bright white clothing could be visually distracting." "Frock Coats to Scrubs: A Story of Surgical Attire." Royal College of Surgeons. https://www.rcseng.ac.uk/library-and-publications/library/blog/frock-coats-to-scrubs/.

73 Egyptian Blue

"Egyptian blue, a captivating pigment . . ." Hatton, G.D., A.J. Shortland, and M.S. Tite. 2008. "The Production Technology of Egyptian Blue and Green Frits from Second Millennium BC Egypt and Mesopotamia." *Journal of Archaeological Science* 35, no. 6 (June): 1591–1604. https://doi.org/10.1016/j.jas.2007.11.008.

"The pigment is produced by . . ." Johnson-McDaniel, Darrah, Christopher A. Barrett, Asma Sharafi, and Tina T. Salguero. 2013. "Nanoscience of an Ancient Pigment." *Journal of the American Chemical Society* 135, no. 5 (February 6): 1677–79. https://doi.org/10.1021/ja310587c.

"This unusual characteristic . . ." Radpour, Roxanne, Christian Fischer, and Ioanna Kakoulli. 2019. "New Insight into Hellenistic and Roman Cypriot Wall Paintings: An Exploration of Artists' Materials, Production Technology, and Technical Style." *Arts* 8, no. 2 (June 24): 74. https://doi.org/10.3390/arts8020074.

74 Sonoluminescence

"The process involves . . ." Song, Dan, Wen Xu, Man Luo, et al. 2021. "Influence of Carbon Nano-Dots in Water on Sonoluminescence." *Nanoscale* 13, no. 33: 14130–38. https://doi.org/10.1039/D1NR02194J.

"Sonoluminescence was first observed at the University of Cologne in 1934." Frenzel, H., and H. Schultes. 1934. "Luminescenz im Ultraschallbeschickten Wasser." *Zeitschrift Für Physikalische Chemie* 27B, no. 1 (January 1): 421–24. https://doi.org/10.1515/zpch-1934-2737.

75 Cherenkov Radiation

"One such phenomenon is . . ." Cerenkov, P. A. 1934. "Visible Emission of Clean Liquids by Action of γ Radiation." Doklady Akademii Nauk SSSR 2, 8: 451–454. https://doi.org/10.3367/UFNr.0093.196710n.0385

"Cherenkov radiation occurs when . . ." Frank, I., and I. Tamm. 1991. "Coherent Visible Radiation of Fast Electrons Passing Through Matter." In *Selected Papers*, edited by Boris M. Bolotovskii, Victor Ya. Frenkel, and Rudolf Peierls. Berlin, Heidelberg: Springer. https://doi.org/10.1007/978-3-642-74626-0_2.

"The speed of light through water is . . ." Brody, Jed, Laura Griffin, and Phil Segre. 2010. "Measurements of the Speed of Light in Water Using Foucault's Technique." *American Journal of Physics* 78, no. 6 (June): 650–53. https://doi.org/10.1119/1.3373942.

"In nuclear reactors . . ." Liu, Zhu. 2022. "What Is Cherenkov Radiation?" International Atomic Energy Agency News. July 28, 2022. https://www.iaea.org/newscenter/news/what-is-cherenkov-radiation.

76 Chalcanthite

"Chalcanthite is a bright-blue, sometimes blue-green, mineral consisting of a copper ion, a sulfate polyatomic ion (an ion with multiple atoms), and water molecules in its hydrated state . . ." "Chalcanthite: Facts About Chalcanthite." *Geology* https://www.geologyin.com/2020/02/chalcanthite-facts-about-chalcanthite.html.

77 YInMn Blue

"Smith was tasked with heating . . ." 2022. "YInMn Blue." Oregon State University Department of Chemistry. October 5. https://chemistry.oregonstate.edu/chemistry-news-events/yinmn-blue.

78 Ice Giants

"Together they are known as the ice giants . . ." Hubbard, W. B. 1997. "Neptune's Deep Chemistry." *Science* 275, no. 5304 (February 28): 1279–80. https://doi.org/10.1126/science.275.5304.1279.

"But the giants' rich blue is not due to a liquid sea . . ." Irwin, P. G. J., N. A. Teanby, et al. 2022. "Hazy Blue Worlds: A Holistic Aerosol Model for Uranus and Neptune, Including Dark Spots." *Journal of Geophysical Research: Planets* 127, no. 6 (June): e2022JE007189. https://doi.org/10.1029/2022JE007189.

"This is because its atmosphere is less turbulent . . ." Gemini Observatory, a Program of NSF's NOIRLab. 2022. "Why Uranus and Neptune Are Different Colors." NASA Solar System Exploration. May 31. https://solarsystem.nasa.gov/news/2232/why-uranus-and-neptune-are-different-colors.

"Neptune doesn't form this haze since . . ." NASA Solar System Exploration Hub. "Neptune: Facts." https://solarsystem.nasa.gov/planets/neptune/in-depth.

79 Navy Blue

"After polling over 26,000 participants . . ." Carter, Dom. 2019. "G.F Smith Reveals the World's Most Relaxing Colour." Creative Bloq. April, 10. https://www.creativebloq.com/news/gf-smith-reveals-the-worlds-most-relaxing-colour.

80 Blacklight

"Ultraviolet (UV) light is a range . . ." "Observing Ultraviolet Light." HubbleSite. https://hubblesite.org/contents/articles/observing-ultraviolet-light.

"Many animals, including bees and some birds, can see UV light." Kelber, Almut, Misha Vorobyev, and Daniel Osorio. 2003. "Animal Colour Vision—Behavioural Tests and Physiological Concepts." *Biological Reviews of the Cambridge Philosophical Society* 78, no. 1 (February): 81–118. https://doi.org/10.1017/S1464793102005985.

81 Han Purple
"Around 3,000 years ago, people in China . . ." Doehne, Eric, and Qinglin Ma. 2004. "Rediscovering Ancient Technology: Microbeam Analysis of Han Purple." *Microscopy and Microanalysis* 10, no. S02 (August 1): 910–11. https://doi.org/10.1017/S1431927604887257.

"Researchers have discovered . . ." Sebastian, S. E., N. Harrison, C. D. Batista, L. Balicas, M. Jaime, et al. 2006. "Dimensional Reduction at a Quantum Critical Point." *Nature* 441, no. 7093 (June): 617–20. https://doi.org/10.1038/nature04732.

82 Tyrian Purple
"In November 2020 . . ." Lee, Jeongchan, Joonwon Kim, Ji Eun Song, et al. 2021. "Production of Tyrian Purple Indigoid Dye from Tryptophan in Escherichia coli." *Nature Chemical Biology* 17, no. 1 (January): 104–12. https://doi.org/10.1038/s41589-020-00684-4.

83 Amethyst
"Something surprising happens when amethyst is heated:. Between 800 to 900 degrees Fahrenheit, the amethyst will shift to resemble the orange-yellow mineral citrine . . ." Cheng, Renping, and Ying Guo. 2020. "Study on the Effect of Heat Treatment on Amethyst Color and the Cause of Coloration." *Scientific Reports*. vol. 10, no. 1, September, p. 14927. www.nature.com. https://doi.org/10.1038/s41598-020-71786-1.

84 Gentian Violet
"This vibrant dye has been valued . . ." Lauth, C. 1867. "On the New Aniline Dye, Violet de Paris." Laboratory 1: 138–39.

"The dye, chemically known as . . ." National Center for Biotechnology Information. "PubChem Compound Summary for CID 11057, Gentian Violet." PubChem. https://pubchem.ncbi.nlm.nih.gov/compound/11057.

"In the late nineteenth century, Albert Ritter von Mosetig-Moorhof." Craig, William. 1891. "Methyl-violet in Malignant Disease." Periscope: Monthly Report on the Progress of Therapeutics. *Edinburgh Medical Journal* 36 (June).

"In 1884, Hans Christian Gram discovered . . ." Gram, Hans Christian. 1884. "Über die isolierte Färbung der Schizomyceten in Schnitt und Trockenpräparaten." Fortschritte der Medizin 2: 185–89.

85 Lepidolite
"In fact, rubidium was discovered in 1861 . . ." Kirchhoff and Bunsen. 1860. "IX. Chemical Analysis by Spectrum-Observations." The London, Edinburgh, and Dublin *Philosophical Magazine and Journal of Science* 20, no. 131 (August): 88–109. https://doi.org/10.1080/14786446008642913.

"The color of lepidolite can . . ." Deer, W. A., Robert A. Howie, and Jack Zussman. 2013. An Introduction to the Rock-Forming Minerals. 3rd ed. London: Mineralogical Society of Great Britain and Ireland. https://doi.org/10.1180/DHZ.

"This means lithium ions are very small . . ." Munoz, James L. 1971. "Hydrothermal Stability Relations of Synthetic Lepidolite." American Mineralogist 56: 2069-87.

86 Mauveine
". . . After repeated attempts, one of the "failed" samples left behind a black residue with bright purple remnants." William Henry Perkin. Science History Institute. https://www.sciencehistory.org/education/scientific-biographies/william-henry-perkin/.

"The current methods of lithium extraction . . ." Lee, Annie. 2023. "China Lithium Probe Puts Spotlight on Reserves and ESG Risks." 2023. *Bloomberg*. March 9. https://www.bloomberg.com/news/articles/2023-03-10/battery-materials-china-s-lithium-probe-puts-spotlight-on-reserves-esg-risks#xj4y7vzkg.

87 Purpleheart
"Purpleheart is a group of trees . . ." Chudnoff, Martin. 1984. "Peltogyne spp." In *Tropical Timbers of the World*. 607. USDA Forest Service Agriculture Handbook, US Government Printing Office.

"The oxidation process behind the color change . . ." Gutiérrez-Macías, Paulina, Cinthya G. Gutiérrez-Zúñiga, Leticia Garduño-Siciliano, et al. 2019. "Purple Pigment from Peltogyne Mexicana Heartwood as a Potential Colorant for Food." *Journal of Food Science and Technology* 56, no. 7 (July 1): 3225–38. https://doi.org/10.1007/s13197-019-03779-6.

88 Avocado Dye
"After saturating a white fabric or color field, the earthy-red liquid can transform into a soft and natural pink similar to the popular 'millennial pink'." Verde, Isvett. "Avocado Dye Is, Naturally, Millennial Pink." *The New York Times*. July 15, 2019. https://www.nytimes.com/2019/07/15/fashion/avocado-dye-is-naturally-millennial-pink.html.

89 Magenta
"Magenta light is created by our brains . . ." Plutino, Alice, Gabriele Simone, and Alessandro Rizzi, eds. 2022. Color Design & Technology—A Multidisciplinary Approach to Colour—Part 1. Research Culture and Science Books, vol. 5: 58-71. IT: Gruppo del Colore—Associazione Italiana Colore. https://doi.org/10.23738/RCASB.005.

"Isaac Newton, the father of optics himself . . ." Newton, Isaac. 1952. Opticks: Or, a Treatise of the Reflections, Refractions, Inflections & Colours of Light. New York: Dover Publications, Inc.

90 Astaxanthin
"First, algae synthesize astaxanthins (alongside many other pigments). The algae is then consumed by shellfish and crustaceans, where it can appear as a dull to soft pinkish orange as it's stored in the body." "Astaxanthin: The Reason Flamingoes Are Pink!" 2021. University of Bristol, Molecule of the Month. (June). https://www.chm.bris.ac.uk/motm/astaxanthin/astaxanthinh.htm.

91 Baker-Miller Pink
"In the late 1970s, researchers proposed . . ." Schauss, Alexander G. 1979 "Tranquilizing Effect of Color Reduces Aggressive Behavior and Potential Violence." *Journal of Orthomolecular Psychiatry* 8, no. 4: 218–21.

"Preliminary results indeed reflected . . ." Schauss, Alexander. 1985. "The Physiological Effect of Color on the Suppression of Human Aggression: Research on Baker-Miller Pink." *International Journal of Biosocial Research* 7 (January): 55-64.

"Later studies suggested the calming effect was temporary." Genschow, Oliver, Thomas Noll, Michaela Wänke, and Robert Gersbach. 2015. "Does Baker-Miller Pink Reduce Aggression in Prison Detention Cells? A Critical Empirical Examination." Psychology, *Crime & Law* 21, no. 5 (May 28): 482–89. https://doi.org/10.1080/1068316X.2014.989172.

"May have simply been a response to the novelty . . ." Gilliam, J. E., & Unruh, D. 1988. "The Effects of Baker-Miller Pink on Biological, Physical and Cognitive Behaviour." *Journal of Orthomolecular Medicine* 3, no. 4: 202–206.

Reithinger, Susanne, et al. 2017. "The Myth of Baker-Miller Pink: Effects of Colored Light on Physiology, Cognition, and Emotion?" Lux Europa 2017, Ljubljana, September 18–20, 2017.

92 Ruby Chocolate
"It was unveiled in 2017 . . . " "Ruby: A true gift from nature," Barry Callebaut. https://www.barry-callebaut.com/en-US/ruby-true-gift-nature.

93 Hydrangea Pink
"A fascinating property of the hydrangea is its ability to essentially function as a soil-pH indicator through color shifting." "Curious Chemistry Guides Hydrangea Colors." *American Scientist*. February 6, 2017. https://www.americanscientist.org/article/curious-chemistry-guides-hydrangea-colors.

Structural Colors

"The parts of the Feathers of this glorious Bird appear, through the Microscope, no less gaudy then do the whole Feathers . . ." Academia.Dk Robert Hooke: Micrographia. http://www.academia.dk/MedHist/Biblioteket/Print/hooke_micrographia_plain.html.

94 Opal
"This is due to the neatly and tightly packed arrangement of silica nanoparticles. When these particles are arranged just right," Opals And Photonic Crystals. https://www.uvm.edu/~dahammon/Structural_Colors/Structural_Colors/Opals_And_Photonic_Crystals.html.

95 *Cystoseira tamariscifolia*
"The surprising difference, however, is that . . ." "New Type of Opal Formed by Common Seaweed Discovered." School of Biological Sciences press release. April 16, 2018. University of Bristol. https://www.bristol.ac.uk/biology/news/2018/light-induced-dynamic.html.

96 Giant Blue Morpho Butterfly
"The microscopic arrangement of its wings . . ." Mohamed Ragaei, Al-kazafy Hassan Sabry. 2015. "Role of Color Interference on the Insect's Cuticle Coloration", *International Journal of Science and Research* (IJSR), vol. 4 no. 6 (June): 2306-2314. https://www.ijsr.net/getabstract.php?paperid=SUB155789

97 Marble Berry
"This berry has the distinction of . . ." Vignolini, Silvia, Paula J. Rudall, Alice V. Rowland, et al. 2012. "Pointillist Structural Color in Pollia Fruit." *Proceedings of the National Academy of Sciences* 109, no. 39 (September 25): 15712–15. https://doi.org/10.1073/pnas.1210105109.

98 Oil or Soap & Water
"The thickness of the layers determines which wavelengths of light are separated and observed through constructive or destructive interference." Thin-Film Interference. http://physics.bu.edu/py106/notes/Thinfilm.html.

99 Monarch Chrysalis Gold
"The yellow pigmentation of these spots is due to carotenoids, the same yellow pigment of autumn leaves." "Striking Gold: Why Are Butterfly Chrysalises Gold?" Ask an Entomologist. December 8, 2016. https://askentomologists.com/2016/12/08/striking-gold/.

100 Colloidal Gold
"This causes shorter wavelengths of light . . ." Kraemer, E. O., and S. T. Dexter. 1927. "The Light-Scattering Capacity (Tyndall Effect) and Colloidal Behavior of Gelatine Sols and Gels." *The Journal of Physical Chemistry* 31, no. 5 (May 1): 764–82. https://doi.org/10.1021/j150275a014.

"The color of the gold particles can range . . ." Turkevich, J., G. Garton, and P. C. Stevenson. 1954. "The Color of Colloidal Gold." *Journal of Colloid Science* 9, supp. 1 (January): 26–35. https://doi.org/10.1016/0095-8522(54)90070-7.

"In the medical field . . ." Stuchinskaya, Tanya, et al. 2011. "Targeted Photodynamic Therapy of Breast Cancer Cells Using Antibody-Phthalocyanine-Gold Nanoparticle Conjugates." *Photochemical & Photobiological Sciences*, vol. 10, no. 5 (May): 822–31. https://doi.org/10.1039/c1pp05014a.

"The conductivity of the nanoparticles . . ." Huang, Daniel, et al. 2003. "Plastic-Compatible Low Resistance Printable Gold Nanoparticle Conductors for Flexible Electronics." *Journal of the Electrochemical Society*, vol. 150, no. 7 (May): G412. https://doi.org/10.1149/1.1582466.

"Additionally, its sensitivity to environmental factors . . ." Ali, M. E., et al. 2012. "Nanobioprobe for the Determination of Pork Adulteration in Burger Formulations". J*ournal of Nanomaterials*, vol. 2012 (February): e832387. https://doi.org/10.1155/2012/832387.

Impossible Colors
"There is science to help facilitate . . ." Churchland, Paul. 2005. "Chimerical Colors: Some Phenomenological Predictions from Cognitive Neuroscience." *Philosophical Psychology*, vol. 18, no. 5 (October): 527–60. https://doi.org/10.1080/09515080500264115.

Photo Credits

Cosmic Void © NASA
Vantablack © Tyler Thrasher
Black Substance © Flowersandtraveling/Shutterstock
Eigengrau © Brett/Adobe Stock
Black Pearl © Tyler Thrasher
Cuttlefish Ink © Shutterstock
Anthocyanin in Black Plants © Andriana Syvanych/Shutterstock
Gray Matter © Dr. Norbert Lange/Shutterstock
Glaucous © Tyler Thrasher
Lunar Dust © NASA / GSFC / Arizona State University
Polar Bear Fur © MyImages Micha/Shutterstock
White Rot © KYTan/Shutterstock
Lead White © John a. Shaw/Shutterstock
Ultrawhite © Shutterstock
Mistake Out ©Tyler Thrasher
Ivory ©Tyler Thrasher
Cosmic Latte © Muratart/Adobe Stock
Landlord White ©Tyler Thrasher
Mummy Brown © schusterbauer.com/Shutterstock
Brown Dwarf © nazarii/Adobe Stock
Feuille Morte © Tyler Thrasher
Carmine © raptorcaptor/Adobe Stock
Ancient Chlorophyll © Shutterstock
Falu Red © DrimaFilm/Shutterstock
Hydrogen-Alpha © JulioH Photography/Adobe Stock
Dragon's Blood © Tyler Thrasher
Pompeian Red © ArchaiOptix/Wikimedia
Kermes Red © Prostasoy AN/Shutterstock
The Great Red Spot © Artsiom P/Adobe Stock
Realgar © Jirik V/Shutterstock
Redshift © NASA's Goddard Space Flight Center/F. Reddy and Z. Zhai, Y. Wang (IPAC), and A. Benson (Carnegie Observatories)
Blood Moon © lukszczepanski/Adobe Stock
Martian Red © rtpye/Adobe Stock
Poppy Red © In Green/Shutterstock
International Orange © Joel Kowsky/NASA
The First Color © ESA and the Planck Collaboration
Fulvous © Shutterstock
Tiger's-Eye © Tyler Thrasher

Orpiment © Steve Todd/Shutterstock
Bastard Amber © Shutterstock
Sodium-Vapor Light © Callum Fraser/Alamy
Baltic Amber © hischneider/Adobe Stock
Venusian Yellow ©/Shutterstock
Libyan Desert Glass ©/Tyler Thrasher
Imperial Yellow © Malcolm Park/Alamy
Gold © Bjorn Wylezich/Adobe Stock
Indian Yellow © Japansainlook/Shutterstock
Letharia vulpina © Tyler Thrasher
Luciferin © songdech17/Adobe Stock
Fluorescein © Tyler Thrasher
Uranium Glass © Tyler Thrasher
Radium Decay © Kim/Adobe Stock
Earth Aurora Green © BobNoah/Shutterstock
Helenite Green © Tyler Thrasher
Scheele's Green © Aaren Goldin/Shutterstock
Fuchsite © Tyler Thrasher
Chalkboard Green © choat/Adobe Stock
Smaragdine © Rachmo/Shutterstock
Malachite © Andrey_S/Shutterstock
Mercury E-line © Callum Fraser/Alamy
Green Pea Galaxies © SDSS and NASA, ESA, CSA, and STScI
Mirror © Tyler Thrasher
Comet C/2002 E3 © Wikimedia/Axlecrusher
Zelyonka © Tyler Thrasher
Water © Milan/Adobe Stock
Maya Blue © Mardoz/Adobe Stock
Unappetizing Blue © Mara Zemgaliete/Adobe Stock
Prussian Blue © Wikimedia
Tsetse Fly Blue © Charles O. Cecil/Alamy
Horseshoe Crab Blood © Minden pictures/Alamy
Quasar Blue © UPI/Alamy
Ciel © wavebreakmedia/Shutterstock
Egyptian Blue © Hemro/Shutterstock
Sonoluminescence © Nara & DVIDS Public domain archive
Cherenkov Radiation © Parilov/Shutterstock
Chalcanthite © Tyler Thrasher
YInMn Blue © Tyler Thrasher

Ice Giants © NASA/Alamy Worldspec

Navy Blue © Olesya/Adobe Stock

Blacklight © KIBECphoto/Shutterstock

Han Purple © The Picture Art Collection/Alamy

Tyrian Purple © Jon G. Fuller/VWPics/Alamy

Amethyst © Tyler Thrasher

Gentian Violet © Yana Maliarenko/Shutterstock

Lepidolite © Nyura/Shutterstock

Mauveine © Herlock_00/Shutterstock

Purpleheart © Tyler Thrasher

Avocado Dye © Troshyna Yaroslava/Shutterstock

Magenta © Artemisa Gajda/Shutterstock

Astaxanthin © belyaaa/Adobe Stock

Baker-Miller Pink © suidmanexe/Pink Shutterstock

Ruby Chocolate © laplateresca/Adobe Stock

Hydrangea Pink © dolphfyn/Shutterstock

Opal © Macroscopic Solution/Adobe Stockr

Opal inset image © Nano Lab LLC

Cystoseria tamariscifolia © Damsea/Shutterstock

Giant Blue Morpho Butterfly © Tyler Thrasher

Marble Berry © Debbie Jolliff/Age of stock

Oil or Soap & Water © Alexfilim/Shutterstock

Monarch Chrysalis Gold © Sujo Studios/Shutterstock

Monarch Chrysalis Gold inset image © Nano Lab LLC

Colloidal Gold © Tyler Thrasher

Page i: Colorful microscopic view of Epsom Salt or Magnesium Sulfate heptahydrate Crystals. Abstract background texture. Captured under polarized light with a microscope. © Moe Shirani/Adobe Stock

Pages ii-iii: Abstract banner color gradient. © Katsukakun/Adobe Stock

Page iv: Crystals of citric acid, microscope image. © Henri Koskinen/Adobe Stock

Page v: © Tyler Thrasher

Page vii: Psychedelic background surface of colorful soap bubble. © Alex/Adobe Stock

Page xii: Crystal layer on microscope object glass, seen in polarized light. This causes random unforeseeable color effects. © Kim/Adobe Stock

Page xiii: © Tyler Thrasher

Page xxvi: © Tyler Thrasher

Page 5: © Tyler Thrasher

Page 6: Abstract banner color gradient. © Katsukakun/Adobe Stock

Pages 194-195: Bismuth hopper crystal macro detail texture background. Closeup raw rough unpolished semiprecious gemstone. © Mineral Vision/Adobe Stock

Page 199: Vibrant gradient background. © Your Hand Please/Adobe Stock

Pages 214-215: Abstract background texture of iridescent paints. Soap bubble Psychedelic patterns. © Alex/Adobe Stock

Page 221: Crystals seen in a microscope, using polarized light. © Kim/Adobe Stock

Pages 230-231: Vibrant gradient background. © Your Hand Please/Adobe Stock

Page 233: Microscope image of crystallized ascorbic acid known as vitamin C. © Henri Koskinen/Adobe Stock

Page 249: © Tyler Thrasher

Page 253: Page 6: Abstract banner color gradient. © Katsukakun/Adobe Stock

Page 254: Crystals of citric acid, microscope image. © Henri Koskinen/Adobe Stock

Index

Amethyst, 173
Ancient Chlorophyll, 53
Anthocyanin in Black Plants, 21
Astaxanthin, 187
Avocado Dye, 183
Baker-Miller Pink, 189
Baltic Amber, 91
Bastard Amber, 87
Black Pearl, 17
Black Substance, 13
Blacklight, 167
Blood Moon, 71
Brown Dwarf, 47
Carmine, 51
Chalcanthite, 159
Chalkboard Green, 121
Cherenkov Radiation, 157
Ciel, 151
Colloidal Gold, 213
Comet C/2002 E3, 133
Cosmic Latte, 41
Cosmic Void, 9
Cuttlefish Ink, 19
Cystoseria tamariscifolia, 203
Dragon's Blood, 59
Earth Aurora Green, 113
Egyptian Blue, 153
Eigengrau, 15
Falu Red, 55
Feuille Morte, 49
Fluorescein, 107
Fuchsite, 119
Fulvous, 81
Gentian Violet, 175
Giant Blue Morpho Butterfly, 205

Glaucous, 25
Gold, 99
Gray Matter, 23
Green Pea Galaxies, 129
Han Purple, 169
Helenite Green, 115
Horseshoe Crab Blood, 147
Hydrangea Pink, 193
Hydrogen-Alpha, 57
Ice Giants, 163
Imperial Yellow, 97
Indian Yellow, 101
International Orange, 77
Ivory, 39
Kermes Red, 63
Landlord White, 43
Lead White, 33
Lepidolite, 177
Letharia Vulpina, 103
Libyan Desert Glass, 95
Luciferin, 105
Lunar Dust, 27
Magenta, 185
Malachite, 125
Marble Berry, 207
Martian Red, 73
Mauveine, 179
Maya Blue, 139
Mercury E-Line, 127
Mirror, 131
Mistake Out, 37
Monarch Chrysalis Gold, 211
Mummy Brown, 45
Navy Blue, 165
Oil or Soap & Water, 209

Opal, 201
Orpiment, 85
Polar Bear Fur, 29
Pompeian Red, 61
Poppy Red, 75
Prussian Blue, 143
Purpleheart, 181
Quasar Blue, 149
Radium Decay, 111
Realgar, 67
Redshift, 69
Ruby Chocolate, 191
Scheele's Green, 117
Smaragdine, 123
Sodium-Vapor Light, 89
Sonoluminescence, 155
The First Color, 79
The Great Red Spot, 65
Tiger's-Eye, 83
Tsetse Fly Blue, 145
Tyrian Purple, 171
Ultrawhite, 35
Unappetizing Blue, 141
Uranium Glass, 109
Vantablack, 11
Venusian Yellow, 93
Water, 137
White Rot, 31
YInMn Blue, 161
Zelyonka, 135

About the Authors

TYLER THRASHER is a self-taught chemist and botanist with a BFA in computer animation and art history. He spent much of his childhood living in greenhouses, which would go on to inspire his love for nature. During college Tyler spent his free time crawling through caves, which inspired a body of art that involved synthesizing crystals onto preserved insects and organic matter such as skulls. This quickly became his full-time job and ultimately unraveled a deeper fascination for nature and experimentation, which has carried over into the idea for this very book!

TERRY MUDGE opened the Stemcell Science Shop in 2016 with the goal of elevating the lackluster standard in scientific goods. After several successful years Terry launched his monthly Matter box, one of the most popular science subscription boxes around. He now spends his time hunting down fascinating pieces of nature and science to keep people tantalized by the infinite possibilities of the universe.

Copyright © 2024 by Tyler Thrasher and Terry Mudge
Foreword © 2024 by Hank Green

All rights reserved. No portion of this book may be reproduced or utilized in any form, or by any electronic, mechanical, or other means, without the prior written permission of the publisher.

Printed in China

SASQUATCH BOOKS with colophon is a registered trademark of Penguin Random House LLC

28 27 26 25 24 9 8 7 6 5 4 3 2 1

Editor: Hannah Elnan
Production editor: Peggy Gannon
Designer: Alison Keefe
Front cover photograph © Oleksii/Adobe Stock;
Back: © kosoff/Adobe Stock
Endsheets: © Moe Shirani/Adobe Stock
Interior diagrams: Terry Mudge
Sonoluminescence image, page 155, reprinted with permission from David J. Flannigan and Kenneth S. Suslick. 2012. "Temperature Nonequilibration during Single-Bubble Sonoluminescence," *The Journal of Physical Chemistry Letters* 2012 3 (17): 2401-2404. https://doi.org/10.1021/jz301100j.

Library of Congress Cataloging-in-Publication Data

Names: Thrasher, Tyler, author. | Mudge, Terry, author.
Title: The universe in 100 colors : weird and wonderful colors from science and nature / Tyler Thrasher and Terry Mudge.
Other titles: Universe in one hundred colors
Description: Seattle: Sasquatch Books, [2024] | Includes bibliographical references and index.
Identifiers: LCCN 2023053979 (print) | LCCN 2023053980 (ebook) | ISBN 9781632174925 (hardcover) | ISBN 9781632174932 (epub)
Subjects: LCSH: Color--Popular works. | Colors--Popular works. | Colors--Analysis. | Color--Terminology.
Classification: LCC QC495.3 .T47 2024 (print) | LCC QC495.3 (ebook) | DDC 535.9--dc23/eng/20240129
LC record available at https://lccn.loc.gov/2023053979
LC ebook record available at https://lccn.loc.gov/2023053980

ISBN: 978-1-63217-492-5

Sasquatch Books • 1325 Fourth Avenue, Suite 1025 • Seattle, WA 98101

SasquatchBooks.com

This book aims to provide interesting information about the history and properties of various colors and is not intended to provide medical advice. The author and publisher make no representations regarding the safety of medicinal uses of the chemical compounds mentioned in this book and specifically disclaim any liability for the use of information contained in this book. You should consult with your doctor if you believe you have any medical conditions that may require treatment.

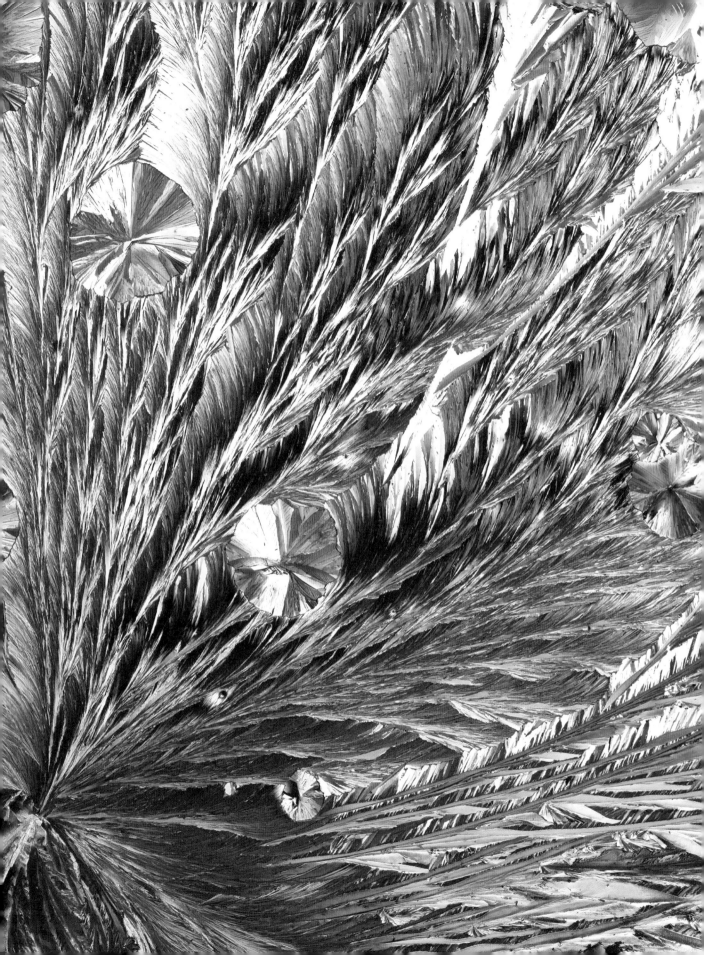